garden in a
gallery

The Architecture of the Barnes Foundation

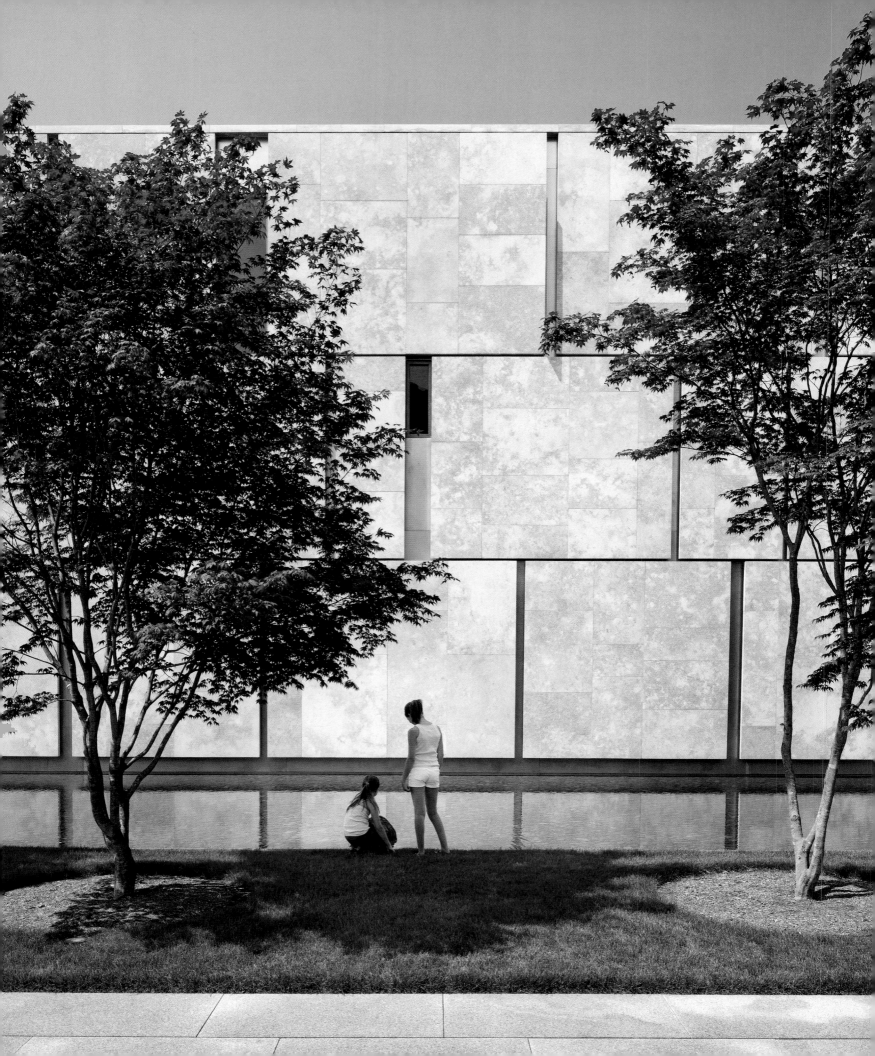

The Architecture of the Barnes Foundation

Gallery in a Garden, Garden in a Gallery

TOD WILLIAMS BILLIE TSIEN

Edited by Octavia Giovannini-Torelli

Principal photography by Michael Moran

in association with The Barnes Foundation, Philadelphia

CONTENTS

When we first started to imagine moving the magnificent Barnes collection from Merion, just outside Philadelphia, to a new home in the city, the challenge seemed almost insurmountable—in part because of the Foundation's history and in part because of the intricacy of the installation. We had a wonderful site on the Benjamin Franklin Parkway in Philadelphia's cultural neighborhood, and now we needed a building. For more than three years, the Building Committee and the board held a series of conversations about the wishes of Dr. Barnes and the purpose of his world-famous collection.

During meetings, seminars, and retreats, we considered the galleries, the question of access to the collection, and the educational mission of the Barnes Foundation. Over time, we agreed that our obligation was to replicate the hang in the original galleries, and that the new building should allow for more visitors, longer hours of operation, various amenities, and adequate office space for the staff. We decided to offer programs with other approaches to art appreciation and art history, complementing the Foundation's established Barnes method. We hoped the new building would allow for additional classrooms, seminar rooms, a library, a state-of-the-art conservation lab, a special exhibition gallery, and an auditorium.

During the architectural selection process, several of the trustees met with philanthropist Mrs. Walter H. Annenberg to discuss our progress. We spent a good amount of time reviewing the space and circulation requirements, and evaluating the site on the Parkway. At our final meeting over tea, Mrs. Annenberg gently expressed her hope that our building would be beautiful. I did not realize it at the time, but beauty, of course, became our unwritten aspiration, in addition to the long program we had developed.

We considered and met with talented architects in the United States, Europe, and Asia. In the end our choice was unanimous: the team of Tod Williams and Billie Tsien. We had visited and admired several of their buildings, including the Phoenix Art Museum; the Neurosciences Institute in La Jolla, California; the American Folk Art Museum in New York; and Skirkanich Hall at the University of Pennsylvania in Philadelphia. Each of these projects had challenged the architects in various ways, and we knew they would be able to confront the enormous difficulty of replicating the Merion galleries in an authentic way.

During our initial discussions with Tod and Billie, they emphasized the domestic atmosphere of the original galleries and spoke of their desire

to extend that feeling to the new building. They also wanted to re-create the surroundings of those galleries—an environment that separates visitors from the hectic city, gets them to drop their shoulders and quiet down, making them more receptive to really *seeing* the collection. "We do not teach students how to paint, for that would be like teaching an injured person how to scream. We teach them how to learn to see; that is, to perceive the meanings in the events of everyday life, as well as in paintings, sculpture, music, furniture, objects in wrought iron, trees and flowers" (Dr. Barnes, WCAU radio address, April 9, 1942). Tod and Billie's idea of creating a gallery within a garden—and, on a smaller scale, a garden within a gallery—may seem obvious in retrospect, but their execution of this simple concept is indeed beautiful.

Tod and Billie turned out to be a wonderful choice, not only because of their attention to detail and their selection of materials but also because of their talent for working from the inside out, and their special ability to create an experience. But mostly it is because of who they are as people. In addition to caring about quality and design, they also care deeply about the individuals they work with. They value the opinions of others regardless of their status, from quarry workers in the Negev desert of Israel to the construction team, staff of the Barnes, and members of the board. Dr. Barnes desired a stronger democracy and valued every individual. I can only imagine that he would have been as overjoyed working with Tod and Billie as we have been.

During the construction, Tod mentioned the desire to honor and give recognition to the craftspeople and other individuals who contributed to this project. A plaque on a wall of the terrace at the Barnes Foundation now lists more than two thousand names. When the plaque was unveiled at the construction party, a line immediately formed to take photos of individual names. As the evening wrapped up, it was Billie's turn to speak. Her words were direct and full of emotion: "Some of us work with our heads," she said, "and some of us work with our hands. But to have built this together, all of us here have worked with our hearts."

Aileen Roberts
Trustee, The Barnes Foundation, and Chair, the Building Committee

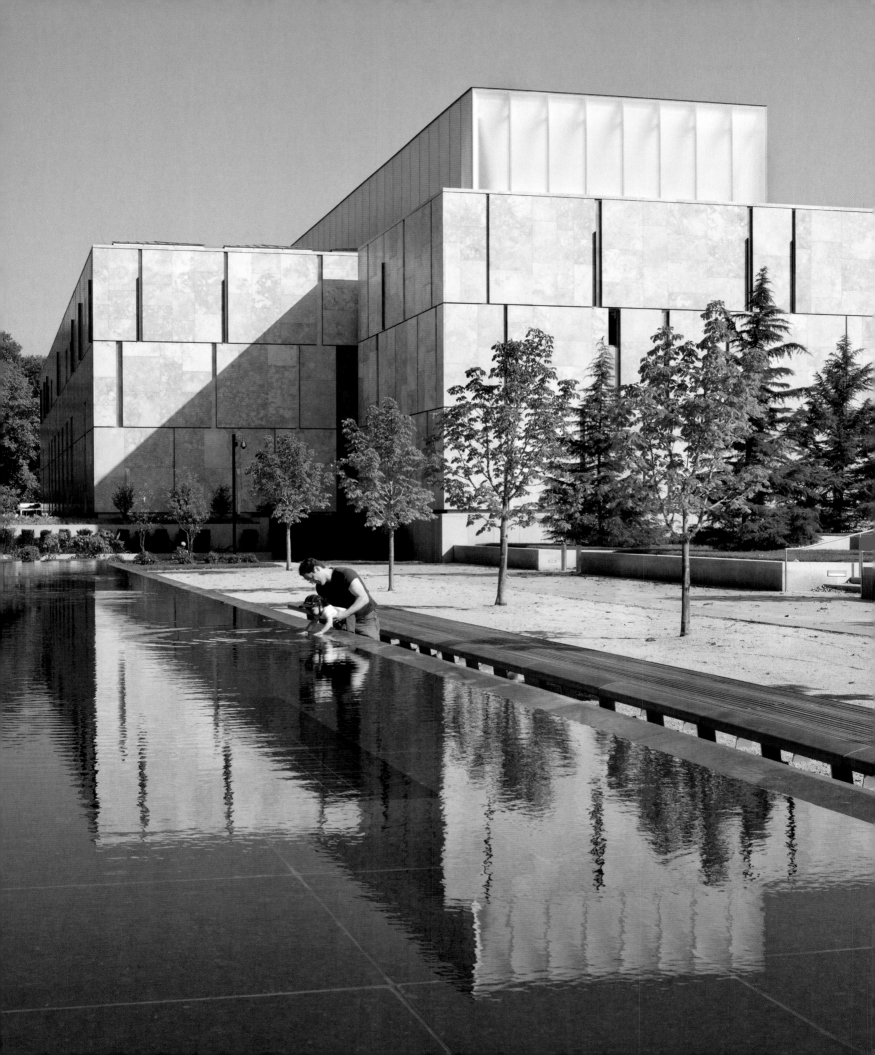

Kenneth Frampton

"Once he had cut himself off from contemporary life, he had resolved to allow nothing to enter his hermitage which might breed repugnance or regret; and so he had set his heart on finding a few pictures of subtle, exquisite refinement, steeped in an atmosphere of ancient fantasy, wrapped in an aura of antique corruption, divorced from modern times and modern society. For the delectation of his mind and the delight of his eyes, he had decided to seek out evocative works which would transport him to some unfamiliar world, point the way to new possibilities, and shake up his nervous system, by means of erudite fantasies, complicated nightmares, suave and sinister visions."

J.-K. Huysmans, *À Rebours*, 1884

It is not often that an architect has the opportunity to add to an urban set piece that has existed for more than a century, this being the time that has elapsed since Albert Kelsey first drew up his plan for a parkway in Philadelphia in 1902. The effort, inspired by the City Beautiful Movement, got underway with remarkable alacrity given that fifteen city blocks were cut through and demolished in order to arrive at a grand tree-lined avenue extending from City Hall to the Philadelphia Museum of Art by the time of the stock market collapse of 1929. It is equally remarkable that almost all of the neoclassical buildings occasioned by this *percement* were already in place on either side of Logan Square by the same date. The ensuing Great Depression and the Second World War totally foreclosed on Jacques Gréber's lateral elaboration of the Benjamin Franklin Parkway, which he had initially projected in 1919. The net outcome was that nothing culturally minded would happen for the next eighty years after the completion of Paul

Cret's diminutive Rodin Museum in 1929, until the realization in 2012 of the Barnes Foundation, on the same side of the Parkway.

It is somehow fitting that both institutions have origins in the Francophile passions of two self-made men: the movie theater mogul Jules Mastbaum, whose obsession with collecting Rodin bronzes eventually necessitated the construction of a museum to house them; and the chemist Dr. Albert Barnes who, with a fortune accruing from the sale of the antiseptic Argyrol, assembled a virtually unparalleled collection of post-impressionist and early modern art, which he installed in a gallery that he had expressly commissioned. The gallery and an attached house—set within a pre-existing arboretum in the well-appointed Philadelphia suburb of Merion—were completed in 1925 to the designs of Paul Cret.

Some thirty-five years after the deaths of Dr. Barnes and his wife, Laura, there followed a highly controversial legal battle waged by the Barnes Board of Trustees to survive as an independent organization by deviating from the charitable trust document that established the Foundation, in order to move the collection from Merion to a site on the Benjamin Franklin Parkway, which had been made available by the city for this express purpose. Once this essential variation was legally established, the Foundation launched an architectural search process and interviewed a short list of firms from which they selected Tod Williams Billie Tsien Architects as the designers of the new building. Once appointed, the architects immediately engaged in a fast-track design process that intimately involved the client from the outset—from an early sketch known as the "medallion" scheme, in which the symmetrical form of the gallery was echoed by an equally symmetrical building, to the final *parti* of December 2008, in which the symmetrical gallery was accompanied by an asymmetrical administration building that served to enclose a court between the two. The enduring symmetry of the gallery was made desirable by the legal settlement of 2004 in which it was stipulated that the original arrangement of the art had to be maintained. The only major concession the Barnes board gave the architects in the reinterpretation of the original Cret gallery plan was the introduction of two buffer volumes to separate the three *en suite* rooms at either end of the building from the core cluster of rooms in Cret's plan. This allowed the architects to introduce a light well and classrooms into an elongated version of the original building.

By the end of 2008, the design was finalized by the addition of an out-sized lantern light transforming the overall plastic form of the building

into a tripartite composition consisting of the gallery, the support building—L-shape in plan—and the monumental, translucent lantern light that surmounted the court and essentially crowned the composition. This rather dominant feature had the effect of transforming what would have otherwise been a rather staid, stone-clad megalith into a dynamic plastic composition, animated by a discreet if nonetheless discernible allusion to Suprematism. In this way the assembly presents itself as a hybrid work that, on the one hand, asserts its monumental presence as a kind of neo-Kahnian stone-faced block with classical affinities, and, on the other, posits itself as a combination of opaque and translucent masses harking back to the visions of the Russian avant-garde.

On entering the site and moving toward the entrance, one is captivated by the syncopated, modular character of the stone rain screen that envelops the entire structure. This screen—divided into three equal courses for the full height of the building and built of large panels of pale Ramon gray stone quarried in the Negev—is articulated vertically by recessed joints of varying width. The resulting low relief is accented occasionally by bronze fins inserted here and there between the panels. These inflections are augmented by projecting stone ribs. Although this constructional relief continues around the entirety of the building, its effect on the Parkway side is countermanded by the symmetrical fenestration of the gallery that houses the original collection. Here, the classical deportment of the elevation, totally determined by Cret's layout, overrides the continuing asymmetrical pattern of the rain screen, not only by virtue of its symmetry and the beautifully proportioned windows, but also because of how it projects out toward a four-foot-deep ha-ha, planted with shrubs, running out beyond the base of the building toward the tree-lined Parkway.

One of the most subtle aspects of the stone revetment is the treatment of the stone itself at two distinctly different levels—in one way, the stochastic weaving of small stone rectangles into the larger fifteen-foot slabs from which the tripartite coursework is assembled; in another way, the tooling of the stone itself, a treatment that is particularly noticeable once one passes from the exterior facing to the interior lining. Since each cuneiform inscription stems from a different hand, the chisel marks are at one and the same time both consistently repetitive and unique—a kind of "literature without an alphabet" as Henry van de Velde once described his own aestheticism. A different stone, granite, plays an equally crucial role

as paving in the stepped forecourt of the building at the intersection between North Twentieth Street and the Parkway. Here, at the conjunction of areas of deconstructed gravel with an elevated fountain pool made from basalt, an unexpected spatial rapport is set up between the forecourt and the neoclassical facade of the adjacent Free Library, all of which serves to evoke the ineffable Parisian park atmosphere sought by the architects at this juncture.

Apart from the narrow-fronted Rodin Museum, this is the first monumental building to be built parallel to the Parkway since its inception, and yet, despite the aforementioned frontality, it has nonetheless been largely conceived as an asymmetrical complex embedded in a garden. In accordance with this preconception, the architects, in conjunction with the landscape architect Laurie Olin, have given the overall approach a some-what picturesque aspect. Thus, irrespective of whether one enters on foot from the Parkway or from the hinterland to the north or, alternatively, on foot through the main portico after being dropped off by car under a cantilevered canopy, one is always obliged to turn into the formal approach established to the north of the building, where one progresses through an allée of red maple trees while being contained on one side by the building itself and on the other by a low wall intermittently covered with vines that serves to conceal the parking lot from the approach. This axial promenade is accompanied by a reflecting pool running parallel to the building and by an elevated concrete wall set at right angles to the approach so as to shield the terrace of the museum café from being seen. At the end of this axis, one has no choice but to turn left, cross over the pool, and enter the threshold of the building and from there to turn right immediately and pass through the lobby into the main reception space.

This entry sequence, causing one to turn first this way and then that, serves to initiate one into a slightly uncanny, labyrinthine movement pattern that will be reiterated throughout much of the building. Thus, whether one is outside or inside, one's ambulatory impulse is always on the verge of being checked so that one is invariably caused to pause, here and there, before proceeding further. This delay, so to speak, first occurs in the reception foyer where the deposit of outer clothing entails a descent to the lower level in order to access the coatroom before returning to the first floor by elevator or stair. This necessary deviation is facilitated by the dynamically stepped, abstract form of a timber-sided stair in black walnut that, together

with an equally abstract, luminous chandelier, is a combination that may well evoke the dark vitality of the library in Charles Rennie Mackintosh's Glasgow School of Art.

Out of desire to approximate the atmosphere of the Merion gallery, the architects gave the reception space a domestic character by carpeting the floor throughout and by providing a long baronial table in the same walnut to carry one into the depth of the building from the point of entry. One wall of this space is lined with Belgian linen in beige and gray, held in place by an elegant grid of timber battens. This intimate ambiance changes rather abruptly as one turns toward the large court by virtue of a black-and-white inlaid floor mosaic that serves as a cryptic threshold to the monumental space. Three routes are offered at this juncture: one turns right to continue across an apron of Jura stone and a large wooden floor of recycled ipe wood, laid in a herringbone pattern, to access the terrace at the end of the court; or, one turns left to enter into the temporary exhibition space; or, one moves diagonally across the court to enter the enigmatic stone face of the gallery itself to which one has already been attracted by the interior garden which one initially glimpsed on entering the building. However, this atrium is not the point of entry to the gallery and one is obliged to proceed further across the court to locate a monumental set of double doors that by virtue of their ornamentation again evoke the aura that one first encountered in the reception area. A long table of black basalt, fixed to the floor on the opposite side of this honorific space, represents the public character of the court, as opposed to the intimate, somewhat withdrawn quality of the gallery. The character of this space is greatly enhanced by a series of off-white rectangular wool and silk cord reliefs by the Dutch textile artist Claudy Jongstra, who has also contributed more brightly colored wall hangings to the café space. These off-white reliefs by Jongstra, set within the stone, uncannily recall classical metopes.

As one experiences the all but sacrosanct aura of the gallery, one senses that this almost mythical assembly of art was never just the manifestation of another wealthy patron's taste, for one soon realizes that, for Barnes, the collection was in effect the consummation of his life's work—being seen by him as a coherent and systematic teaching tool, as well as a creative composition in itself. This accounts for his rejection of wall labels, testifying to his confidence in the innate sensibility of every viewer to

appreciate the art and not need to rely on the traditional academic emphasis on the identity of the artist.

However, the gallery is not the only microcosm in this complex. Apart from the honorific realm of the court, there are two other volumes that seem to be worlds in themselves. The first of these is the lower level, accommodating, besides the mechanical services and the aforementioned coatroom, the usual ancillary functions of a cultural institution—namely, a lecture hall, a library, a gift shop, and a coffee bar, all of which are loosely grouped around the initial light well that descends to the lower level. There is something reassuring about the general ambiance of this level in that it provides a moment of intimate calm as opposed to the mega-scale of the court above. The ultimate core of this feeling of repose is unquestionably the lecture hall, with its inset stone floor and seating luxuriously upholstered in leather.

The second sequence that has a similar microcosmic character is the administrative offices that are situated on the second floor together with the conservation studio, which is illuminated by a large, floor-height, plate-glass window at the corner of the block. It serves to crown the official nature of the administration area both inside and out.

The entire complex is delicately articulated throughout via a rich palette of the material finishes, beginning with the cuneiform chiseling of the ocher-colored Ramon gold stone, which is employed within as a monumental revetment. Here and there, patterns and textures are employed so as to hint at the heterogeneous content of the collection. Typical of this is the aforementioned diminutive mosaic threshold to the court designed by Billie Tsien as an abstract black-and-white composition derived from African Kente cloth. This decorative set piece makes a double allusion—first to the Enfield tile work applied to Cret's original building, and second to the African content of the collection itself, the cubistic subconscious, so to speak, of Barnes's much beloved École de Paris.

Apart from the art itself, the most striking aspect of the interior of the gallery is the warm, balanced quality of its ambient light. The sense of fustiness that was so characteristic of the original building was due not only to the relative darkness of the walls but also to the overwhelming density of the art, along with the curtains that were kept permanently drawn against the penetration of the sun. All of these conditions have been totally overcome in the new building through a subtle adaptation, plus the

integration of a number of sophisticated devices that have jointly contributed to the atmosphere of calm that radiates throughout. This all-pervasive luminosity is due, in large measure, to the presence of two materials: the white oak that has been deployed for the floors and the joinery throughout, and the warm yellow ocher burlap lining of the walls. As a result, the ambient light, both natural and artificial, bounces off the walls in such a vibrant manner as to heighten the presence of any artwork, irrespective of its size, format, and chromatic tonality.

To a similar perceptual end, the profiles of the wooden trim have been greatly simplified, particularly when compared to Cret's original moldings. This has had the effect of sharpening the delineation of doorjambs and window reveals, including the muntins. The thin rectilinear sections of these last are key to the subtle treatment of the glazing. Through a combination of architectonic ingenuity and technological virtuosity, the architects were able to create the illusion that there is nothing untoward about the glazing. Thus one walks past these window openings without giving them a second thought, taking them at their face value without appreciating the microtechnology that has been deftly integrated into their form. One has no sense, either inside or out, that one is looking at the external landscape through an eight-layer glass sandwich, 1¾ inches thick, reducing the so-called visible light transmission to 14 percent. This illusion was achieved by a timber muntin inserted into the multilayered membrane so that one perceives the window as if it were made up of traditionally proportioned Georgian-style panes. Equally traditional in feeling are the floors of the galleries, finished in four-inch square-edge-grain tongued-and-grooved blocks laid on top of concrete and framed in the larger galleries by a wide border of three-inch planks perfectly mitered at the corners of each room and separated from the block floor by a strip of darker ipe wood.

Grills in the windowsills and rabbets in the picture rails serve to conceal air registers and strip lighting, with the former feeding tempered air into the galleries from radiators and ducting built into the walls. The window reveals are equipped with built-in roller shades that descend from above; a blackout shade within and a light filter shade without. The return air is through timber grills set in the reveals of the door openings separating one gallery from the next. These inputs and outputs are activated by servomechanisms controlled by sensors that maintain the balance of the

environment in terms of heating, cooling, and lighting while constantly responding to the impact of the sun on the building as a whole. Unlike in the Cret building, the light levels on the top floor are boosted by clerestories let into the roof. The depth of this superstructure varies to admit more or less light according to the art displayed beneath it. The sides of the clerestory prisms are louvered and capped in zinc-coated copper.

Such devices emphasize the hermeticism of the environment and recall the self-contained marine-like environment that Duc Jean Des Esseintes built for himself in Huysmans's *À Rebours*. This association prompts one to fantasize that the reinstated Barnes collection is a cargo of priceless art that has somehow come to dock rather inexplicably along one edge of the court. This disjunctive feeling arises in part out of its stone cladding, as though one is once again confronted by an external facade, and in part from the uncanny radiance emanating from its fenestration, as if its spiritual content were literally on fire as opposed to the rather subdued character of the natural light reflected into the court by the giant lantern hovering above.

Within the gallery the one space that culminates the promenade is unquestionably the balcony that overlooks the vaulted double-height space housing the tripartite mural *The Dance*, expressly painted by Henri Matisse, at Dr. Barnes's request, from 1932 to 1933. Here, the masterstroke of the architects was to create a space that allowed the freestanding sculptures on one side of the balcony to be moved to the mezzanine. This rearrangement, plus the re-siting of the three major works previously lining the walls of the main stair, enabled the architects to free up the circulation in both the stair and the balcony. By shifting Matisse's *Le Bonheur de vivre* of 1905-06, plus accompanying Aubusson tapestries after designs by Georges Rouault (1933) and Pablo Picasso (1934), into an apsidal space between the stair and the elevator the architects were able to provide ample, static space from which to view all three works and the Matisse mural in relative tranquility. Equally felicitous was the decision to dispense with the classical wooden window heads that had previously interfered with one's perception of the Matisse mural. This gesture not only facilitated a fuller perception of the mural as a continuous undulating movement across the space but also served to unify the entire volume.

Barnes's lifelong avant-garde obsession with both the École de Paris and the seemingly abstract art of Africa and North America—sculptures in the first instance and textiles, jewelry, and pottery in the second—were enough

to make him an irritating upstart connoisseur. If anything was against the grain (*rebours* literally meaning "the wrong way"), it was this heresy, as far as the conservative, Philadelphia, academic elite was concerned, and for this categoric rejection he never forgave them. Encouraged by the egalitarian, pedagogical philosophy of John Dewey, Barnes's self-imposed, altruistic mission was to make world art of quality accessible to all. And, despite the egalitarianism of this grand pedagogical gesture, much of what we witness here, when looked at transhistorically, still seems to be "against the grain" at many other levels, be it the self-made collections of Barnes and Mastbaum, now both prestigiously installed side by side, along the axis of the Parkway, or even the Parkway itself, which together with the Philadelphia Museum of Art was always antithetical to the commercial grid of the city and thus it still seems to remain, as the nearby commercialized cacophony of today's downtown Philadelphia makes only too clear.

Kenneth Frampton
Ware Professor of Architecture, Columbia University

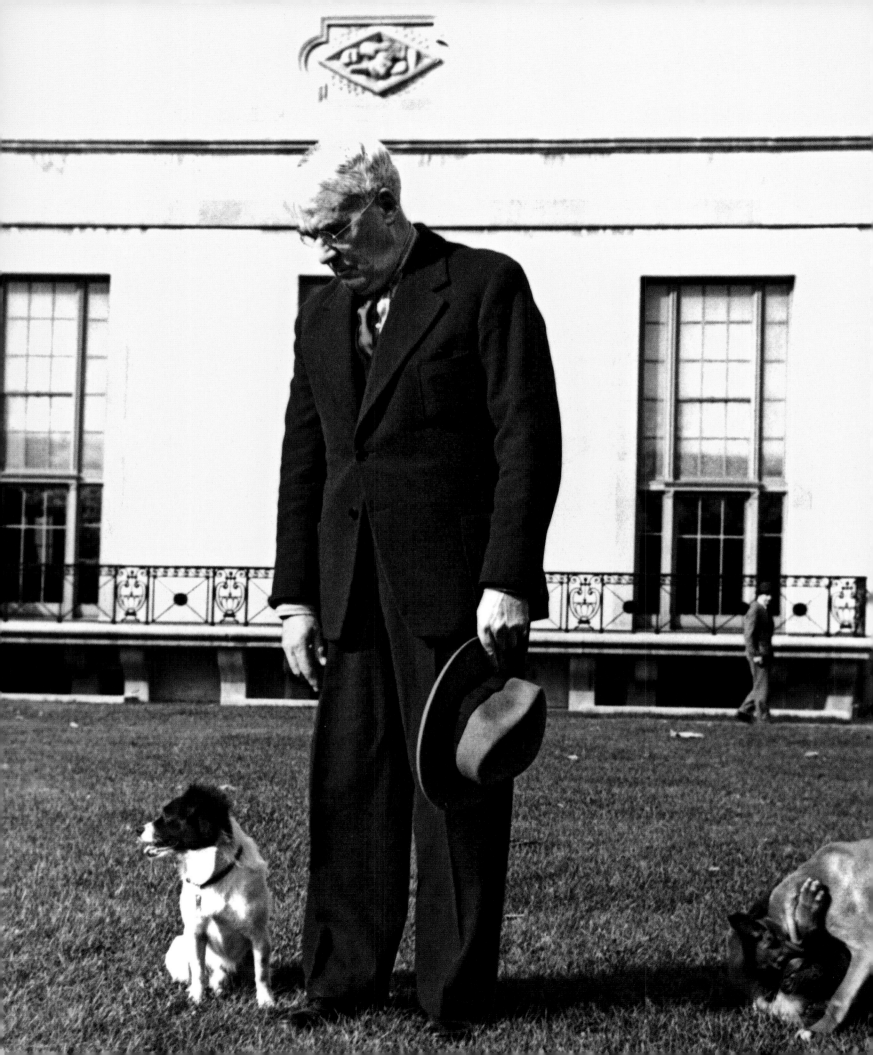

The Phantom Client

This is a book about a building, but first it is about a man. He is, of course, Dr. Albert C. Barnes. And for us he has been the all-powerful, and phantom, client.

Albert C. Barnes with Fidèle, Yogi, and Yankee on the lawn outside the Merion Gallery, 1939

Dr. Barnes was a businessman who made his fortune by manufacturing and distributing Argyrol, a silver-based antiseptic that he co-developed. He used this fortune to pursue his passion. For more than forty years, with early advice from his friend the painter William J. Glackens, he traveled to Europe, buying several hundred paintings. Visiting studios and through his connections with collector Leo Stein and the dealers Paul Durand-Ruel and Paul Guillaume, he was able to acquire some of the great master-pieces of nineteenth- and twentieth-century art. He also collected African art, old master paintings, wrought-iron objects, and Native American ceramics, jewelry, and textiles. In 1930 he commissioned Henri Matisse to make a mural to be installed in the new gallery he built for his collection in Merion, Pennsylvania.

Barnes could not have been an easy client. By all accounts he was a complex and irascible man—with a vision. From his correspondence with Paul Cret, the architect he hired to design the building in Merion, it is clear that he was demanding and had strong feelings about who should be allowed to visit his collection. He believed that the working person—not the connoisseur or the privileged—should have access in order to learn from his paintings. He hung paintings in his factories and developed seminars for his workers on the subjects of art, aesthetics, and philosophy. Inspired by the teachings of his friend John Dewey, Barnes appointed him first director of education in 1923, a year after he started his foundation. Dewey, an educator and philosopher, believed that a democracy could succeed only by the elevation of the common people through education. Barnes thought

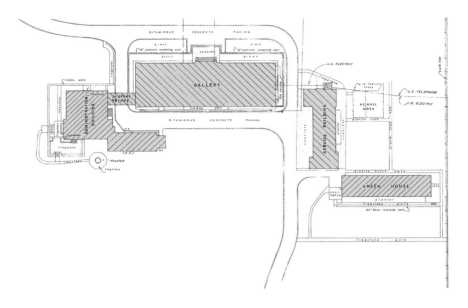

his foundation would be a force for social change, and we admire his determination to use his collection as a means of educating the eye and the mind.

Barnes developed a method of installation that considered each work of art's line, form, and color. Paintings and objects—hinges, utensils, and locks from the fourteenth through nineteenth centuries—are arranged in symmetrical groupings. The result is intended to suggest and reinforce visual and conceptual relationships between pieces. This wall arrangement is called the ensemble.

The early criticism of parts of his collection, when it was shown at the Pennsylvania Academy of the Fine Arts in 1923, deepened his profound distaste for the art establishment. That year, he wrote in the *New Republic*: "We do not convey that we have developed a crowd of savants or art connoisseurs, but we are sure that we have stirred an intelligent interest in spiritual things created by living people ... affording a sensible use of leisure in a class of people to whom such doors are usually locked." There are many stories of how Barnes turned away the well-known and the powerful. Apparently Le Corbusier offended Barnes at a dinner, prompting Barnes to deny the architect the privilege of visiting his collection. Le Corbusier wrote to him saying that he had earned the right of entry because as the publisher of *L'Esprit nouveau* he had printed an article about the collection. Barnes replied that Le Corbusier could visit and specified a date that he knew was four days after the architect's scheduled departure. Le Corbusier never saw the collection. In spite of, or perhaps because of, the prickly defense of his beliefs, Barnes seems to us fiercely and profoundly American.

In April 2007, the Barnes Foundation invited us to be part of a small group of architects who were asked to present ideas for a new building, which included a gallery to house the collection. All of the architects were

Dear Mr. Cret:- October 23, 1923.

 In reference to the revision of the construction of the Ser-
vice Building, referred to in your letter of October 20th, we authorize
you to order those changes at a deduction of $480.00 from Baton's con-
tract price. No doubt Mr. Baton will find that the allowance stated is
totally inadequate. But that is a minor matter which can be deferred
until Judgment Day when it will take its place with similar matters, like
the cesspool allowance, etc.
 There should be some provision in the gallery for a gong of
sufficient size to be heard in all parts of the gallery. Its location
should be somewhere in the central hall and it should be concealed. This
gong would be for emergency purposes and no doubt the electrical con-
tractor can arrange to connect it with the rest of his system.
 Another emergency which we would like to prepare for is brought
up by a letter which I received this morning from the Recording Secretary
of the City Parks Association in which reference is made to the "main
facade of the Barnes Museum". There seems to be the general impression
that I have built something which is conceived by various parts of the
public as a "public art gallery", "art museum", "Barnes Memorial". To
do any of those things has never even entered my mind and is evidently
the result of unauthorized newspaper statements working upon low-grade
imaginations. The Barnes Foundation is an educational institution, con-
trolled absolutely by the Board of Directors and admission will be only
by card issued to those people whom the Board of Directors consider are
fit subjects to be benefited by the educational assets of the Foundation.
I anticipate a little difficulty in correcting the public misconception
of the purposes of our institution and I would like to have some mechanical
device installed just inside the main entrance to the gallery to give point
to our intentions concerning eunuchs, morons, boobs, professional exploit-
ers and general counterfeits, represented by such individuals as Watts,
Braun, Crawford, Lewis, Morris, etc., in case they ever appear on our pro-
perty. I thought of a mitrailleuse, an electric chair, a loose stone
leading to an underground dungeon, but all those devices are too subtle
and inadequately expressive of my contempt for the prominentists that one
meets in the art circles of Philadelphia. If there is any architectural
or engineering device that would serve the intended purpose I wish you
would incorporate it in the plans.

 Yours very truly,

 A W Barnes.

 P.S. Thank you for the bulletin of the Detroit Institute.
The initials "R. P." at the bottom of the article "Modern Paintings
Acquired", you may add to the above list of Philadelphians. If he is
the man who wants to reform art opinion in Detroit - God help the
Detroit public. There is always a naive element mixed with the pathetic
in the pretentious ignorance such as that article is.

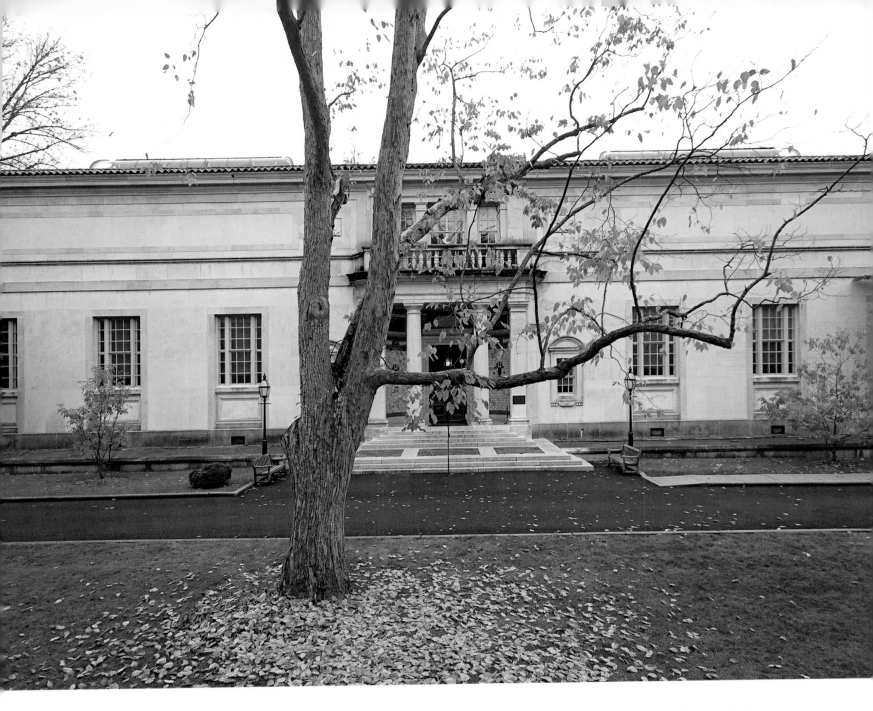

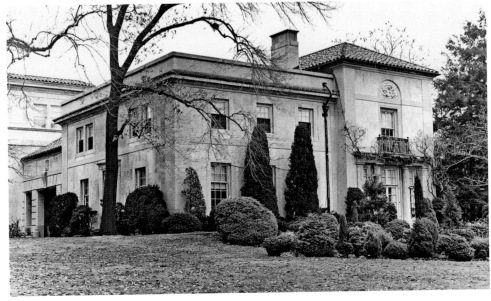

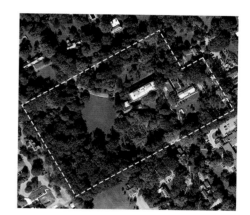

told that the ensembles and the sequence of galleries had to be "replicated." For all of us that word was, to say the least, provocative. Ashamed we had never visited the collection, we immediately made a reservation for an early appointment. After arriving by train at Philadelphia, we took a taxi to Merion. The taxi dropped us off at the gatehouse and, after checking in with the guard, we walked into the garden. We had learned that the site was originally an arboretum and that Barnes's wife, Laura, had started a horticultural program as a corollary to the art program. It was a day in early spring. The gardens were just coming to life with buds. Huge white flowers blossomed on a large magnolia tree. And at the edge of the lawn, fuchsia-colored rhododendrons made a brilliant border against the massing of mature pines. We heard only the sounds of the birds and our own footsteps. This powerful sense of entering through a garden would become an essential part of our concept for the Parkway building.

The Gallery, a handsome neoclassical building made of French limestone, was designed by Paul Philippe Cret, architect of the Detroit Institute of Arts, the Benjamin Franklin Bridge, and the Rodin Museum (the last two in Philadelphia). Cret was also one of the architects who developed early schemes for the Benjamin Franklin Parkway. For many years, he served as dean of the University of Pennsylvania School of Design, where Louis Kahn was his student. Cret's influence on the architecture of Philadelphia is deeply felt. His limestone facade in Merion is dignified and quiet, but, at the entry, the Enfield tile work with its African motif suggests the surprise that lies inside and proclaims Barnes's deep commitment to African art.

Even though we thought we knew what to expect, we were stunned when we walked through the tall wooden doors and into the Main Gallery and

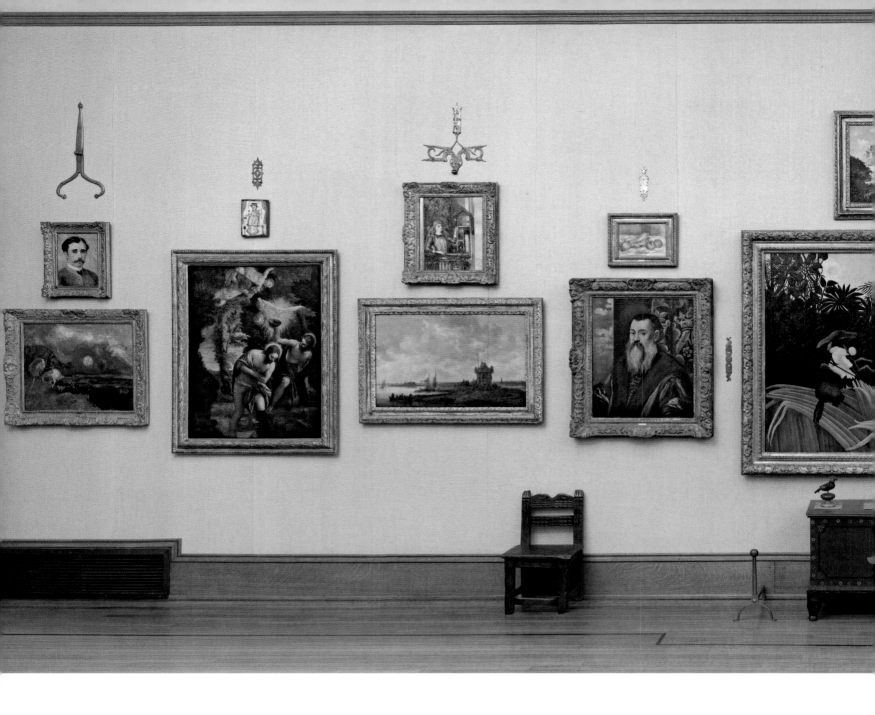

Above Ensemble on the north wall of Gallery 14 in the Cret Gallery in Merion

Opposite Ensemble directions from Barnes to Foundation staff, 1927. Barnes experimented with the display of his collection, arranging the paintings and objects in the ensembles according to formal principles of light, line, color, and space.

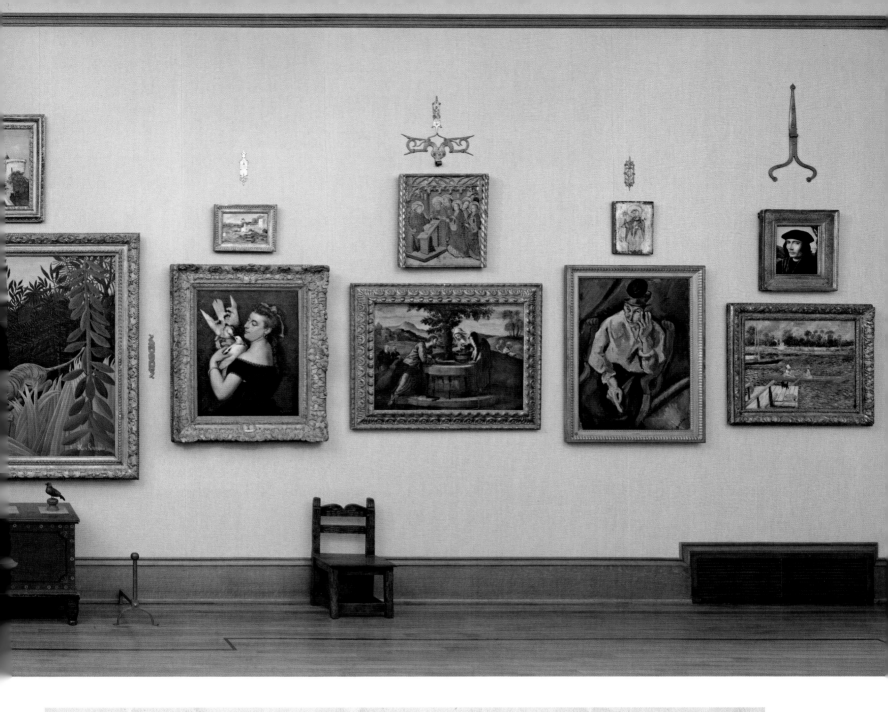

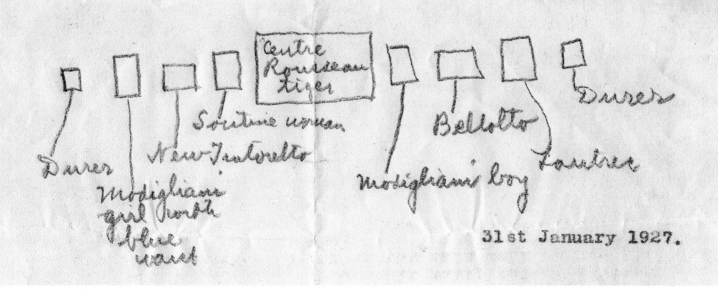

31st January 1927.

saw on one wall Matisse's monumental mural *The Dance* and, below it, works by Picasso and Matisse flanking the windows. Turning in place, we saw each wall had its own share of masterpieces, all mounted on amber-colored burlap. We slowly became aware of the bilateral symmetry and the implied relationships from painting to painting. The hardware interspersed among the paintings seemed like the floaters that drift in and out of one's field of vision when staring at an object. Their small metallic glints added to the sense of a pulsing visual syncopation that was at first very disturbing. Straining to focus on the paintings, we found we were simultaneously trying to parse the visual logic of the Barnesian symmetry. Adding to the distracting experience of the flicker of hardware was the presence of varied pieces of furniture, ceramics, textiles, and assorted artifacts on the floor. Black electrical tape lined the edges of the floor in each room, put down as a visual barrier to keep visitors from getting too close to the paintings. Unknowingly, Billie stepped over the line to avoid a visitor in a wheelchair coming from one of the side galleries and was immediately and loudly chastised by a watchful officer.

By the time we climbed the stairs to the second floor, we were chastened and exhausted. Our heads felt as if they were about to explode. So used to controlled and edited presentations of work in neutral white box galleries, we found the visual multi-tasking required by the ensembles overwhelming. The lighting was dim and, with shades down and the curtains drawn against the natural light, there was the constant temptation to cross the black tape lines in order to get close enough to see. The upstairs rooms felt like an afterthought to the more graciously proportioned rooms on the ground floor. The ceiling heights on the ground floor were fifteen feet or more. On the upper floor, with the exception of the two

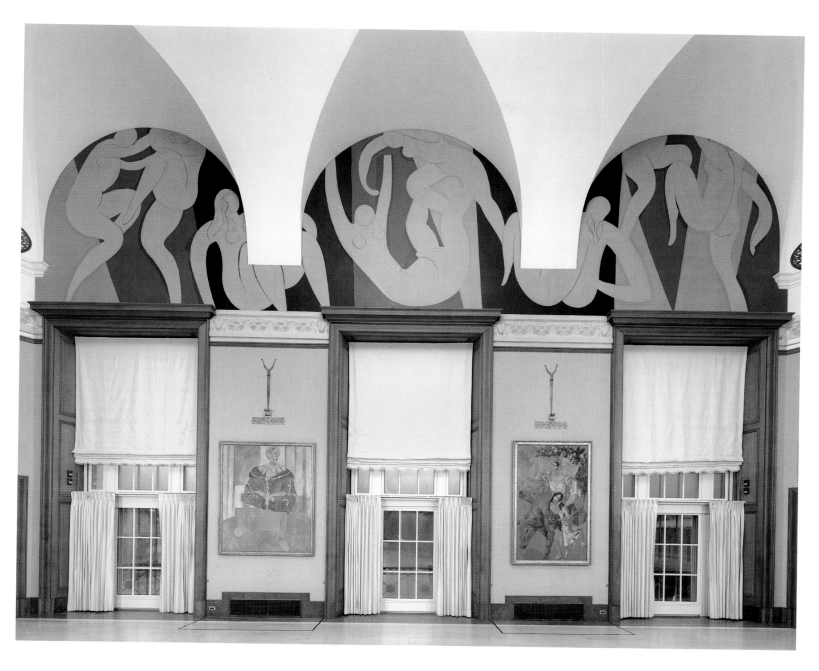
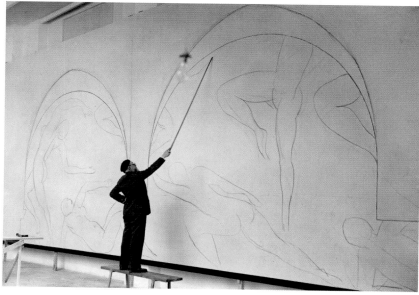

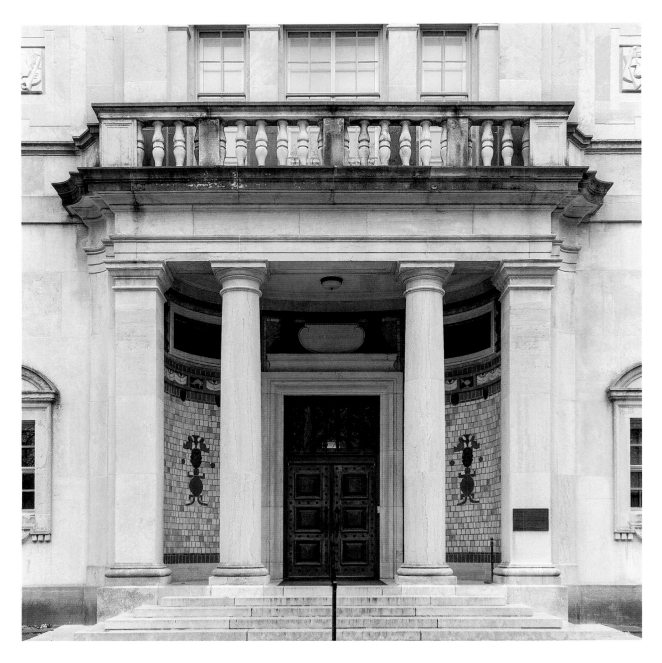

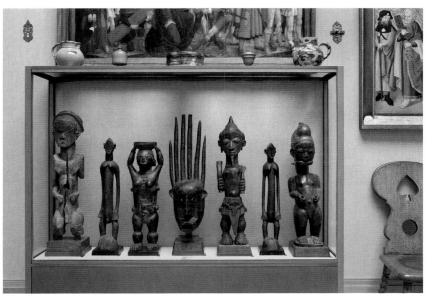

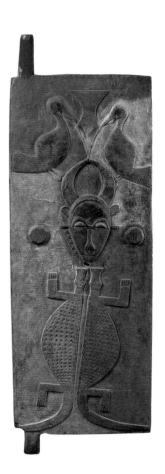

skylit rooms, the ceiling height was closer to ten feet. The spaces felt dark and claustrophobic. It was easy to overlook some of the most beautiful paintings installed on this level.

Moving through the rooms on the second level, we saw the collection of African sculpture and objects. It was clear that Barnes was deeply committed to the consideration of this work as art and not as anthropology. Cret used a crocodile design taken from a Baule door in the collection as the basis for the entry tile work. African motifs also appeared in the building's decorative iron- and plasterwork. The balcony railings bore African masks, which were also worked into the frieze in the double-height Main Gallery. More than decorative, these motifs were woven into the fabric of the viewing experience and emphasized a different, non-Western, way of seeing.

We sat down on a bench in one of the upstairs rooms and tried to gather our thoughts—in an attempt at clarifying our reactions to this experience. Glancing around, we recognized two architects who were also being considered for the project on an adjacent bench and who were clearly as astonished as we. It wasn't until we were leaving that we realized we had missed one of the most important paintings in the collection, *Le Bonheur de vivre* by Matisse. It was hung high in the stairwell, and as we walked upstairs, we had been too tired to look up.

Over time, after many visits to the galleries, this sense of being inundated subsided. We came to appreciate the way the hanging made our eyes jitter across each ensemble, picking up the synchronicities between the paintings and objects. With each visit, we seemed to find more paintings that we had somehow overlooked. The Barnes ensembles prompt you to *see* all the paintings rather than just to look for the "important" ones. We realize that for many people who find the museum experience

to be intimidating, the ensembles provide an entry into simply enjoying what you see.

In the beginning, we were deeply uneasy with the injunction to replicate. Indeed, during his lifetime, Barnes was continually changing and refining the installation of the ensembles, so this directive felt strangely cryogenic—a freezing of time. We have visited the studio/home of Donald Judd in Marfa, Texas, where everything remains as it was when he died. There is an airless feeling that comes when things that were touched and used stand untouched and unused. This highlights the problem of how to respect the past without embalming it. We didn't want to end up with a period room that felt airlifted from another time and place. This desire informs all the architecture of the Collection Gallery on the Parkway. We have come to appreciate the power of the ensembles. Although the new, larger, and far more diverse audience of the Barnes most likely will come intending to *look* for the masterpieces, they will *see* much more. This experience, the education of the eye and the mind, has been the ongoing mission of the Barnes Foundation.

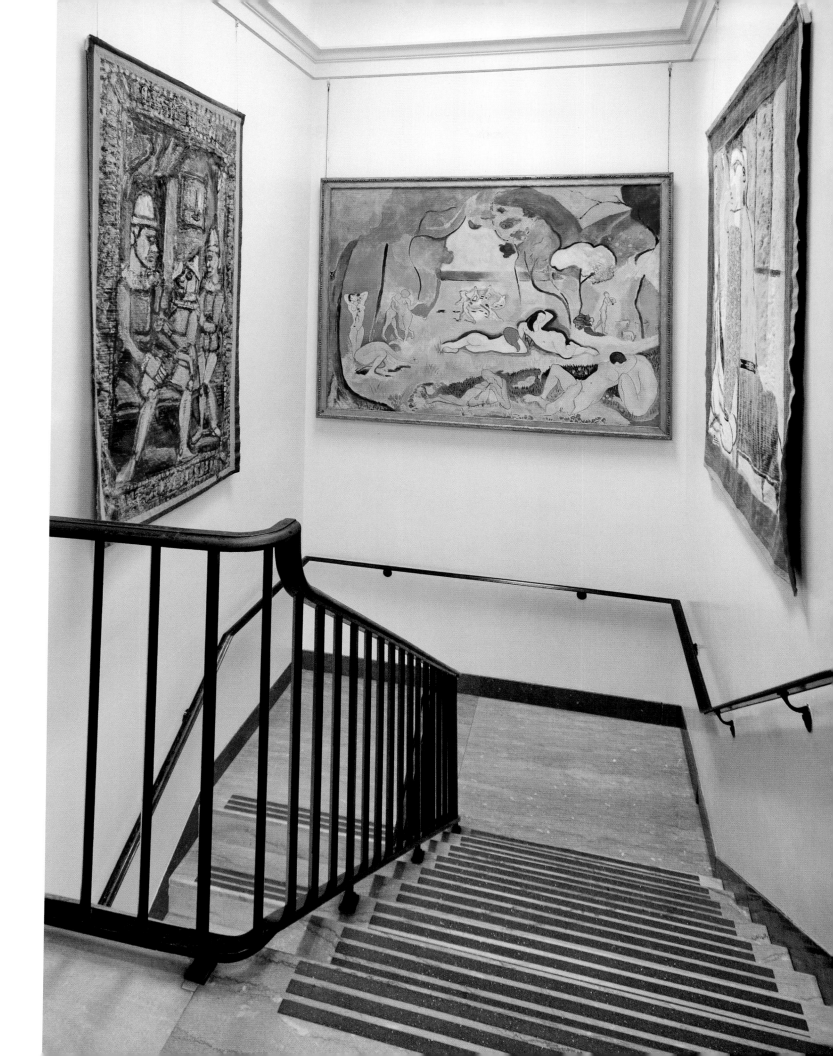

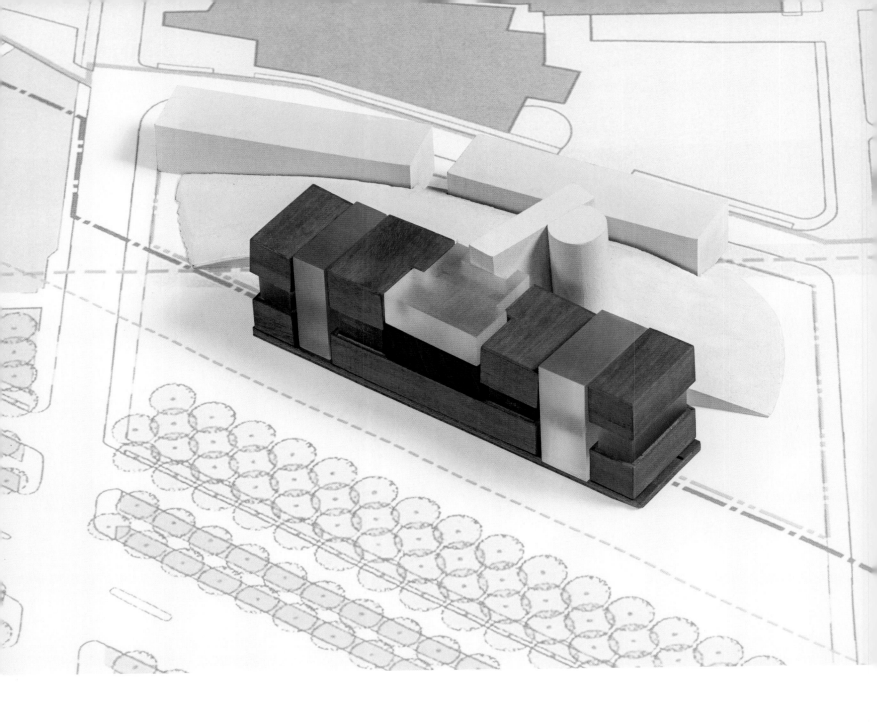

gallery in a
garden

garden in a
gallery

Gallery in a Garden, Garden in a Gallery

As we learned more about the Barnes Foundation collection and began to understand the requirement that the ensembles and the sequence of the rooms remain intact, two points became clear to us. First, the building that contained the art would be essentially predetermined in its size, shape, and placement of windows. Second, the Collection Gallery would require its own identity and needed to "stand alone" rather than be incorporated into a larger whole. Barnes's deployment of his collection was so pure and intense that we felt any new program must not be confused with that "intact" experience.

The new building on the Parkway would more than double the square footage of the buildings in Merion. Much of this additional space was the result of enlarging areas that were already part of the existing complex: the shop, the library, public facilities, conservation, offices, storage, and mechanical space. At Merion, these spaces and systems were outmoded and undersized. And there were new programmatic elements—a lecture hall, seminar rooms, a special exhibition gallery, and restaurant—that were crucial not only to carrying out the Barnes Foundation's original mission but also to supporting and expanding that mission. Yet, even as the new program was in support of the art, we realized it must not interfere with the experience of the art.

A critical relationship existed between Barnes's interest in post-impressionism and its most frequent subjects—landscape, nature, and light. A great many works were directly related to the natural world, so it is not surprising that Barnes settled his home and collection in a garden and arboretum. Both he and Laura were passionate about landscape. Barnes expressed his interest through his painting collection, and Laura expressed hers through the cultivation of the arboretum and the establishment of

Opposite, top A small model from July 2007 shows the Gallery block wrapped by a white support block. Inserts of green Plexiglas suggest gardens while clear Plexiglas represents an additional level of educational spaces, an idea that was later abandoned.

Opposite, bottom Tsien's conceptual diagram contrasts a "gallery in a garden," as in Merion, with a "garden in a gallery," which the architects proposed for the Philadelphia site.

Below A preliminary sketch from April 2007 illustrates the distinctive bar-shaped Collection Gallery wrapped by a support structure.

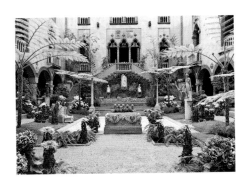

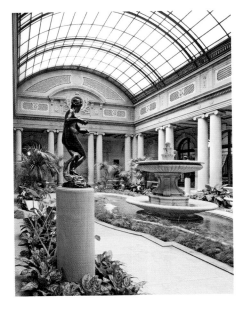

the horticultural program. Cret's design set the Gallery in a garden, with its French windows looking south into the greenery and trees. For years, increased conservation requirements resulted in every window being completely covered by heavy blackout shades. Much of the art had been painted, and was meant to be seen, in natural light. Not only was there little or no natural light, but most of the paintings were also poorly illuminated by outdated artificial lighting. By March 2007, when we first viewed the galleries, the overall experience was deadened by dim, uneven illumination and the lack of connection to the gardens and natural light outside. This was vividly demonstrated when Derek Gillman, the executive director and president of the Foundation, took a few of us on a walk through the Cret Gallery. In Gallery 8, he suddenly pulled up the shades. All of us let out a gasp. There was a complete transformation. Muddied colors became brilliant. Cézanne's landscapes came to exquisite glowing life.

We realized that to visit the Barnes Foundation in Merion was to visit a gallery in a garden, but that the visit was exhausting and almost claustrophobic. We wished to be in a garden—sitting quietly, reflecting on this great collection rather than feeling entombed. A sense of respite or escape seemed crucial. Windows that admitted natural light partly addressed this problem. We also wondered whether a garden could be literally inside, like at the Frick Collection in New York or at the Isabella Stewart Gardner Museum in Boston. Could there be a place within the sequence of galleries to simply rest or dream with the change of a day's passing light?

Another thought was that educational programs, so central to Barnes's vision, might be expanded beyond private classes in the galleries. For

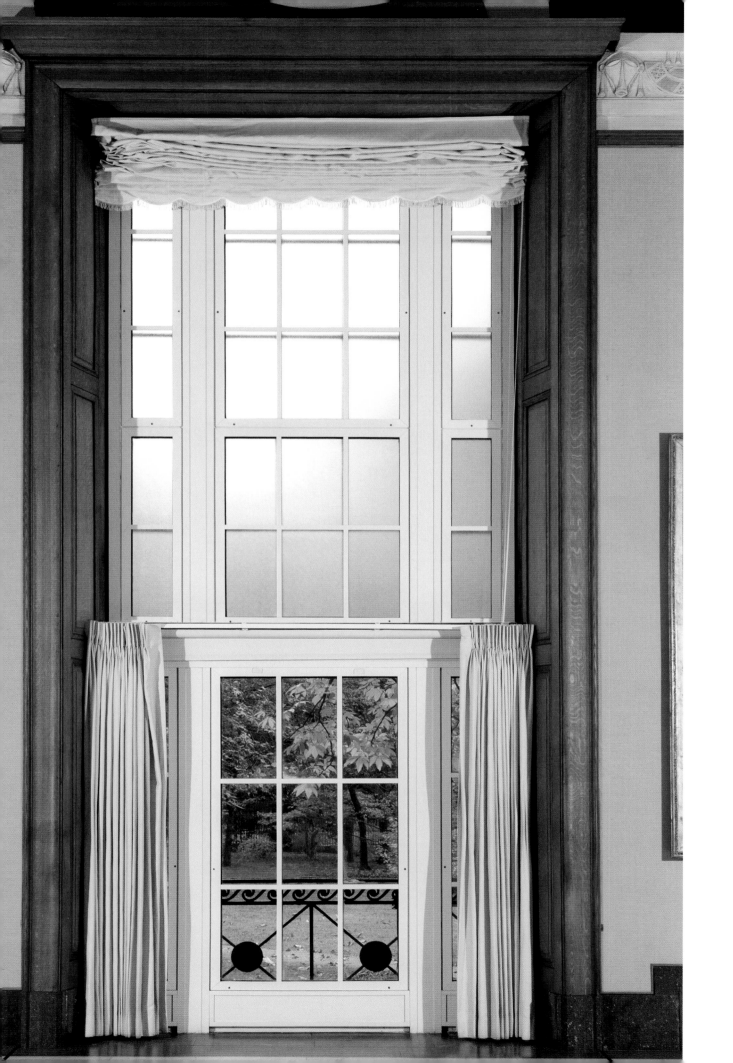

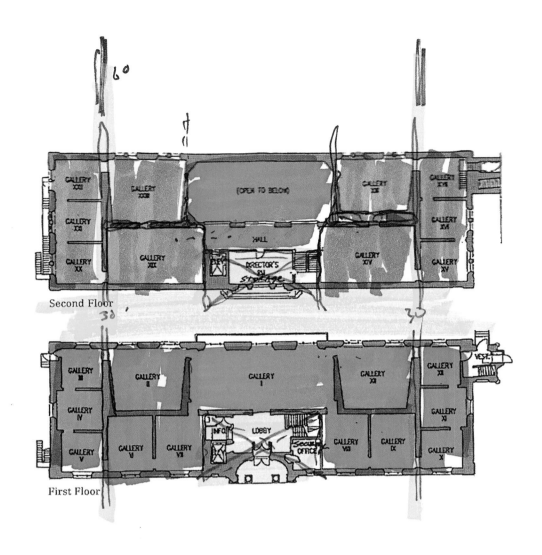

Second Floor

First Floor

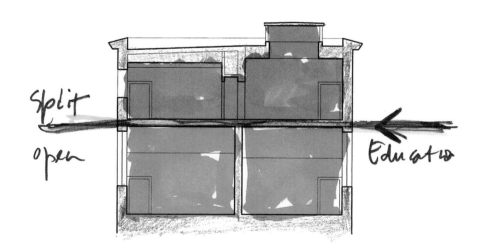

Split
Split

open

Educat...

years the insulated isolation of Merion's setting and lack of parking or public transportation made it difficult for the collection to be shared with the public. Certainly, anyone could sign up, but a brief look at those who took classes showed that they represented but a fraction of the spectrum of people Barnes and Dewey wanted to touch. Could there be places within the sequence of rooms where one might conduct a seminar for students but also where any visitor could sit and read a book about the collection or go online and find additional information about a specific work?

In June 2007, as our interview approached, we didn't know what form our building would take, but we had a sense of the principles our new building should address. One of these was that the new home for the Barnes Foundation on the Benjamin Franklin Parkway should be set within a park. We knew that for the landscape to assert itself as it did in Merion, the overall project would need to be low and visually quiet. We also believed that the Collection Gallery block should be identified as a single architectural statement, a simple rectangular box that faced south toward landscape, also as it did in Merion. We knew that the new building should "fit in," belonging on the Parkway and relating in important ways to the surrounding buildings. In addition, it should honor Barnes's vision, speak in its own way to the present, and ideally be an inspiration and of value to the arts, to education, and to the city of Philadelphia. Prior to the interview, we determined that our concept for the new Gallery was to be both "gallery in a garden" and "garden in a gallery," in order to restore the relationship of interior to exterior.

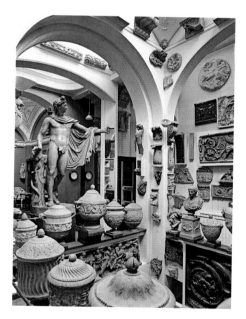

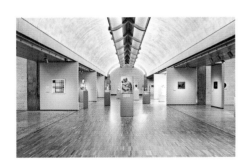

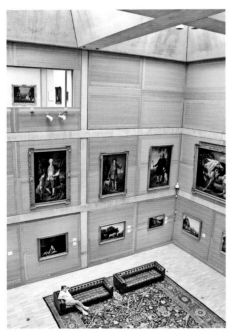

Understanding the Barnes a little better each day, we felt we might open and free up the Gallery experience. A careful examination of Cret's plans revealed that when the ground- and second-floor plans were placed on top of one another, certain walls sat on top of each other. These vertically aligned walls provided a clue, enabling us to open the Gallery experience even as we adhered to the legal ruling. The north-south walls (we described them as "fault lines") separated the three small galleries at each end of the building from the central block. By conceptually slicing the walls open and spreading them apart, we realized we could insert a section of new space without disrupting the twenty-three-room sequence. Our first thought was that a garden could be inserted into each of these new "found" spaces to provide a pause and sense of serenity, and to relieve the Gallery fatigue experienced as one proceeded from room to room. And, for the interview, we also speculated (though later we realized this would not be feasible) that we could also make this cut horizontally between the first and second floors of the Gallery and insert a new floor of classroom space. These two insertions represented the dual mission of the Barnes Foundation—art and horticultural education. The principles of refreshing the Gallery experience with light, calm, and reflective discourse, we felt, were sound.

For the July 2007 interview, we prepared a series of diagrams and two very simple models to illustrate our concept and stimulate discussion. A small site model conveyed the locations of the building units and their relationships to each other and the Parkway. We had determined early on that the Collection Gallery should have its own identity, so we represented it as a solid wooden box upon a transparent Plexiglas base. While

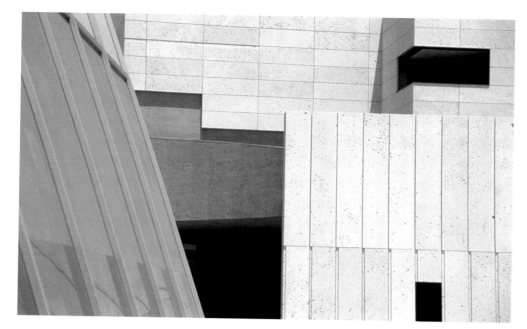

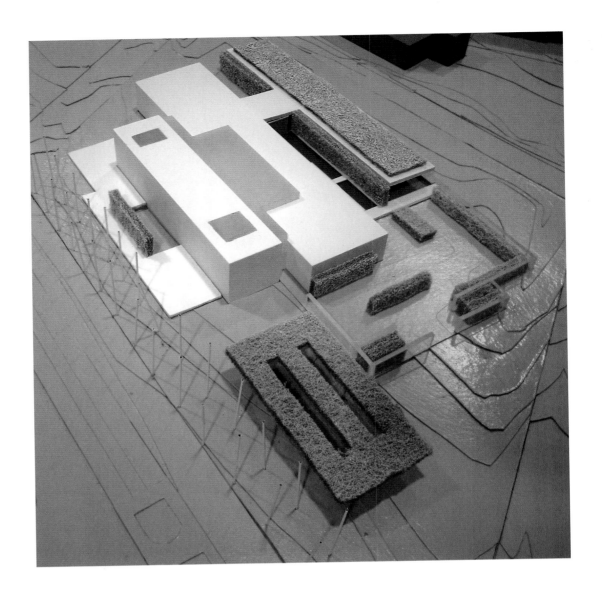

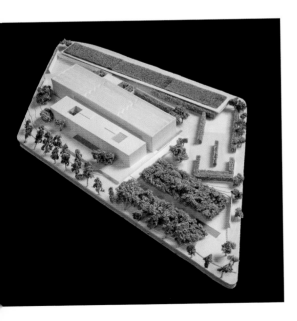

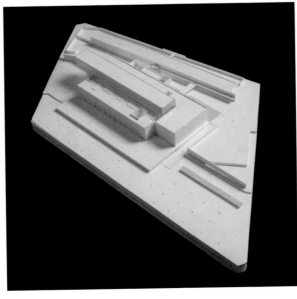

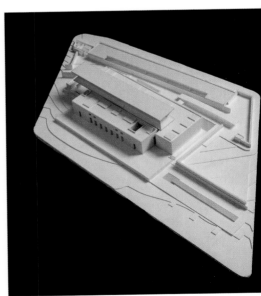

not yet totally clear about how to handle the support space, we were certain that it should not be confused with the Gallery block. We proposed that the Collection Gallery be located along the Parkway; that the building be solid and sober in appearance; and that it be in contrast to the remaining elements. The support space was identified as two above-ground elements set to the north along Pennsylvania Avenue. These two buildings appeared to be separate from the Collection Gallery but were connected to it via an underground passageway. This allowed the landscape to surround the Collection Gallery block. In the model, we painted these support spaces white to match the ground because we wanted to show that these spaces were secondary to the Collection Gallery. This would be the "gallery in a garden." The second model was small enough to fit in one hand and represented the Gallery building as it was in Merion. It was constructed so that blocks of wood slid apart so that we could insert green Plexiglas representing gardens and white Plexiglas representing classrooms. In our presentation, we started with the solid block and then slid pieces aside and dropped in little slabs of green and white to show the insertion of new spaces. The insertion of green would be the "garden in a gallery." Although both models were tiny and simple, they were able to clearly express our ideas to people who were not architects.

We discussed our belief that the new Barnes should relate to its original home in Merion by being dignified and solid, warm and textural, perhaps even incorporating African or metal ornamental motifs in some form. We shared precedents: Sir John Soane's Museum in London, for the singularity and intensity of the visionary architect and

05/16/2008

05/30/2008

08/04/2008

12/09/2008

collector; the Isabella Stewart Gardner Museum and the Frick Collection, as previously noted, for both the interior-exterior relationship and their domestic (though of a grand scale) sensibility; and the Mercer Museum in Doylestown, Pennsylvania, for its originality of structure and for Henry Mercer's idiosyncratic collection and installation. We also cited the work of Kahn not just because he was Cret's student, a Philadelphian, and one of the twentieth century's seminal architects, but because of his great museums. Kahn's Kimbell Art Museum in Fort Worth was a particular focus, because it has a strength and quiet that we admire. He placed this building in a landscape that is part of the experience of visiting the museum. Indeed, we later visited Kahn's Yale Center for British Art and the Kimbell with members of the Building Committee and our studio.

Finally, it was clear that we would bring our own experience to bear. The committee visited several of our projects: the Neurosciences Institute in La Jolla, the American Folk Art Museum in New York, and Skirkanich Hall at the University of Pennsylvania in Philadelphia. The Neurosciences Institute gave us the opportunity to design a complex where the building and the landscape were equally important. We learned that the same stone in different finishes can take on very different appearances. We balanced the inherent coolness of concrete with the inherent warmth of stone. At the American Folk Art Museum we addressed the premise of a museum with a domestic scale. And, at Skirkanich Hall, we designed a building that created a powerful new entry to the Penn Engineering campus, unifying the complex quadrangle and in the process creating two small urban parks. For this project we worked to develop new

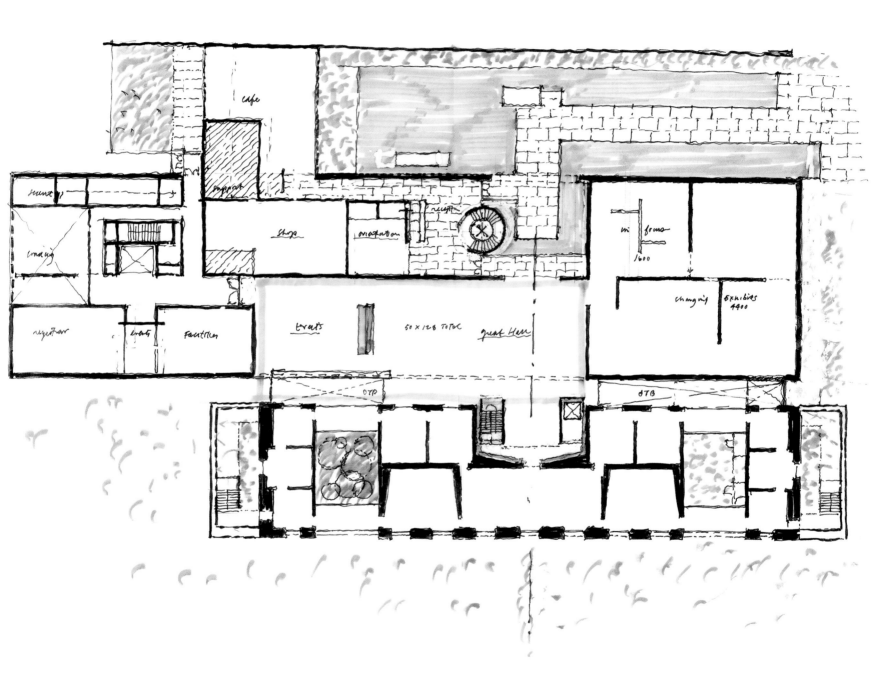

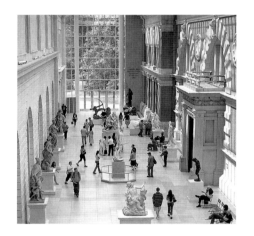

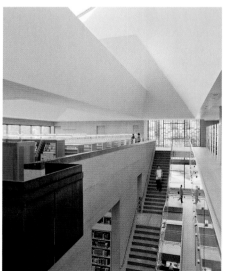

finishes for tile and glazed brick, relying on the skills and accumulated knowledge of the fabricators.

We recognized that the design approach we were suggesting still needed to find its form. At the interview, we indicated that our palette would be of concrete and stone with important elements of glass. The use and expression of concrete as the building's foundation would honor its anchorage to the land. And we felt a warm, dense, and refined stone would not only balance the cooler concrete but also become the building's primary expression. We believe that each building must find its own material, and we therefore resist determining what that is for as long as possible.

When we found that we were selected as the architects, we were overjoyed but anxious because of the enormity of the challenge. Still, we began to design as we always do—from the inside. The life of any building, as indeed the life of each person, exists primarily on the interior. This is where we, as architects, begin—a natural course for all of us who are asked to organize and design spaces for work and life. The list of requirements and desires is called the program. The simple definition of a program is the allocation of uses and square footage, but we believe a program must also be a statement of intention for the building. Even before our interview, the Barnes gave us a brief program that was developed by the studio of the distinguished architect James Polshek. One concern we expressed was that the square footage seemed larger perhaps than the Barnes's budget would permit. This was particularly true relative to the Foundation's desire for the highest quality. We worked with the Barnes and, through discussions, the

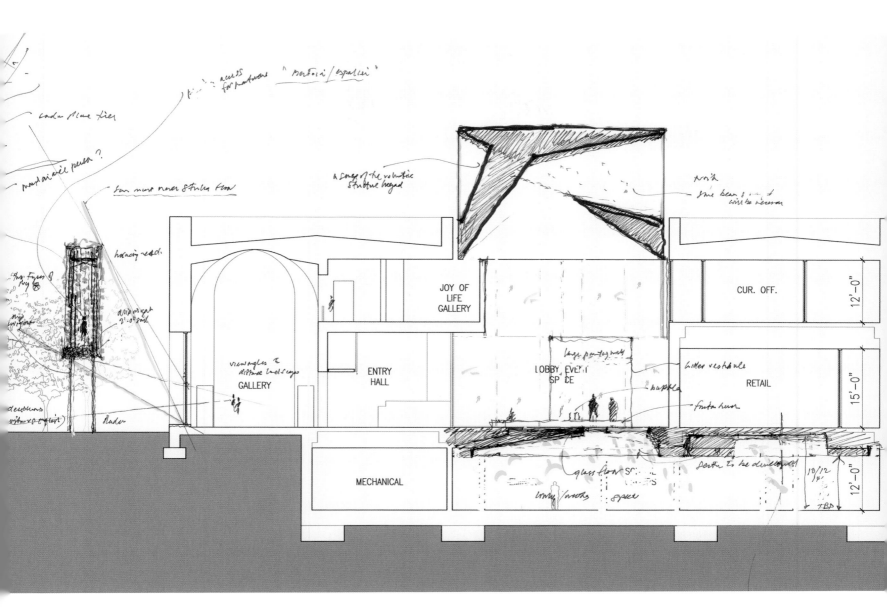

GALLERY — ENTRY HALL — JOY OF LIFE GALLERY — LOBBY EVENT SPACE — CUR. OFF. — RETAIL

MECHANICAL

12'-0" — 15'-0" — 12'-0"

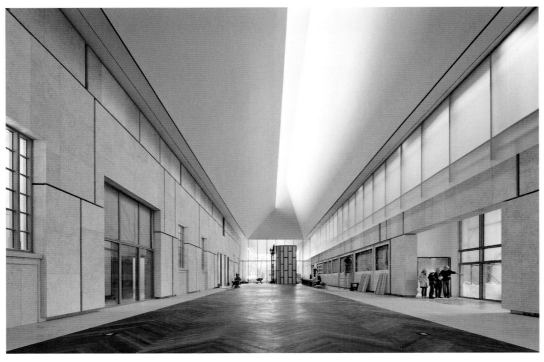

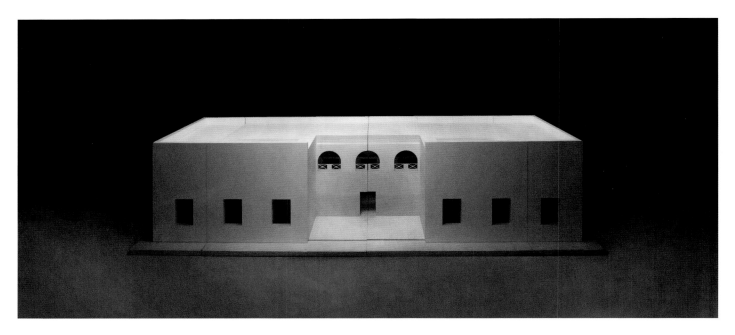

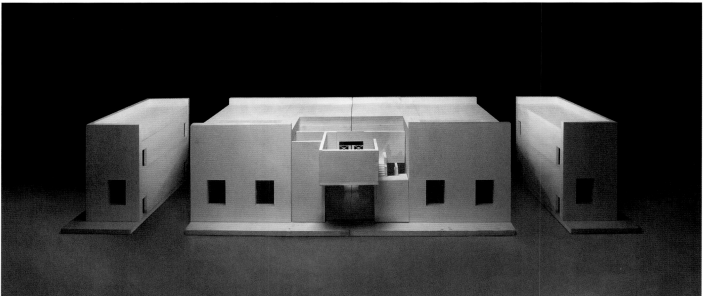

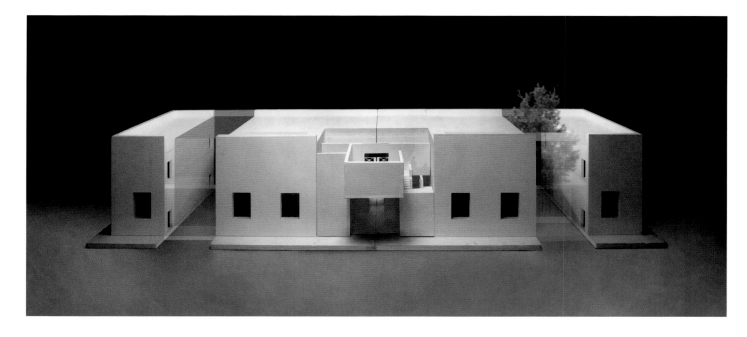

square footage was reduced and reallocated. With this work came a
description of revised intent.

As we began the design, we knew that the massing and proportions
of the gallery block were fixed. This was a direct result of maintaining
the sequence and size of the galleries and the ensembles. We also knew
that we did not want to embed the Collection Gallery inside another build-
ing. We believed that it should be essentially freestanding so that its
relationship to the landscape would stay intact. The Collection Gallery is
sited to face south to keep the same orientation and light conditions as at
Merion. It was important that the light enter the Collection Gallery rooms
from the same direction.

As the design phase progressed, we recognized that the realization
of our concept—to make a gallery in a garden and a garden in a
gallery—would pose a bigger challenge than we first thought. The pro-
posed square footage of the new program was considerably larger
than at Merion, but the site was no more than half the size of the Merion
campus. In addition, at the new location we had zoning setbacks,
existing trees, and a large sewer line that ran under the northwest corner
of the site. As we worked, the form and placement of the additional
program changed but the common denominator was that it always
remained separate from the Collection Gallery. During the interview, we
had proposed two distinct volumes, the Collection Gallery and the
support spaces that were separated by a garden. Once we received the
commission, our desire was to create what felt like a single building,
while continuing to keep the Collection Gallery block separate from the
support spaces in order to preserve clarity of the art experience. In time,

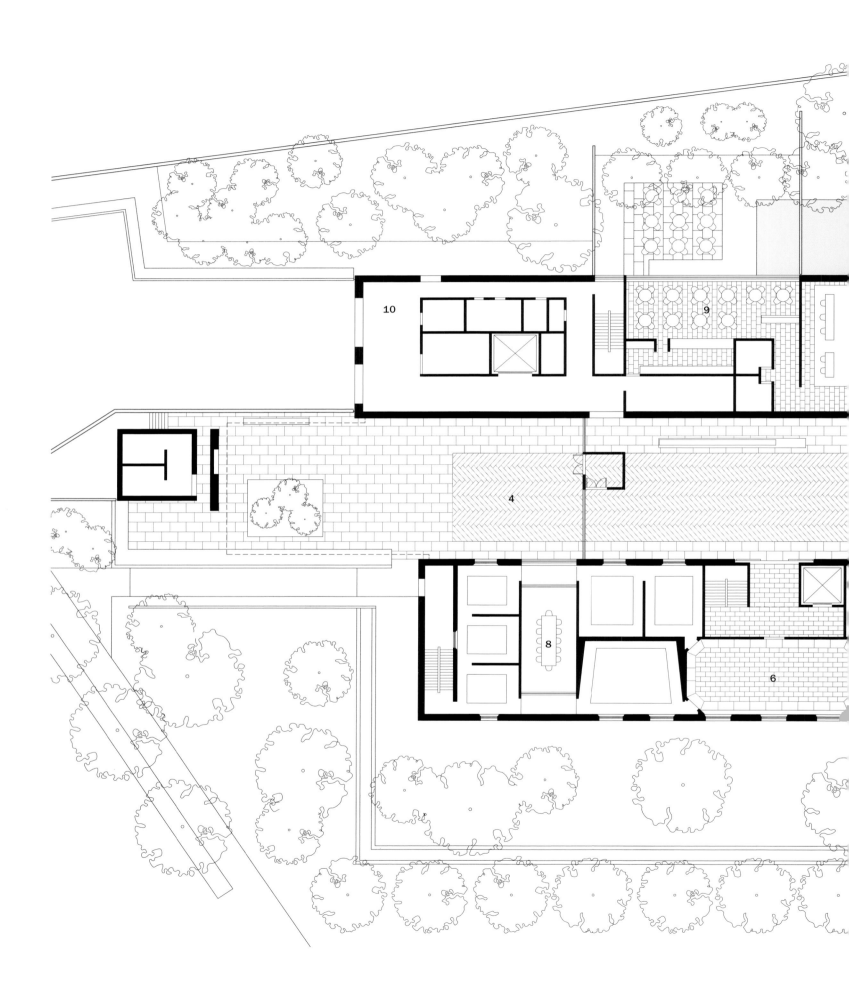

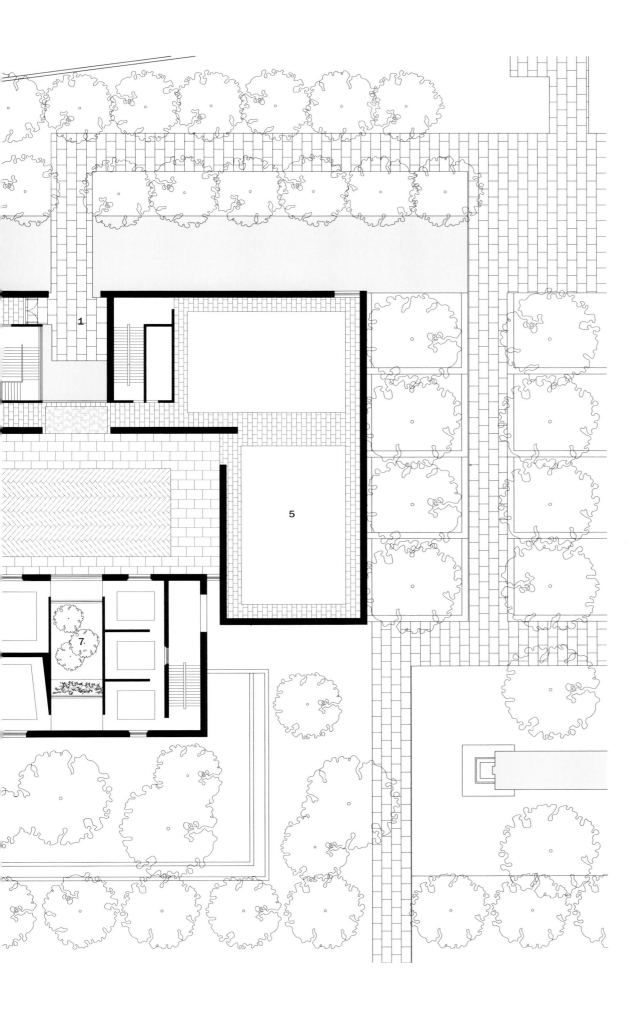

First Level Plan

1 ENTRY

2 LOBBY

3 LIGHT COURT

4 WEST TERRACE

5 SPECIAL EXHIBITION GALLERY

6 COLLECTION GALLERY
 MAIN ROOM

7 GALLERY GARDEN

8 GALLERY CLASSROOM

9 RESTAURANT

10 SUPPORT

0 10 35

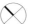

Second Level Plan (Top)

1 CONSERVATION

2 ADMINISTRATION

3 LIGHT COURT (BELOW)

4 BALCONY

5 *LE BONHEUR DE VIVRE* ROOM

6 GALLERY CLASSROOM

Lower Level Plan (Above)

1 COATROOM

2 SHOP

3 LOWER LOBBY

4 SEMINAR ROOMS

5 AUDITORIUM

6 GALLERY GARDEN

7 COFFEE BAR

8 LIBRARY

9 SUPPORT

0 10 35

Below The construction of the
Gallery Garden, August 2010
(top) and October 2010 (bottom)

we framed the Collection Gallery block with a protective L-shaped building that we call the Pavilion. The Pavilion is both an entry and a service element. It contains the public entrance and lobby on the first level, with a special exhibition gallery to the east and the restaurant and its kitchen to the west. This block's second level contains offices and conservation and their supporting services. We conceptualized the Pavilion as solid and quiet and more modern to distinguish it from the more classically inspired Collection Gallery.

Between the L-shaped building and the Collection Gallery is a void—the Light Court. This third element, conceived as an outdoor room, is set between the Pavilion and the Collection Gallery uniting the composition. In our discussions with the Building Committee we had used the Petrie Court at the Metropolitan Museum of Art in New York as a precedent. In that case, the space between two separate buildings was enclosed with glass to create a light-filled public space that is used for the display of sculpture. At the Barnes, as at the Metropolitan, the space is conceived as a public space. In plan, the scale is similar, but the Barnes ceiling is higher. The Light Court is naturally lit by a monumental light box, a kind of "super monitor" that extends west beyond the building's mass to cover an outdoor terrace. This atmospheric box of light is a development of our previous indirect lighting approach at the C. V. Starr East Asian Library at the University of California at Berkeley. It centers and grounds the innermost architectural experience through the magic of shifting light. Its appearance from the outside is of a dynamic luminous glass box; inside, this is a light-filled volume, establishing at our building's heart a great room for visitors.

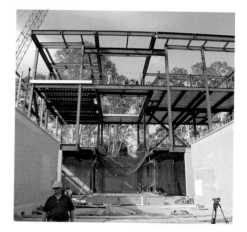

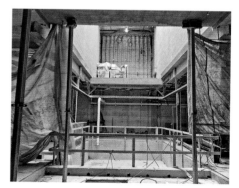

Below A view of the Gallery Garden
from the Light Court

Opposite From the Gallery Garden
on the first level of the Collection
Gallery, visitors see through
to the Light Court and beyond to
the building entry.

The lowest level serves the needs of visitors and students, housing
a hub of educational spaces that complement the classrooms within
the Collection Gallery. There are seminar rooms, an auditorium, a library,
a small coffee bar, a shop, a coatroom, and a comfortable seating area,
which is a more relaxed version of the Light Court one floor above. These
spaces are configured around the outdoor garden that extends down
through the Collection Gallery.

Our design for the 93,000-square-foot Barnes Foundation building
was unveiled on October 7, 2009, two years after we were selected as
the architects. Ultimately, the building plan is a relatively simple tripartite
organization set within a layered landscape. The visitor moves from
a series of public gardens into the Pavilion, and then to the Light Court
and finally the Collection Gallery. On the exterior, the composition
appears as one; on closer inspection it is two blocks that support a glass
light box. Beneath, and uniting all of it, is a single entity: Philadelphia's
Barnes Foundation.

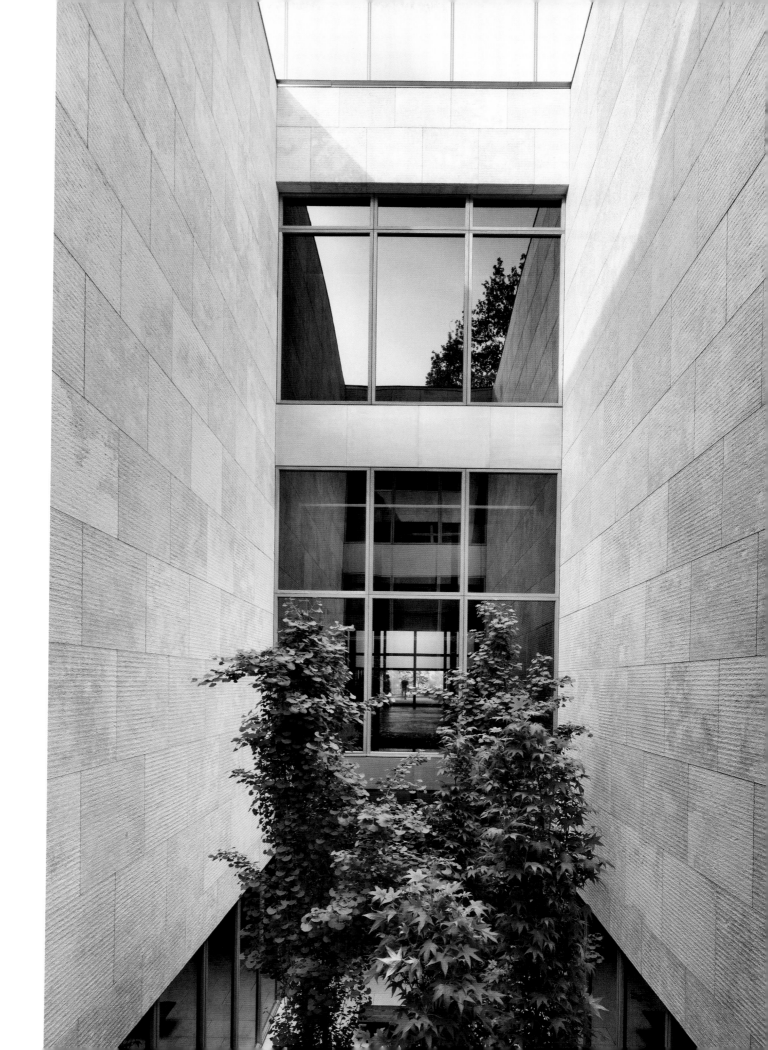

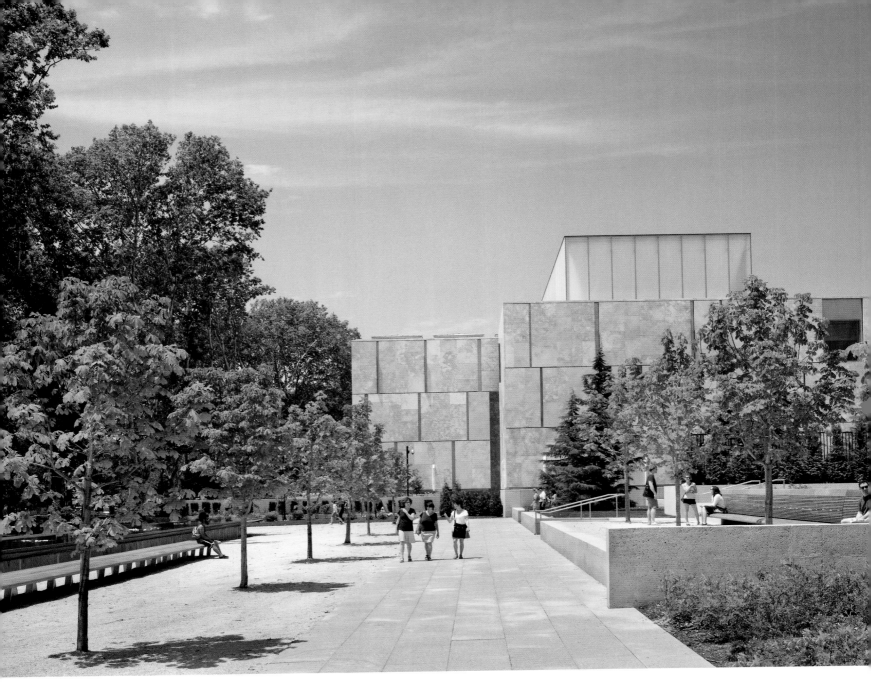
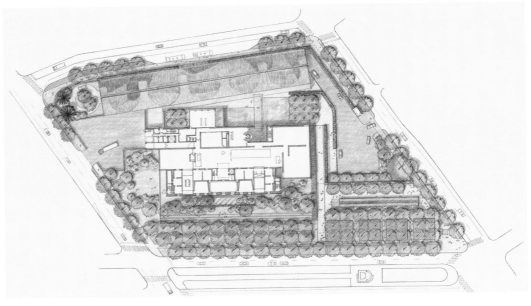

Building on the Parkway

The Benjamin Franklin Parkway is the great avenue of civic buildings planned in 1907 by Jacques Gréber and constructed from 1917 to 1926. Equal parts municipal gesture, park, transportation link, and real estate development project, the creation of the Parkway obliterated the brick factories and neighborhoods in its path, making room for one of the grand boulevards of the City Beautiful movement. Diagonally superimposed onto the grid, the Parkway adds scale and grandeur to Philadelphia and connects City Hall with Fairmount Park and the lush suburbs of the northwest. Here one finds Logan Square with its Swann Fountain, the Free Library of Philadelphia, the Rodin Museum, and, on axis, the great steps of the monumental facade of the Philadelphia Museum of Art. The Barnes Foundation is the first major cultural addition to the Benjamin Franklin Parkway in more than eighty years.

The four-and-a-half-acre site of the Barnes Foundation sits on the Parkway between the Rodin Museum, designed by Paul Cret, and the Free Library of Philadelphia, designed by Horace Trumbauer. A handsome but forbidding building from the early 1950s, the optimistically named Youth Study Center previously occupied the site. Its name belied its actual use as a juvenile detention center. When we first visited the site, homeless people were encamped along the base of the building, and the park was unkempt and unsafe. Once demolition began and the front facade was pulled off, we stared up at the forlorn square rooms painted pink and blue. The site is a complex one, an irregular parallelogram that slopes eleven feet diagonally from its northwest to southeast corners. Three rows of towering London plane trees define the Parkway edge of the site. The three remaining sides are bordered by narrow feeder streets: Pennsylvania Avenue, North Twentieth and North Twenty-first

Opposite, top The public plaza along the Benjamin Franklin Parkway at the Barnes Foundation, Philadelphia

Opposite, bottom An August 2008 landscape plan that sites the building within a series of gardens. To the north is the parking area with a pattern-planted roof inspired by Matisse's painting *The Dance*. The planted roof was not realized in the final design.

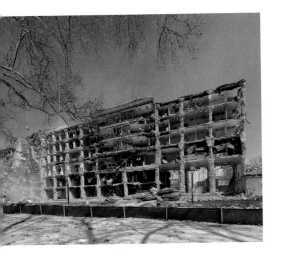

streets. Close by, to the north, is a residential area, while the east, west, and south are civic in scale and nature. The site is an island with people entering from all sides.

We wanted our building to address the civic scale of the Parkway without feeling monumental and detached. Since our concept was rooted in the idea of a "gallery in a garden," designing the site as a series of interconnected gardens and plazas would create this condition and help form a relationship between the new building and the landscape of the Parkway and the city. We studied and thought about places we had visited, where the garden was a part of the experience of visiting a museum. At Soane's Dulwich Picture Gallery outside London, one passes through a much more humble gateway (really just a garden fence) than in Merion and walks down a meandering path to reach the entry to the gallery. Another precedent, and one of our favorite museums, is the Louisiana Museum outside Copenhagen, where one walks into a landscaped park with a view of the North Sea and then finds a museum that seems to be hardly there. But both these places exist outside cities. So the problem for us was to create the sense of a garden on a site in the middle of Philadelphia with many lanes of traffic moving past. We believed a series of larger-scale and more intimate gardens was a gift to the public realm and the lives of people, both residents and visitors.

With this as our vision, we sought out Laurie Olin, the preeminent landscape architect for Fairmount Park and for the Rodin Museum. At the time, he was at the American Academy in Rome for three months of writing and drawing. We decided to go there to talk to him, and we met one evening in a small bar. Trading stories about our pasts, we learned that as a young designer he worked for the landscape architect Rich Haag

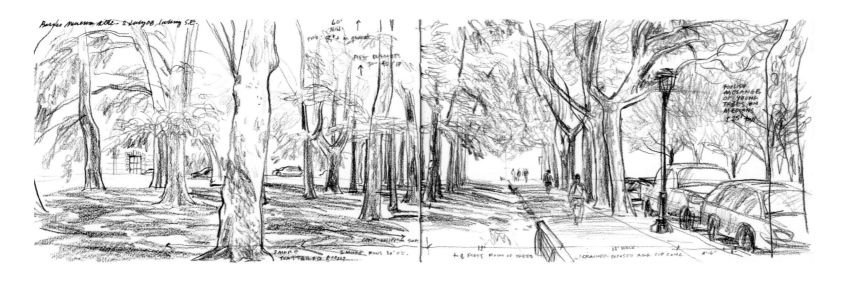

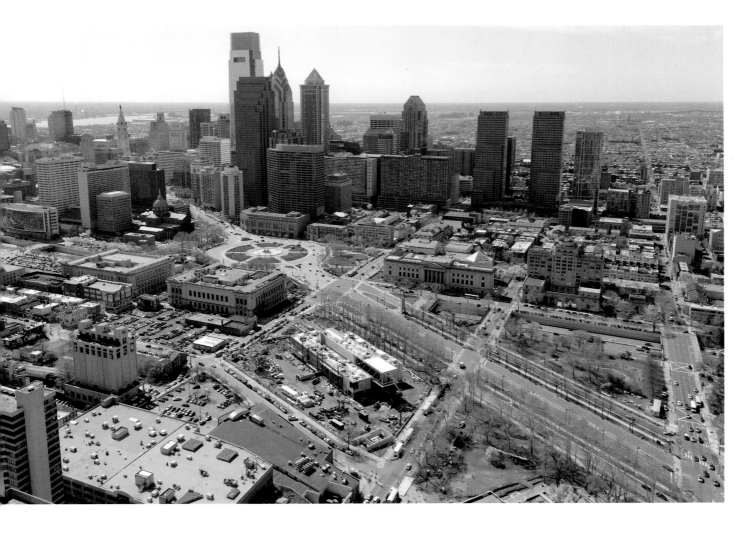

1 PHILADELPHIA MUSEUM OF ART

2 EAKINS OVAL

3 CITY BASEBALL FIELDS

4 RODIN MUSEUM

5 THE BARNES FOUNDATION

6 THE FRANKLIN INSTITUTE

7 FREE LIBRARY OF PHILADELPHIA

8 LOGAN SQUARE

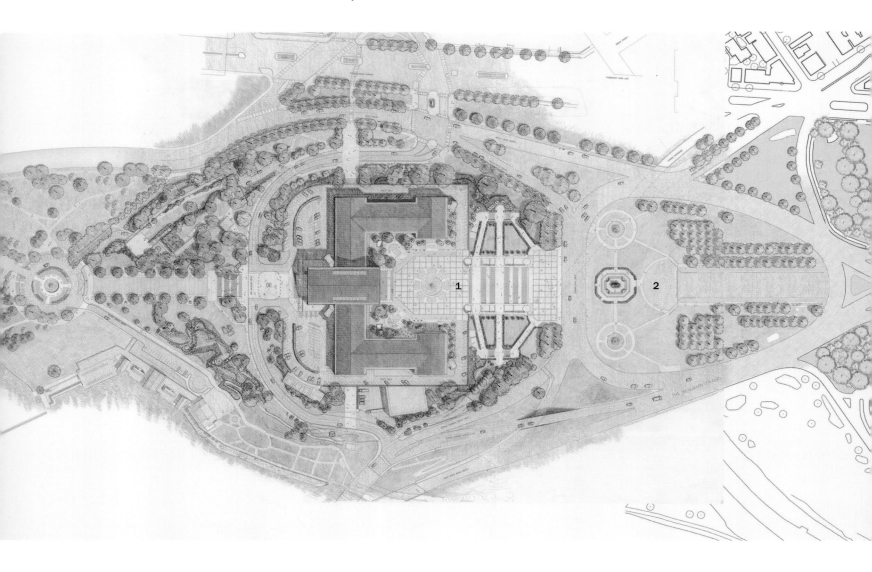

Above The landscape architect's May 2010 plan of the Benjamin Franklin Parkway

Opposite A view from March 2012 of the nearly completed Barnes Foundation

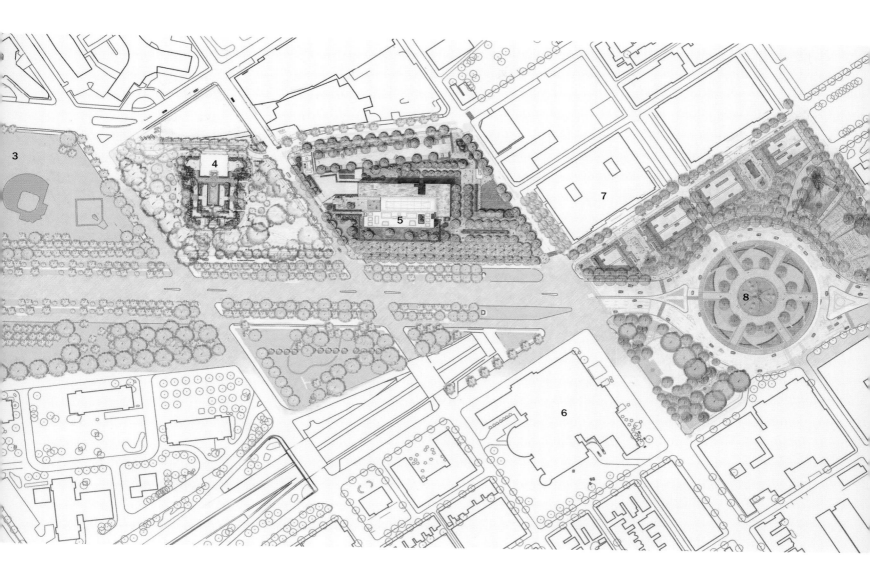

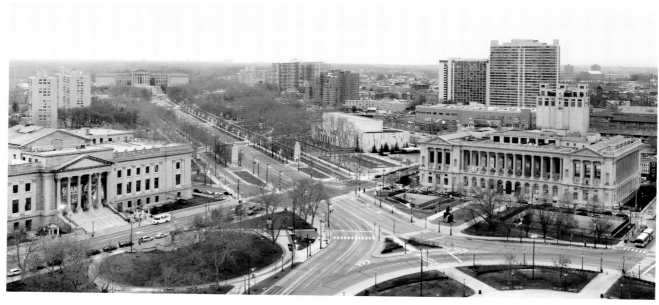

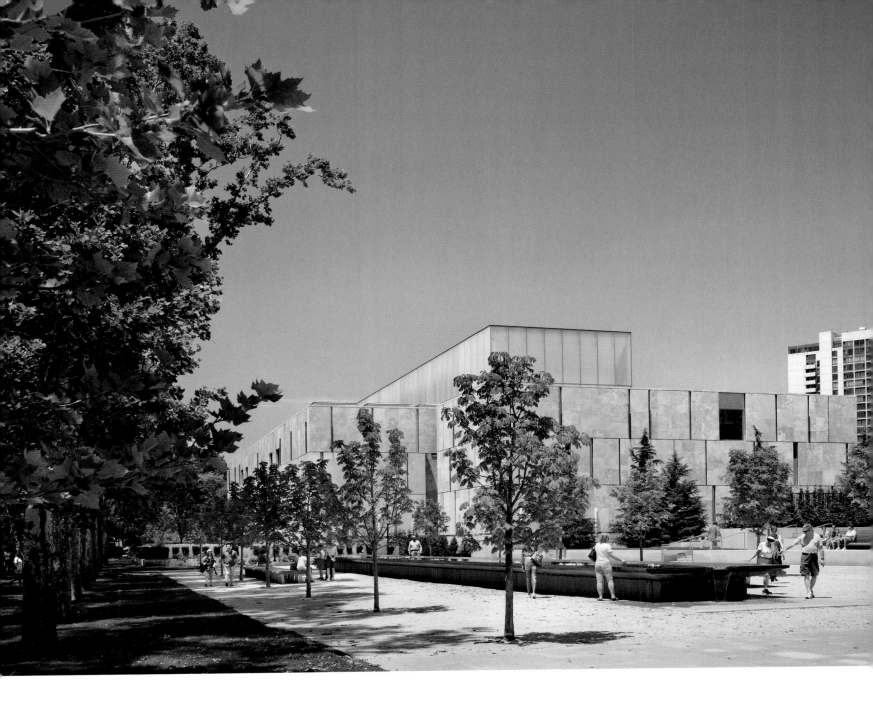

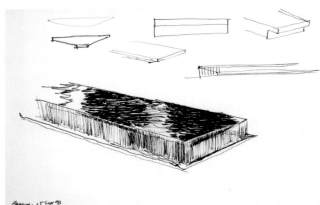

on the Bloedel Reserve on Bainbridge Island, in Washington. We used an image of a pool there, when we talked about the sense of quiet and containment we wanted to emulate in the gardens around the Barnes. After our conversation over wine and a few napkin sketches, we walked out into the night knowing that we could work together.

Later, Olin came to our first meeting on site with his black sketchbook. He showed us the sketches he had done as he walked around all four edges of the site. He drew all the problems—too many layers of cars, telephone and cable wires, odd poles, parking lots to the north, and gaps in the rows of London plane trees. It was clear that the building siting and the landscape needed to address not only the Parkway to the south, but also North Twentieth and North Twenty-first streets and Pennsylvania Avenue to the east, west, and north, respectively. With Olin, we developed a layered landscape that welcomes people into the gardens from all directions. No matter which direction you enter from, you see the building through landscape. This series of gardens, walls, and plazas settles the building forms into the site, reduces the scale, and establishes places for contemplation and gathering. Beginning with the civic scale that addresses the Parkway, the landscape becomes progressively more intimate and quiet, as one walks closer to the building's entrance. The most public garden lies directly on the Parkway. Olin has added a dramatic plaza that has at its center a magnificent stone fountain. It is a 140-foot-long by 12-foot-wide granite table of water, with water lilies planted in its center. At each end, water pours down onto a bed of stone. Two rows of American horse chestnuts are planted parallel to the fountain. Beneath these trees, crushed gravel defines the ground plane and a civic space, not unlike the Tuileries and recalling the monumental garden planning of Paris that so influenced

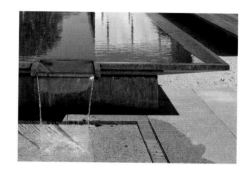

Opposite, top The water table at the center of the public plaza along the Parkway

Opposite, bottom Olin's sketches from November 2008 illustrate the design of the proposed water table.

Top Williams's sketch from June 2009 suggests the shape of the water table.

Above Detail of the sculptural water table's stone spillway

Following spread Olin's sketch of the ramped terrace in winter leading from the public plaza toward the building's entry, November 2009

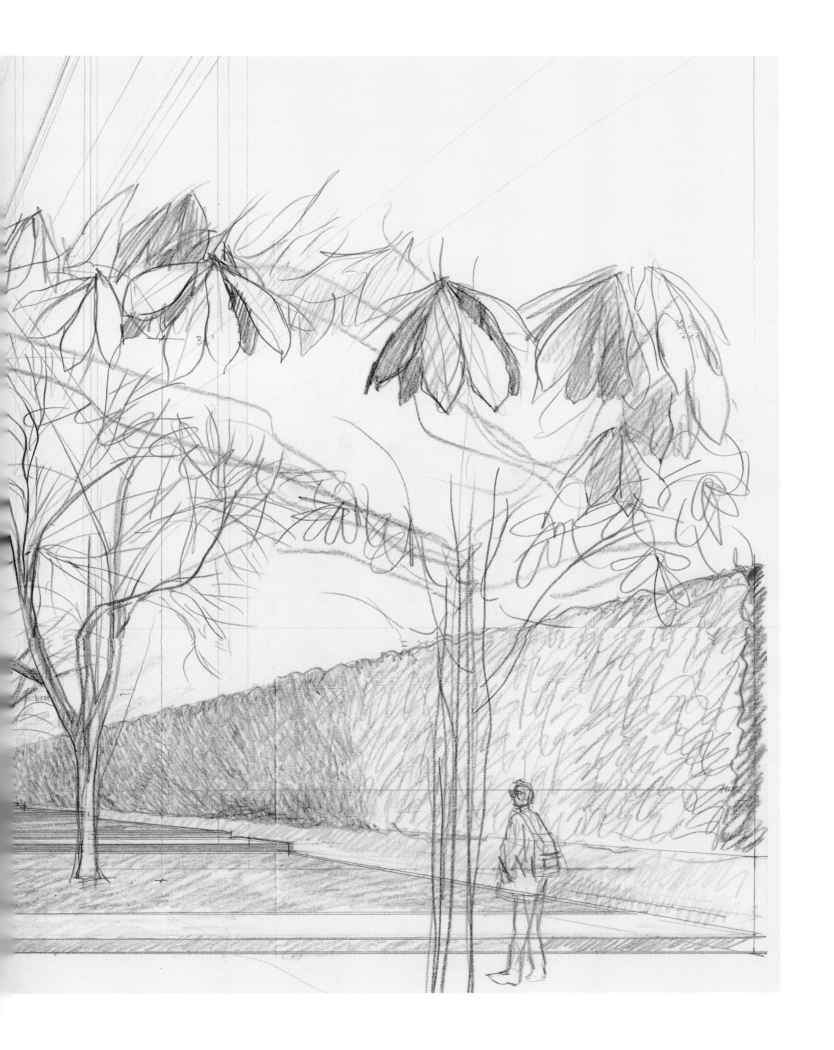

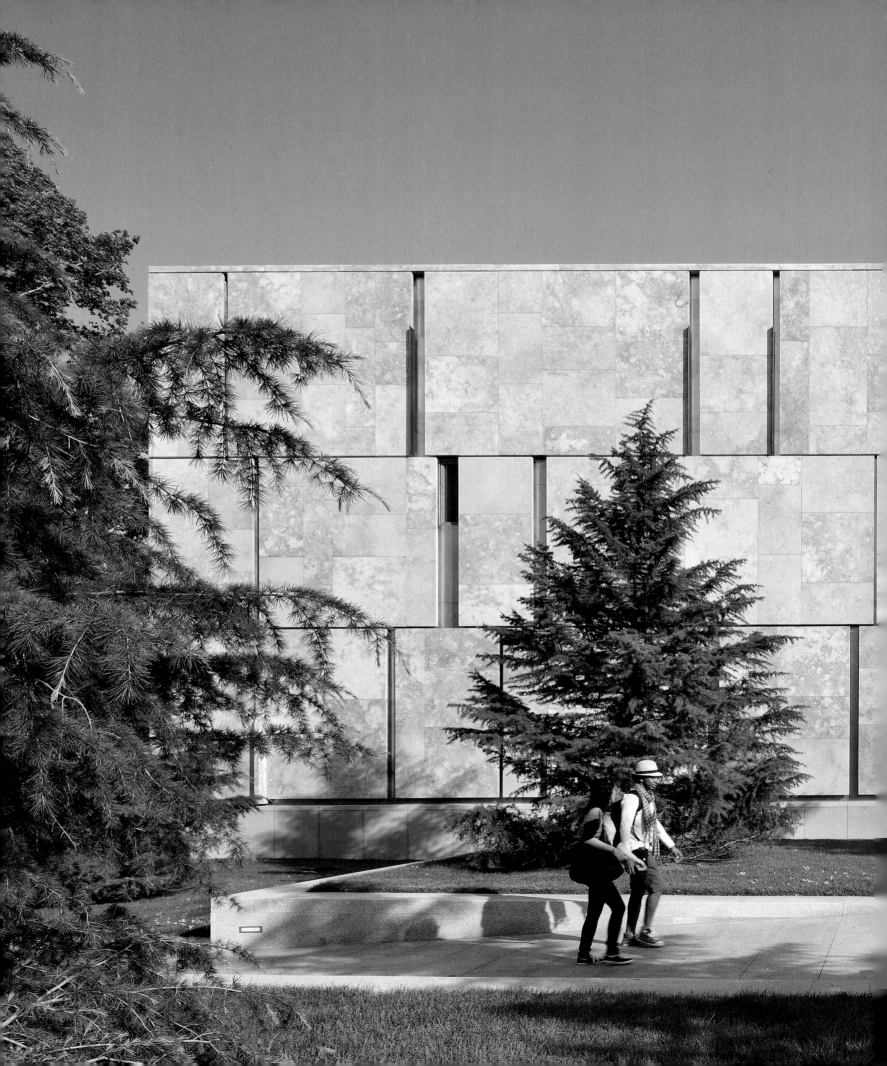

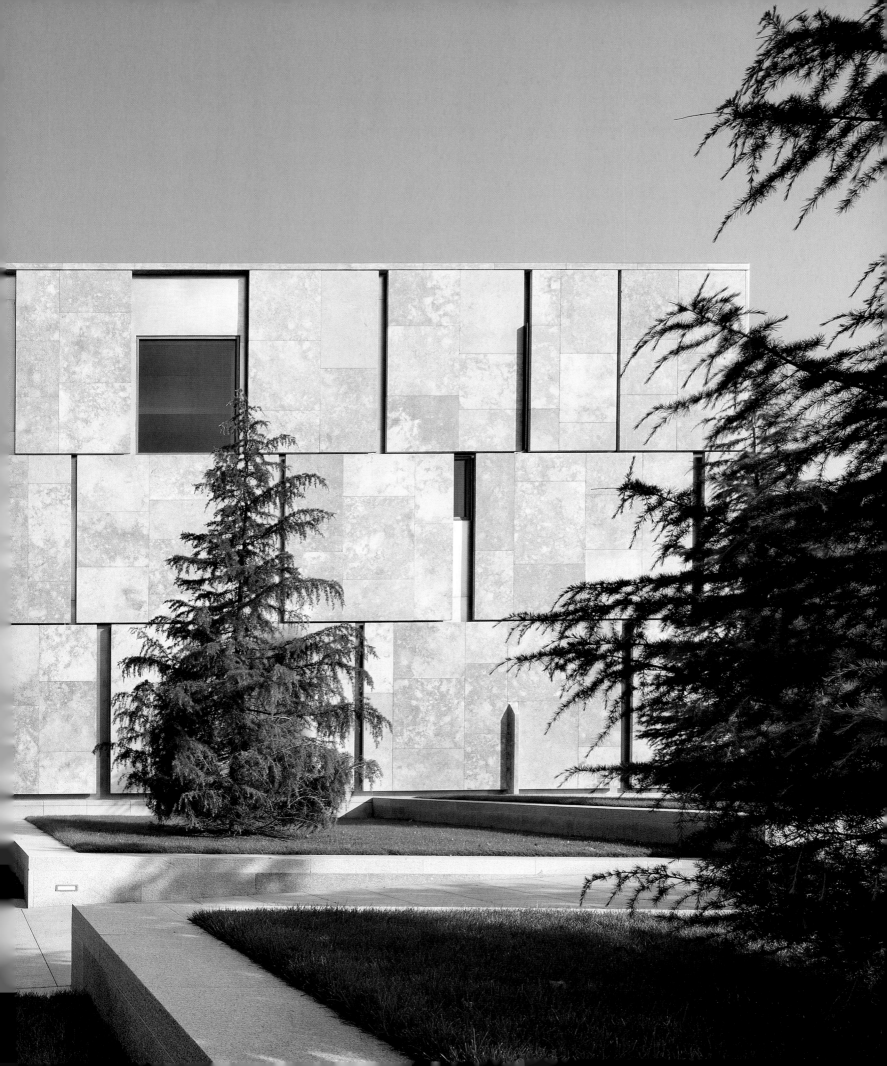

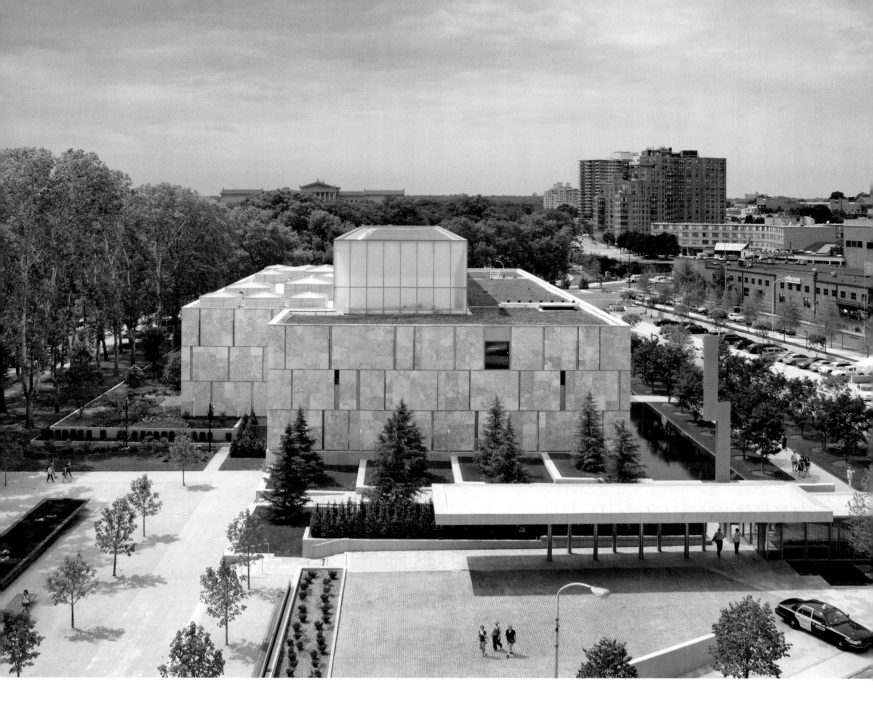

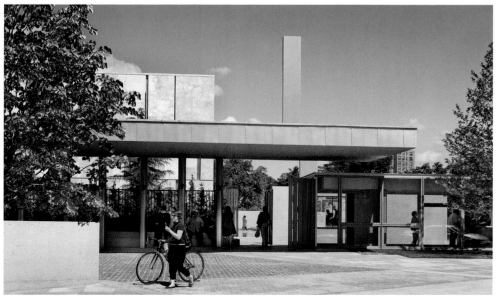

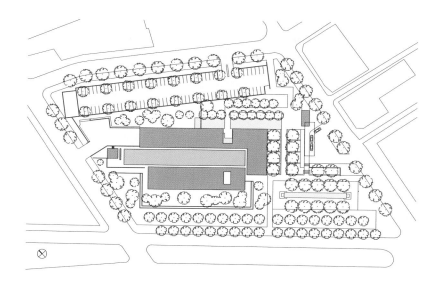

Gréber and Cret. Centered in this composition, the monumental water table acts as a serene counterpoint to the exuberance of the Swann Fountain at Logan Square. From this place, a gently inclined walk takes the visitor north through an allée of grand deodar cedars to the Entry Court.

A second garden—this one designed for visual impact rather than inhabitation—sits on a raised plinth in front of the Collection Gallery. Planted with a wide variety of trees, bushes, flowers, and ground cover, it intentionally evokes the character of the arboretum in Merion. This landscaped foreground is crucial to views from the interior, where the plantings both screen the Parkway traffic from the Main Room's floor-to-ceiling windows and, as Matisse intended, provide a balance for the colors of *The Dance*.

In order to make the entrance to the Foundation feel less institutional, we wanted to have the business of ticketing taken care of before the visitors entered. All visitors, entering by foot or dropped off by car at the Entry Court on North Twentieth Street, stop at a small glass building set under a large cantilevered canopy. It is here, at the gatehouse, that most transactions occur. The domestic nature of this diminutive wood and glass structure deliberately separates it from the civic scale of the Parkway.

Parking, long a point of contention in Merion, has been sited in a slightly lowered and walled landscape of its own, accessed from Pennsylvania Avenue. This long rectangular space, planted with trees, is a handsome "room" for vehicles. Pedestrians from the neighborhood to the north, as well as those who park here, gently descend along a planted path to the gatehouse.

All paths lead to the Contemplative Court, where the stainless steel *Barnes Totem* (2012) by Ellsworth Kelly is sited. The soaring forty-foot

Previous spread At the eastern end of the building, 30-foot-tall deodar cedars ascend the gradually ramped terrace that leads visitors from the Parkway to the entrance.

Opposite, top A westward view of the Barnes Foundation with the Parkway to the south and the parking area to the north

Opposite, bottom The paved Entry Court and domestically scaled gatehouse are sheltered by a large cantilevered canopy.

Above Site plan

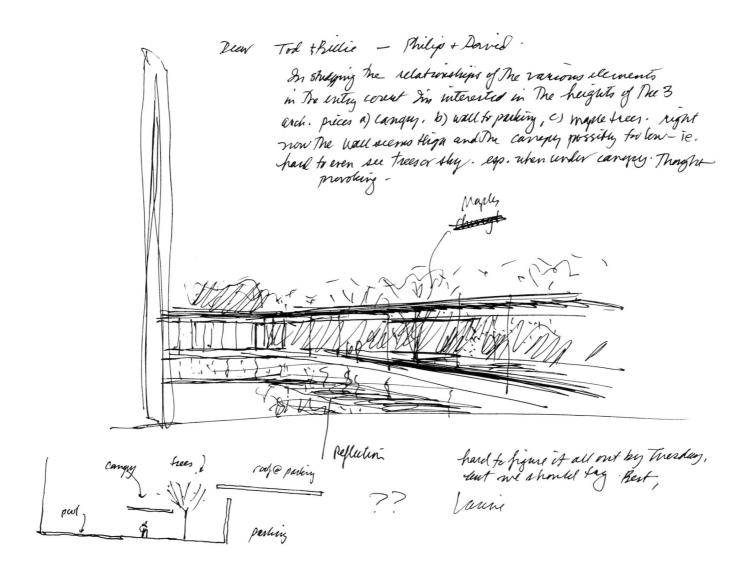

Dear Tod & Billie — Philip + David.

In studying the relationships of the various elements in the entry court I'm interested in the heights of the 3 arch. pieces a) canopy. b) wall to parking, c) maple trees. right now the wall seems high and the canopy possibly too low — ie. hard to even see trees or sky. esp. when under canopy. Thought provoking —

Maples

Reflection

hard to figure it all out by Tuesday, but we should try. Best,

Laurie

??

canopy trees. roof @ parking

pool

parking

Sketches from February 2009 of the Contemplative Court by Olin (above) and Williams (opposite) reveal a long reflecting pool at the building's base, a bridge leading visitors to the front door, and a canopy, which was later removed from the design.

Following spread The Contemplative Court brings visitors through an allée of Japanese maples.

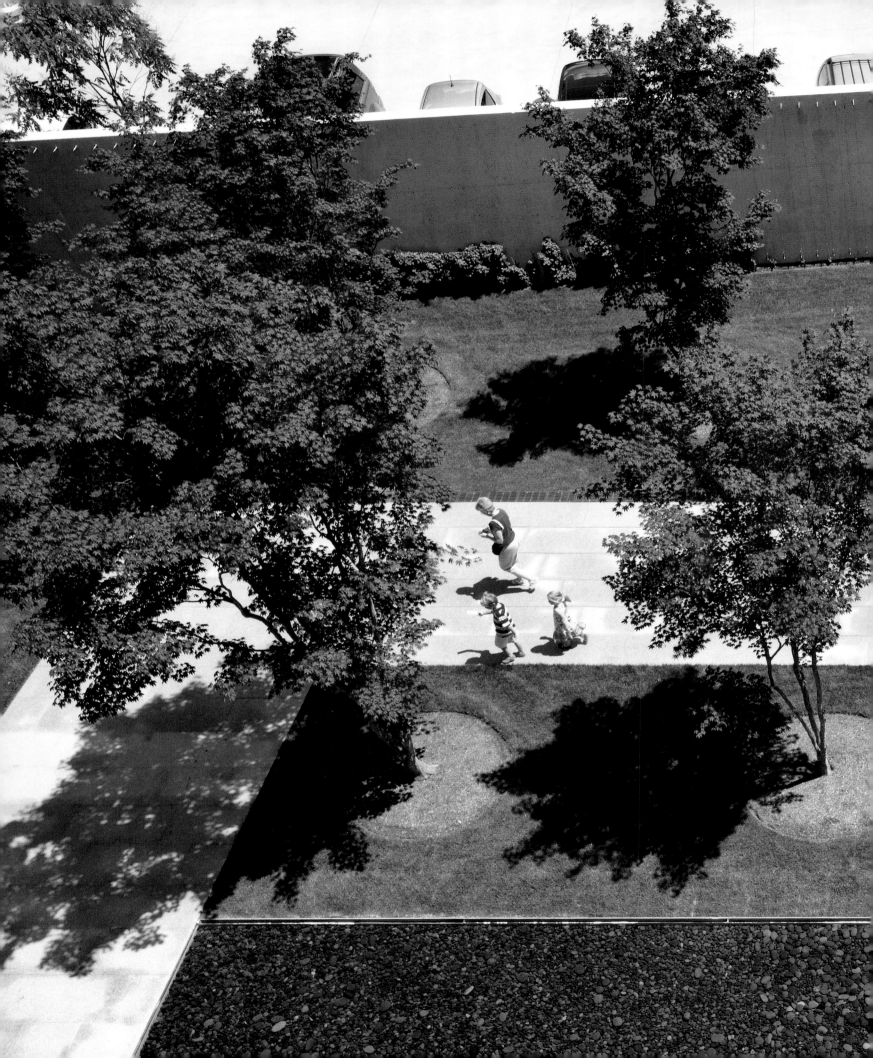

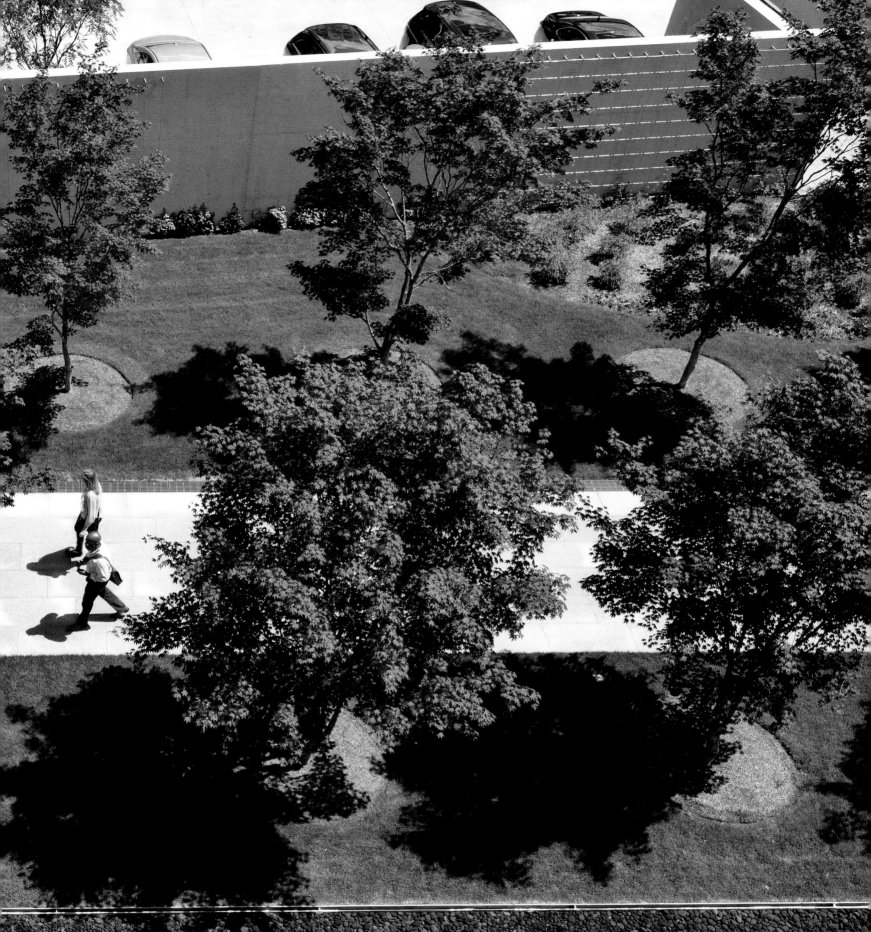

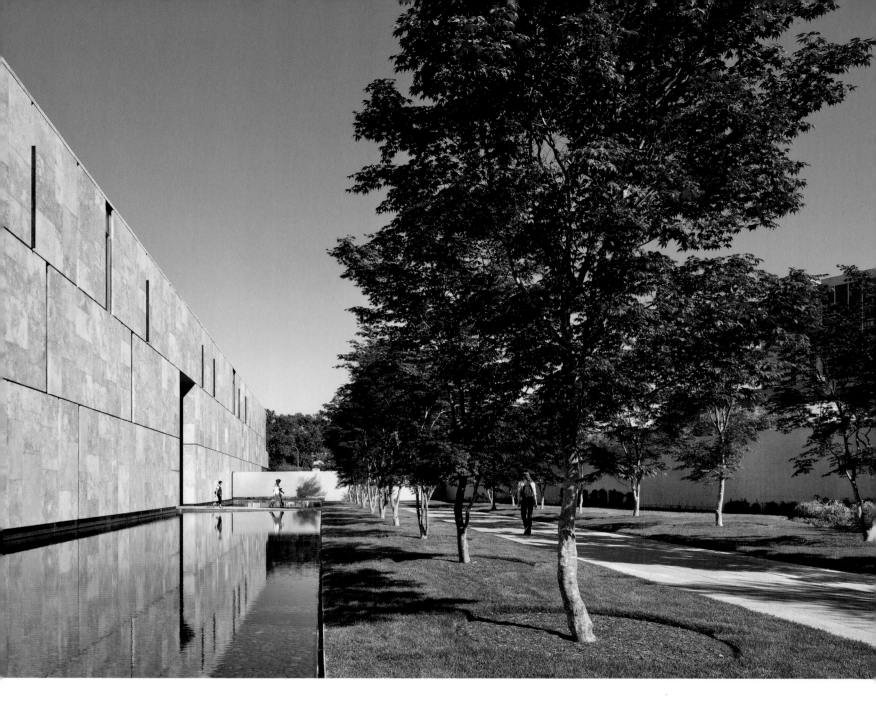

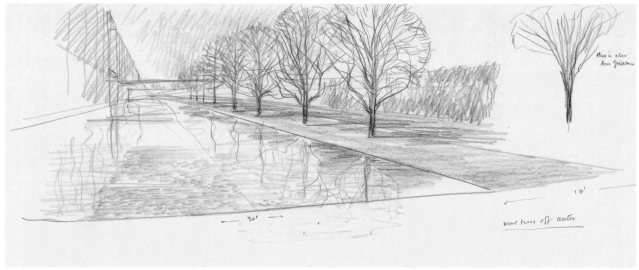

sculpture is at once monumental and evanescent, for it appears to reflect and merge with the sky as the day progresses. A path bordered by an allée of red maples runs alongside a second long pool of water that, unlike the water table on the Parkway, is still. This is the pool, discussed with Olin, that was inspired by one at the Bloedel Reserve. A diagonal wall, covered with a rich tapestry of vines, creates a forced perspective to make the garden look very deep. A second wall, perpendicular to the parking wall, is cut open at the bottom so that the pool's water flows through. It was inspired by a wall in a Chinese garden we visited in Suzhou. Here, we have tried to create a powerful sense of remove and quiet. Seasonal flowering plants, chosen by Olin, refer to the arboretum in Merion and give a more domestic sensibility to this institution that is at its heart deeply personal. Entering the Barnes must feel as if you have come to a special place where the pace of life slows, shoulders drop, and you can take a deep breath. It is a place apart; you must leave what you can behind, and you must enter through a garden. The power of landscape is so strongly present in Barnes Foundation paintings that we wanted visitors to be as aware of the landscape as of the building itself.

Opposite, top Every visitor passes through the Contemplative Court, turning at its end to cross the bridge to the building's entrance.

Opposite, bottom Olin's perspective drawing of the Contemplative Court, August 2009

Above Williams's perspective sketch of the Contemplative Court, December 2008

Ellsworth Kelly's soaring 40-foot-high *Barnes Totem* (2012) crowns the reflecting pool in the Contemplative Court.

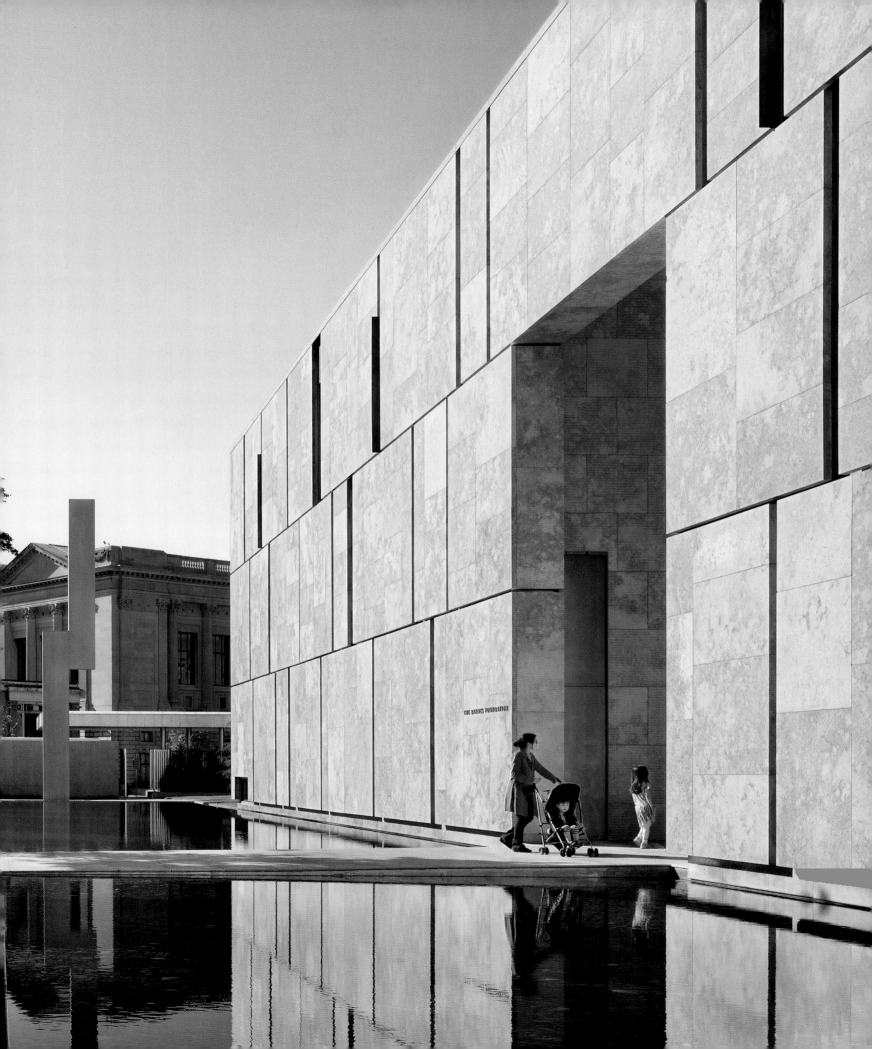

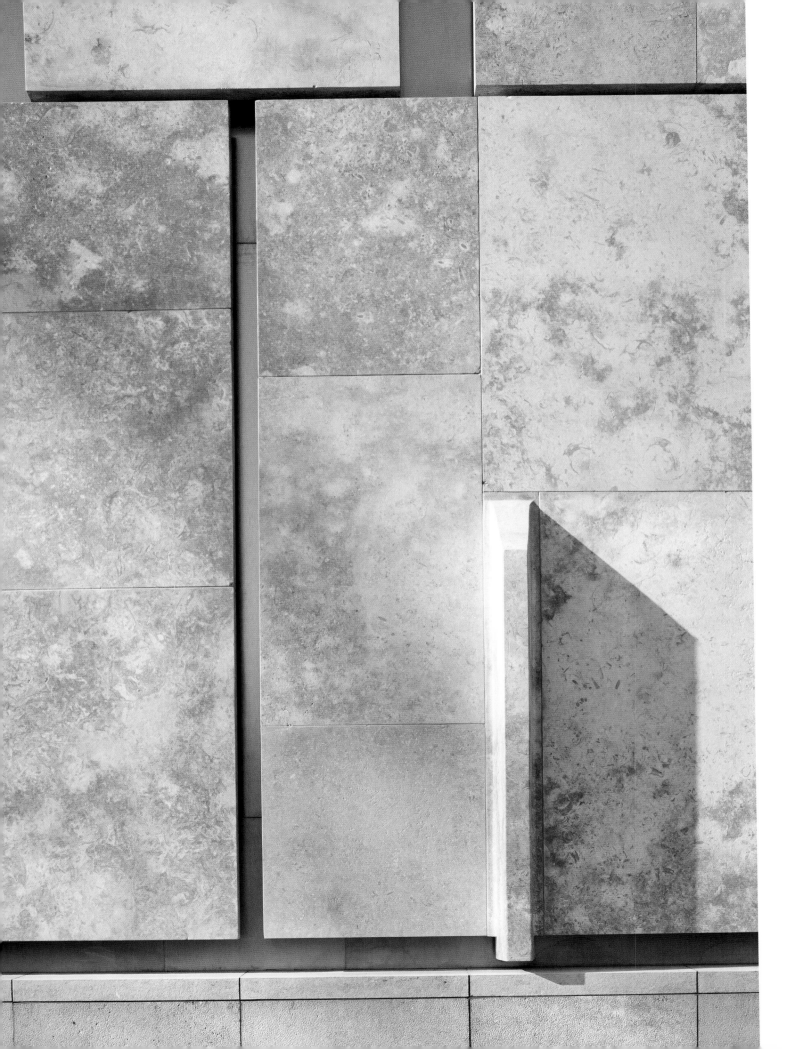

A Tapestry of Stone

Since the purpose of a building's exterior is to contain, protect, and project the interior, its facade should develop in concert with, or just after, its interior. When we consider the facade, questions we immediately contemplate, along with what its presence should be and what it should look like, are: What is it made of and why? What is the role of structure? What is needed thermally, and how do we keep the water out? What is its dimension? These seem mundane, but if they are not embedded in our thinking, these functional issues will only cause trouble later and may very well dismantle our most creative aesthetic idea. Out of these concerns, we settled upon a stone rain-screen system for the facade. It is akin to an outer garment, an attractive layer that is the first line of protection, covering the more utilitarian inner layers.

We studied the Gallery facade in Merion thinking about how to design a facade that felt related but also completely new. There was a faded richness to the large flat expanses of Cret's facade; the north side was handsome and a little abstract, with few windows. In thinking about the Collection Gallery building, we knew that we would maintain the position of each room's windows. These, then, would be visible on the exterior and might express the Beaux-Arts organization throughout our design. This would inevitably lead to a symmetrical Beaux-Arts result, yet there was nothing about the new program requirements or the site that suggested symmetry. And while we wished to enhance the Parkway's landscape and architecture, there was nothing about the new social condition, the vibrant message of what we believed the collection should mean, or the reality of Philadelphia, that suggested adherence to symmetry or a style based on hierarchy. Even as we respected the Gallery from the inside, we did not wish our building to become a slave to its symmetry. And, although Barnes

The syncopation of the limestone facade is enriched by five-inch-deep stainless-steel recesses and occasional, carved stone bars.

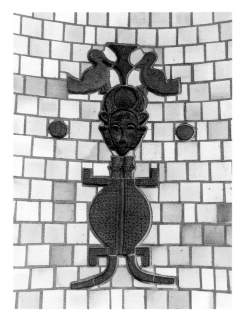

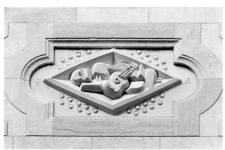

had exploited symmetry as an organizing principle for the display of his collection, this was not the case for his residence, which wrapped the Gallery block in Merion.

With all this in mind, we began to look at the various patterns of African cloth as a way to think about the patterning of the stone in a way that both accepted order and denied it. Barnes and Cret used African motifs at the entry. In our own lives, we have been interested in African art and textiles. Twenty years ago, Tod returned from a trip to Paris with a huge, brown-paper-wrapped object that looked like a sarcophagus. It was a Senufo ritual bed, carved from a single block of wood. Recently, in Brussels, we found a forty-foot Kuba cloth that was made to be worn wrapped many times around the midsection of a body. The appliquéd shapes ranged from simple forms at one end to a complex and fantastical overlay at the other. Over time, we have collected work that has moved us by its exquisite balance of art and intended use. We have been inspired by the combination of order and serendipity that we see in African textiles. We knew that Matisse came from a family of textile manufacturers and, from archival photographs, that he kept a collection of African textiles in his studio. We came to develop a pattern of panels inspired by Kente cloth. Known as *nwentoma*, it is a traditional weaving developed by the Ashanti of Ghana and the Ivory Coast. The fabric is woven in strips and assembled into the full cloth. The pattern within the strips is geometric and is sometimes interrupted by wider bands of solid color. The idea of a banded weaving became the basis for the organization of our stone facade. We wanted to wrap the building in a cloth of stone.

As we were composing the facade, we investigated different kinds of stone. We first considered those already in use on the Parkway, the stone

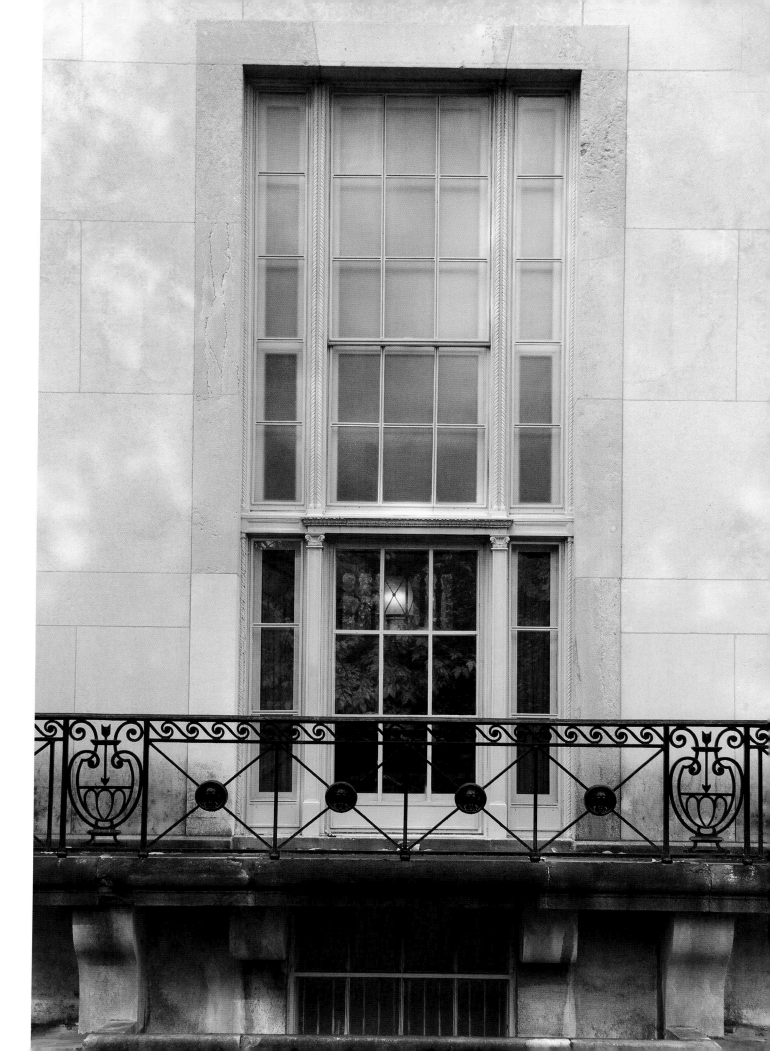

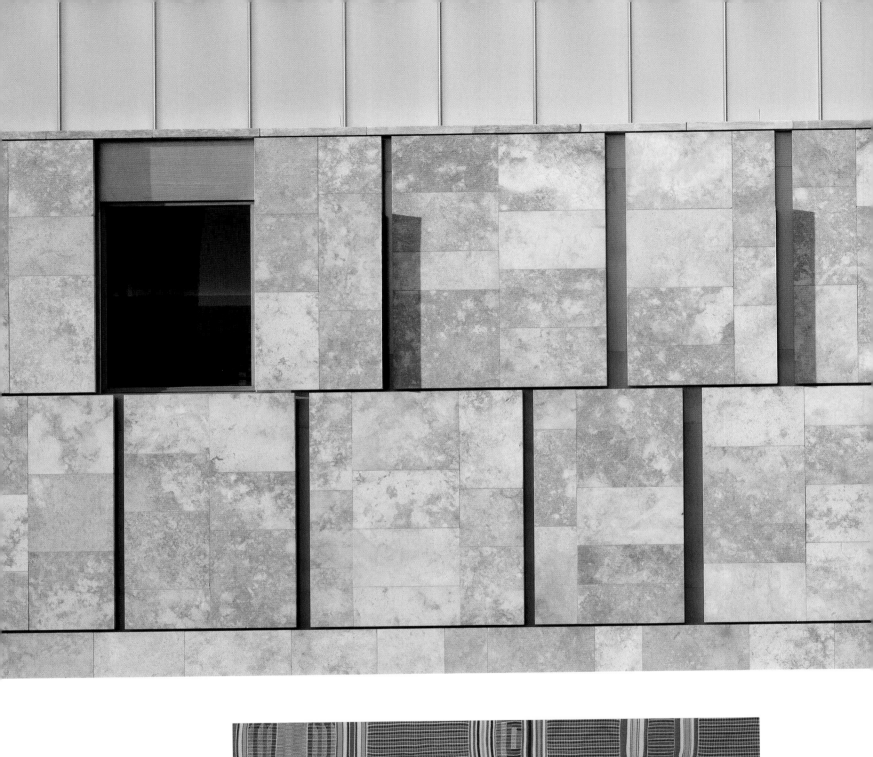

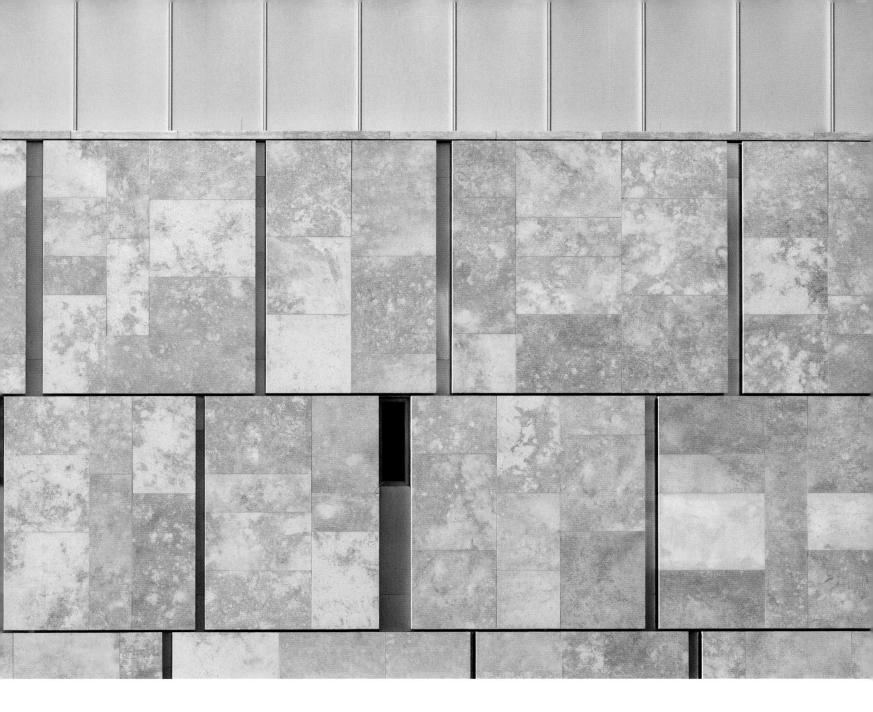

Above The facade has a system
of stone superblock panels that
were assembled from individual
pieces varying in size from 3x5
to 4x8 feet.

Opposite The cadence and pattern-
ing of the facade are informed
by Kente cloth, an African textile
from Ghana.

of many of America's civic buildings — Tennessee pink marble and
Indiana limestone — and, if not one of these, perhaps a beautiful French
limestone. Cret used a mixture of two different limestones in Merion.
We soon dismissed the yellow Kasota stone of the Philadelphia Museum
of Art as being competitive with that institution's presence at the end
the Parkway. Our research into more local Pennsylvania stones produced
only slates, schists, and granites that were dark in color and did not
seem right. We also investigated two new possibilities, both affordable.
One was a greenish-gray stone from Turkey and the other, Jerusalem
stone, a hardier material from the Negev. Large full-scale stone mockups
were erected at the site, along the Parkway. They were covered with tarps
until they were all completed, and we assembled to make a judgment.
Indiana limestone has been so selectively quarried that, to our eyes, it no
longer has the rich character of buildings constructed one hundred years
ago, when architects were happy with the wider range of colors and
densities that were available. The Tennessee pink marble quarries no
longer have material in the size and quantity required and, while
relatively local, it still would have been prohibitively expensive. French
limestone was also rejected, since some of the stone used at Merion
had proved to be too soft, others were no longer quarried, and what was
available was also prohibitive in cost. Eventually, we selected Ramon
gray and Ramon gold from the Negev, because the stone had a great sense
of warmth and variation. Its coloration, although different, related to
the golden hue of the Philadelphia Museum of Art, and it also felt as if it
belonged on the Parkway and was right for our building.

We flew to Israel to better understand the quarrying and properties
of the stone. As a farmer knows which vegetables are best, the quarryman

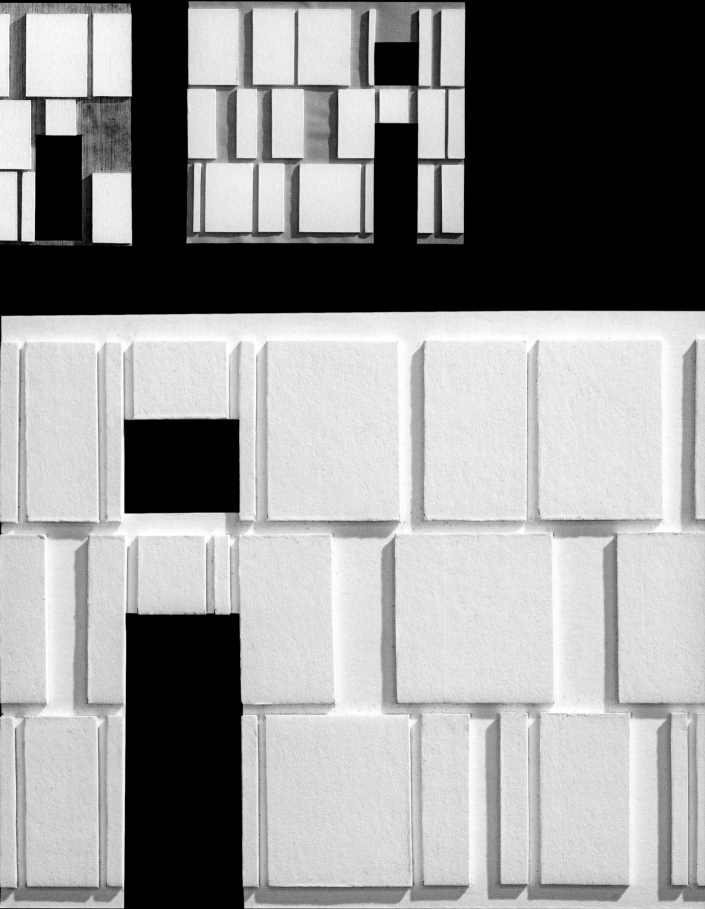

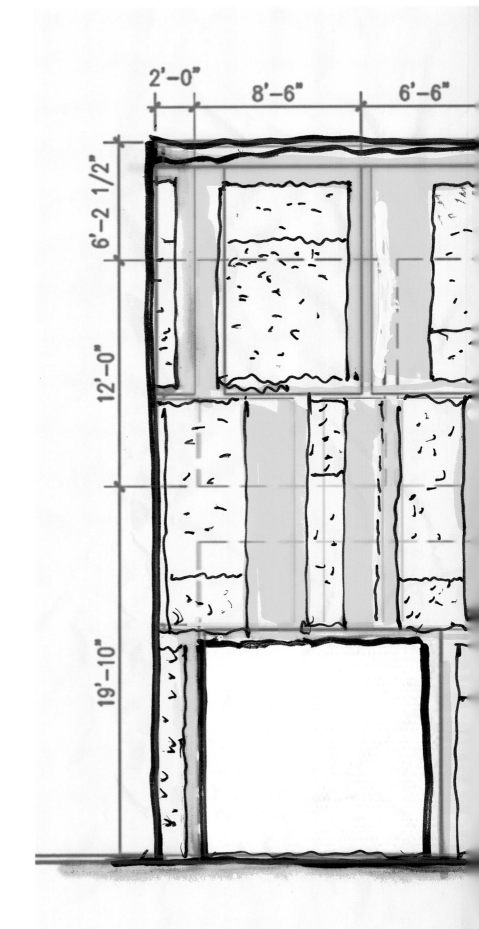

Williams's September 2008
study of the north facade.
The dimensions on the left
correspond to the interior
floor levels.

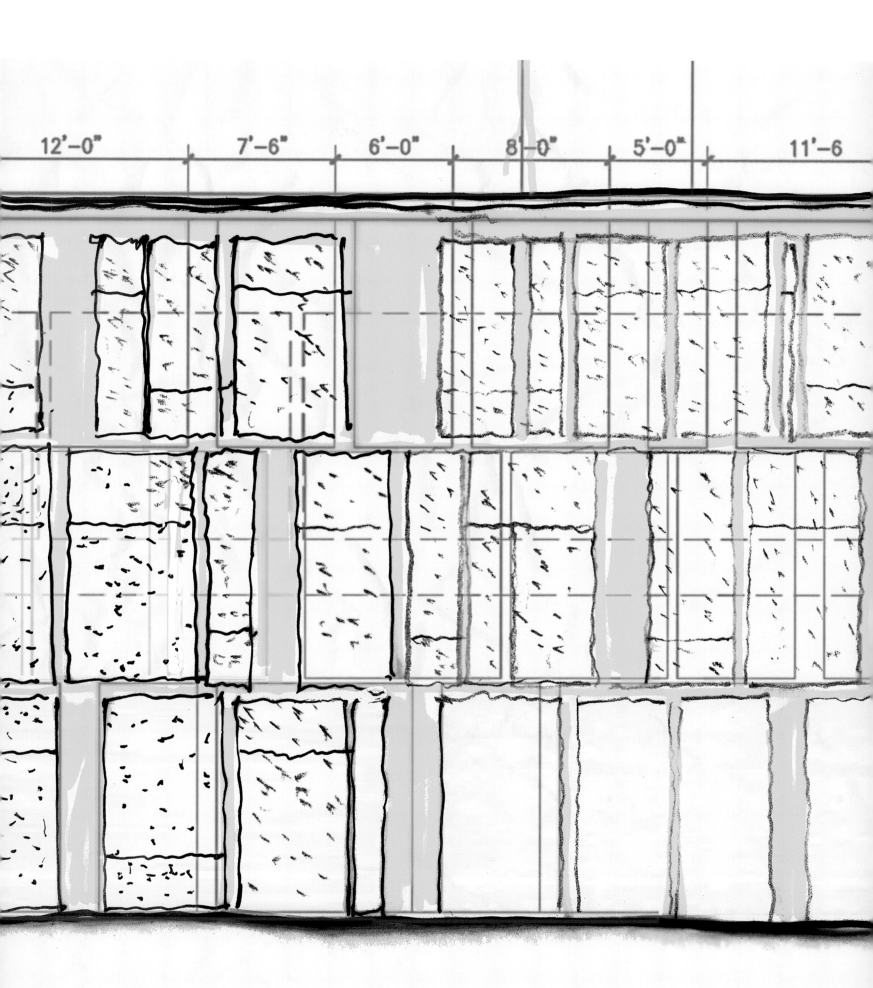

12'-0" 7'-6" 6'-0" 8'-0" 5'-0" 11'-6

knows stone. He knows which area of land produces the best blocks, and
which blocks are strongest and have the best color and fewest flaws.
He knows who can best cut and dress the stone. Our trip to Israel, visiting
quarries and stone yards, helped us select both a quarry in the Negev
and the factory that would cut and finish the stone. We learned of the
differences in the stone's color density and developed various finishing
options with the stone workers. Ramon gray is more prevalent, less
expensive, cooler in coloration, and harder than the warmer and more
colorful Ramon gold. After visiting several shops, we met a group in
Bethlehem who had prepared for our visit by setting out a large quantity
of stone on the ground. We ascended in a forklift, allowing us to study
sizes and patterns of the stone from a distance. In the factory, we watched
workers hand-chiseling stone and noticed that each stone had its own
signature pattern, the result of the stoneworker's strength, body movement,
and swing of the chisel—a mark as personal as hand-writing. The hand
of the maker adds immeasurably to the character, texture, and color of the
stone. We asked these same men to try making more regular marks
that looked like ancient cuneiform writing, and we have used this beautiful
finish on certain interior surfaces and in the garden of the Collection
Gallery. Discussion ensued as to how to most efficiently use the stone
so that we could balance our desire for special finishes with issues of
production and schedule. After sitting with the owners—an Israeli and
a Palestinian who quarry stone in Israel and have it cut and finished
in the West Bank—over an elaborate tea, we all felt confident with our
communication and with one another. We returned to the States with
a much better understanding of the stone, the vendors with whom we

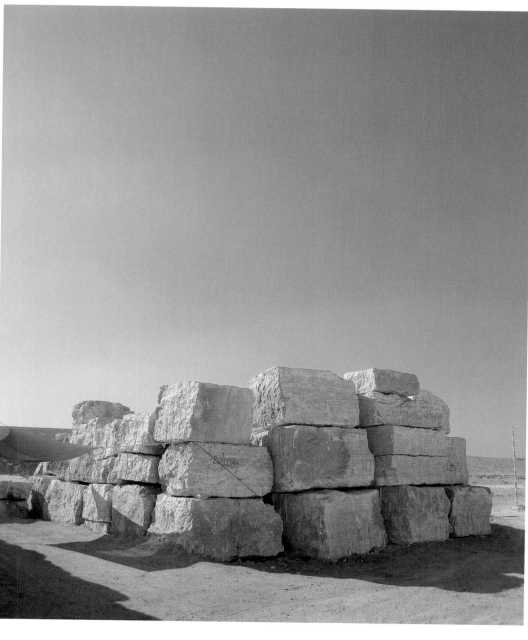

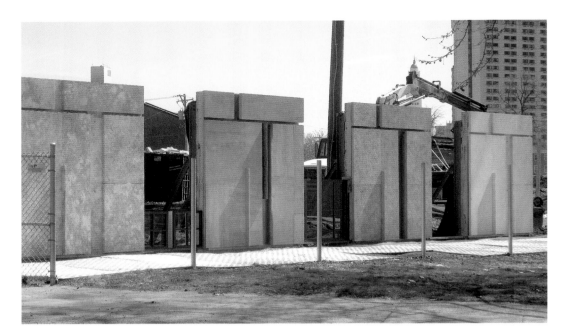

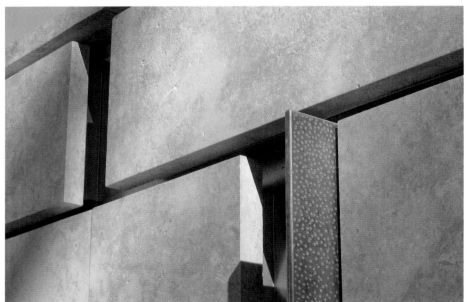

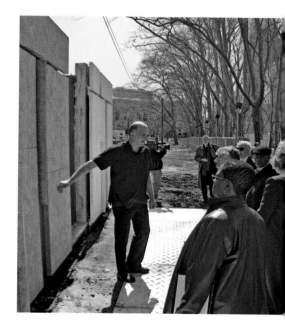

might work, and the sizes, cuts, and finishes we would use—and with a feeling of great hope for our project.

Though it is not at first obvious, there is a system and an order to the facade. We felt the facade must be regular, flat, rich, and varied as we approached the building. To gain a sense of depth and mass, we studied panel size and the depth at which the rain screen would be recessed. A superblock of stone, composed of smaller stone panels, establishes the basic module. The smaller pieces of stone are quite varied in their coloration and pattern. Indeed, these were qualities that we looked for as we thought about our choices. The superblocks are interrupted by vertical stainless steel channels of differing widths that are set back from the face of the stone. The channels create a syncopation that is periodically enriched by the insertion of wood-framed windows, hammered-bronze fins, and carved stone bars. The steel and bronze set up a subtle relationship with Barnes's use of hardware among the paintings in his ensembles.

Knowing that the building would be approximately forty-five feet high and that there was a size limitation on the panel size that we were able to transport by truck, we set a tentative height of approximately fifteen feet for each panel. This horizontal division into three equal parts would create visual seams similar to the construction of Kente cloth. These seams would give vertical scale. This was also a subtle acknowledgment and reinterpretation of the tripartite neoclassical banding in the facade in Merion. Within these horizontal bands, the widths of superblock could vary within a predetermined range. The spacing between them could also vary. Again, we determined minimums and maximums. At the minimum, this spacing had to allow for assembly tolerance, and, at the maximum, had to allow for the placement of a window; but the real benefit

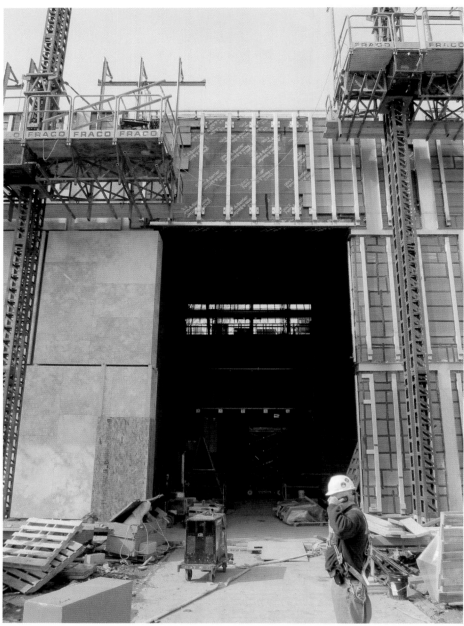

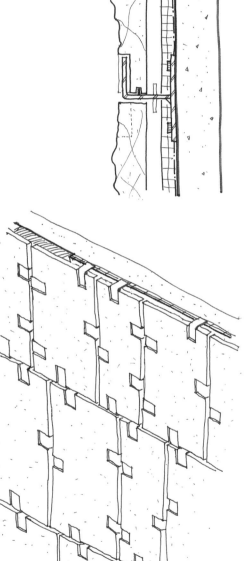

Above The facade employs a stone rain-screen system, as shown during construction in April 2011.

Right Sketches of a system (later abandoned) of bronze clamps to hold stone facade panels, May 2008

Opposite On the building's north facade, a small wood-framed window is recessed into the stainless-steel reveal and surrounded by stone super-block panels.

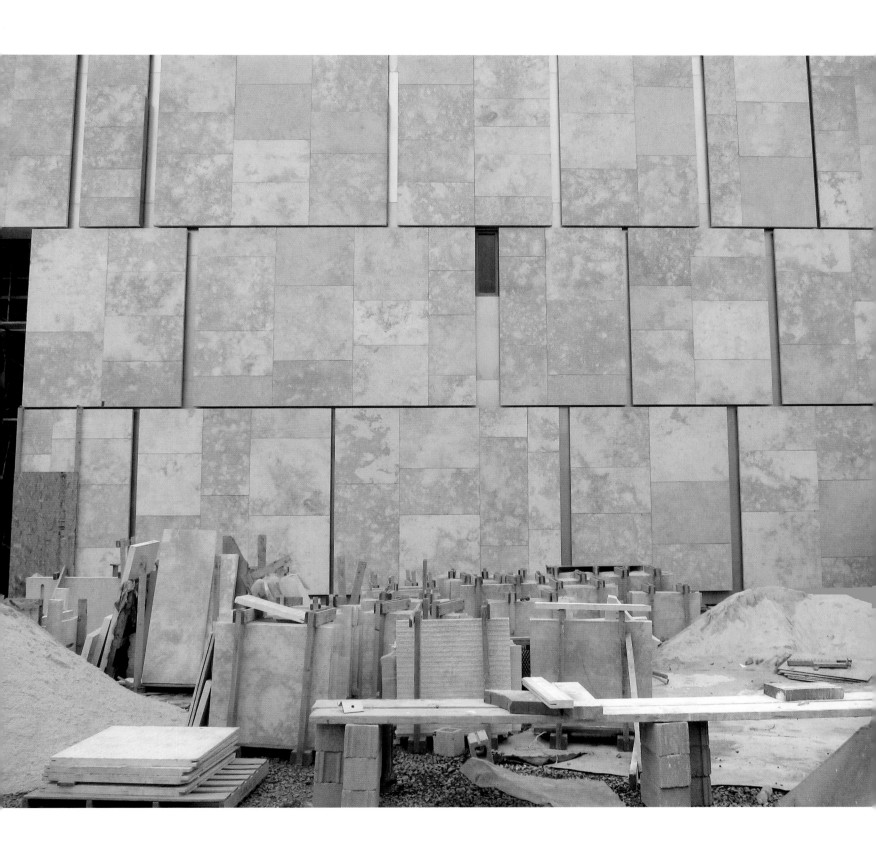

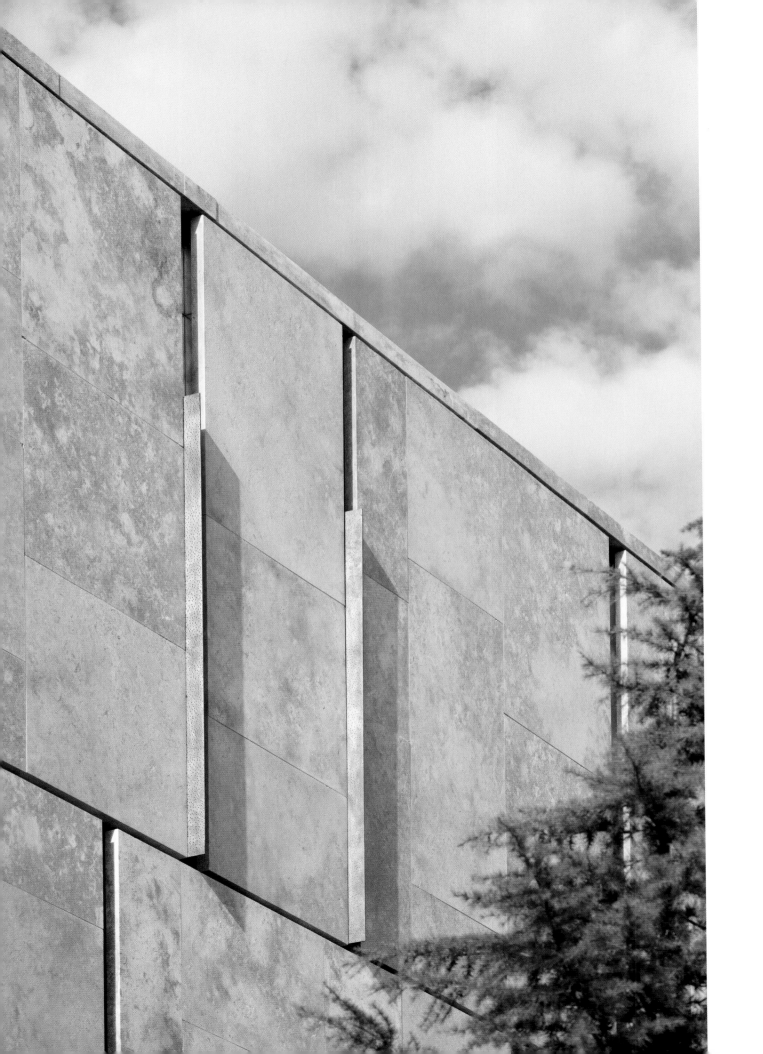

Hammered-bronze fins on
the facade are a subtle nod to
the wrought-iron objects
displayed within the Collection
Gallery ensembles.

of this space is to show the handsome heft of the stone's thickness and to reveal the beauty of the stainless-steel rain screen five inches in from the face of the stone. The interplay of stone and stainless steel is particularly beautiful, a dynamic balance of opposites.

As we developed the facade for the Pavilion building, we temporarily withheld adding any additional windows. This facade, unlike the Collection Gallery with its strong ties to the interior organization, is quiet, abstract, and decidedly modern. Glass, the most common choice of contemporary expression, is often so promiscuously used that it becomes less valued. It has the additional problem of not being energy efficient unless it has many layers and is thus extremely costly. While there may be exceptions, we believe that buildings should be anchored to the ground—have weight, mass, and a commitment to place. And windows, glass, and openings should all be used judiciously, and only where they will truly count. On this facade, there are windows framed in wood but without the mullions seen in the Collection Gallery windows. Windows are used sparingly—there are several at the entrance and exits, a low window in the special exhibition gallery, sliding window doors in the restaurant, and a large north-facing window in the conservation laboratory. Additional windows, which frame selective views, were added as we developed the interior spaces. The Pavilion is largely solid in appearance; the mass and stone fabric of the building emphasizes a quiet sense of power. The overall effect of the facade is one of wholeness and unity, but also of variation and surprise.

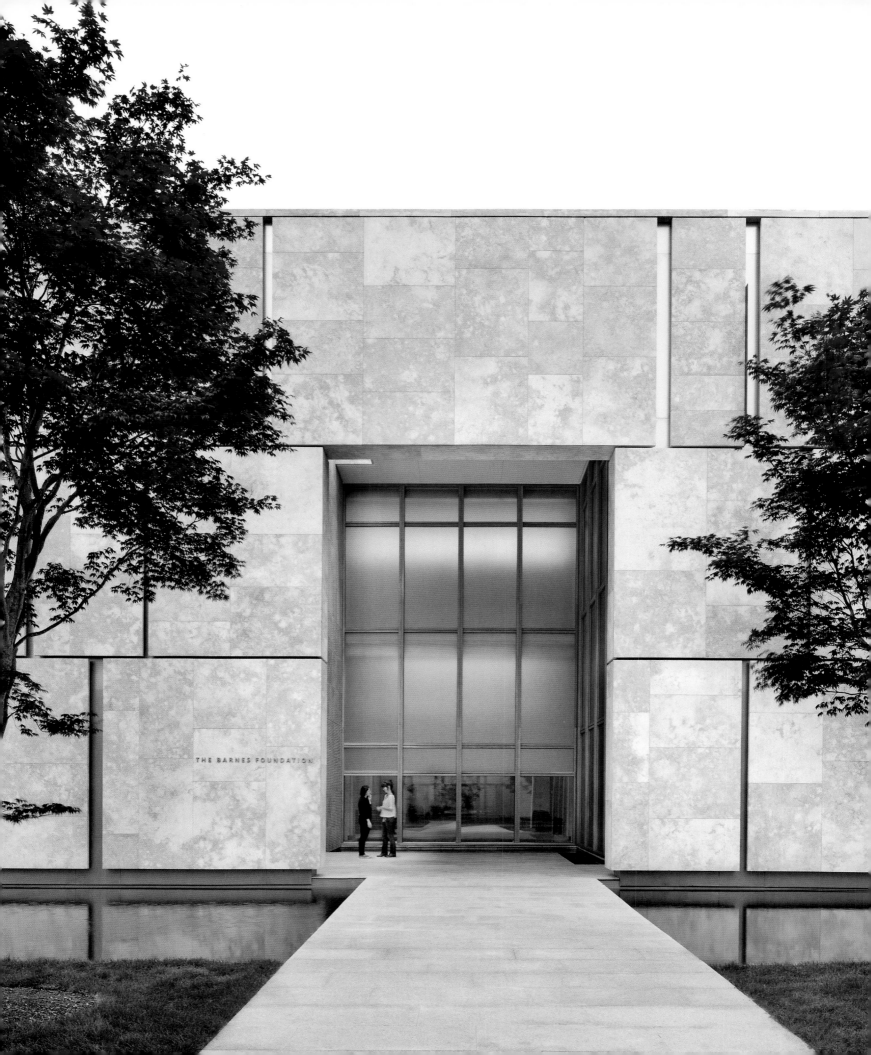

The Support

The Pavilion is the point of entrance to the Barnes Foundation. This long L-shaped building shares the stone detailing used on the exterior of the Collection Gallery, but the use of large panes of glass at the entry reinforces the fact that this is the more contemporary facade. A bridge crosses the long pool of water to a monumental portal twenty-five-feet tall by sixteen-feet wide. This portal opens to a covered area thirty-four-feet high, where a slot in the roof reveals the sky. The entry doors are made of oak to add warmth and balance to the grand scale. This balance—of the warm and the cool, the grand and the domestic—is a constant theme that has informed all the decisions we have made in the design of the interiors. Another theme is that of screened and suggested views. At the entry, higher panels of etched glass pick up flickering light from inside, while eye-level panels of clear glass allow for a glimpse of the visitor's destination.

Passing through a vestibule, the visitor glimpses a handsome wooden stairway that descends to a lower level. The lobby has been designed to feel more in keeping with entering a personal collection than an institutional one. A section of wall is covered with linen, held in place by oak battens. And since ticketing has been completed before entering, we chose to design a long walnut table rather than a standard counter. A series of hand-drawn lines has been inkjet-printed onto a commercial grade carpet that is inset into the stone floor. We wanted to inject the presence of the hand in collaboration with standard manufacturing techniques.

Adjacent to a large elevator is the stairway glimpsed at the entry. It is made of wood. The steps are ipe and the central mast is made of walnut. Public stairs in both the Pavilion and the Collection Gallery are made of hardwood, once again suggesting a domestic character. Above the stairway is an interpretation of a chandelier. Working with lighting designer

To enter, visitors cross over the reflecting pool toward the monumental 25-foot-high portal of the Pavilion.

Below Pavilion during construction, December 2011

Opposite Walking through the entry portal, visitors turn right to enter the building. Shadows from an indoor light fixture dance across the wall of glass.

Paul Marantz, we developed a system of acrylic prisms hung from steel cables to reflect light, and signal the presence of the public functions on the lower level.

The lower level has been designed as prelude and conclusion to a visitor's experience at the Barnes. At this level, there are additional class-rooms, an auditorium, coatroom, coffee bar, shop, restrooms, and mechanical areas. These spaces are configured around the Lower Lobby, which serves as an informal corollary to the more formal Light Court on the ground floor. Sound is softened by a large acoustical wall panel that is covered in Belgian linen and supports a twenty-foot-long solid oak shelf displaying books related to the collection. The auditorium is paneled in the cuneiform-finished stone. Four-inch-wide blocks of this stone in the same finish are used as railings for the walkway to the stage. Material choices are reduced, but each one has a richness derived from the way it is worked. Visitors can enjoy refreshments from a nearby coffee bar and relax or read on the comfortable sofas. From the Lower Lobby, a visitor can actually step outside into the lowest level of the Gallery Garden, which has been planted with sweet gum, gingko trees, and a variety of ferns. This is an experience that is now quite rare in a museum visit, but one we cherished during our visit to the Kimbell Art Museum. The garden brings natural light to the lowest level. Here, once again, the twin focuses of the Barnes Foundation's mission, horticulture and art education, literally intertwine.

Upstairs, at the entry level of the Pavilion, two new program elements have been added. The first is a restaurant that opens to its own walled garden. Water from the long pool in front of the entry extends through an opening in the concrete wall to make a small pool. Seasonal flowers are

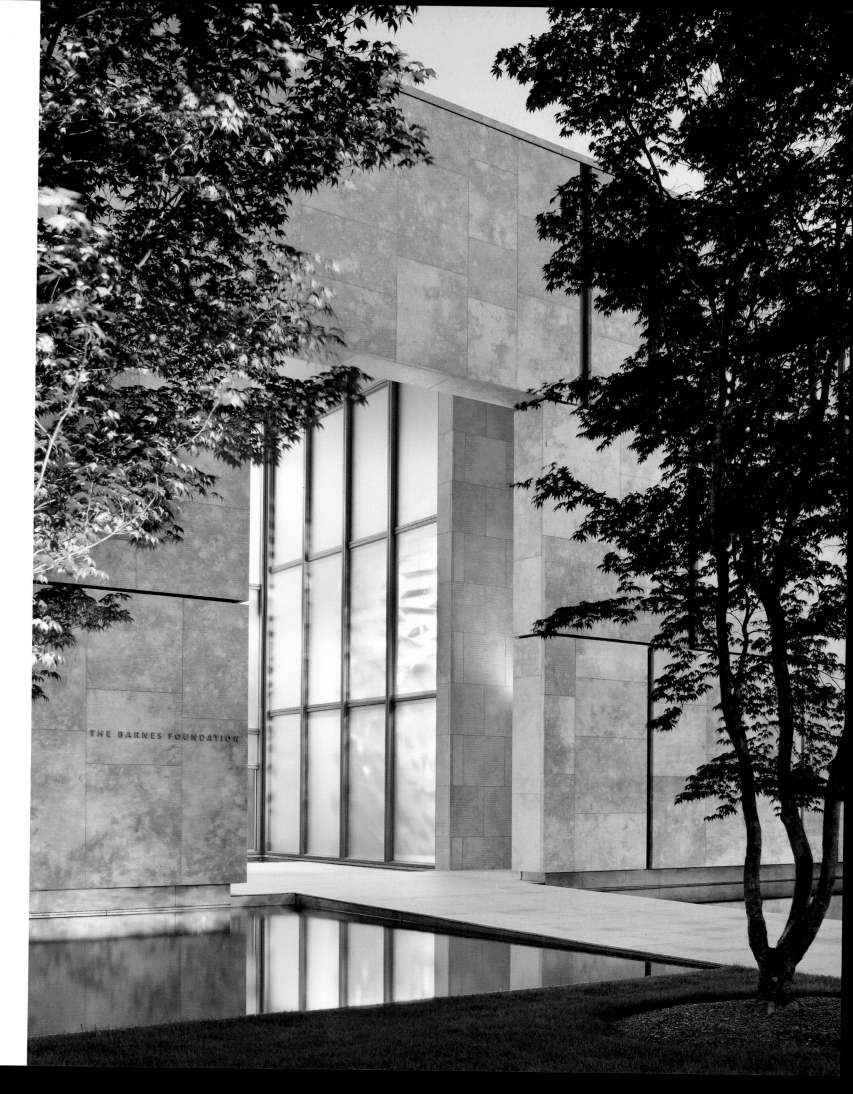

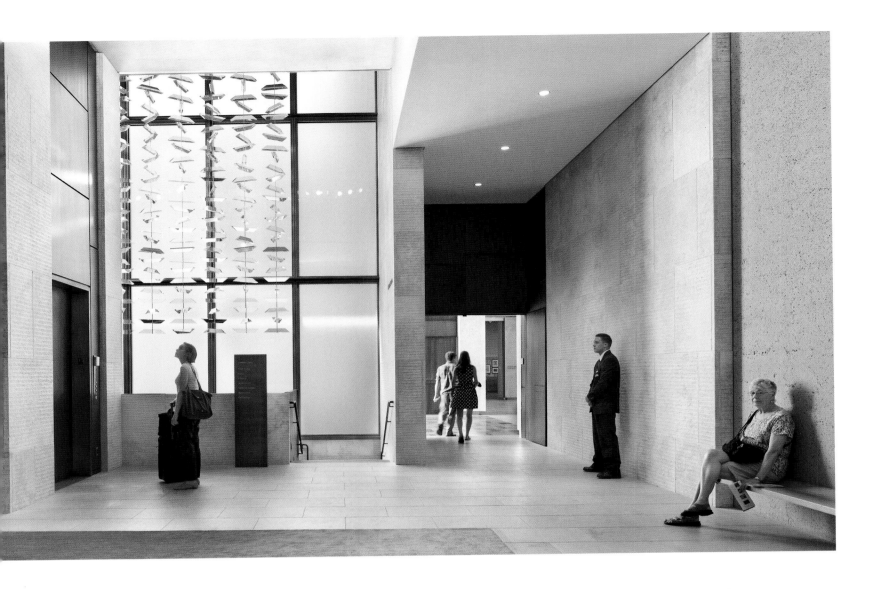

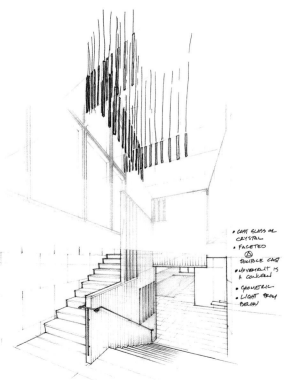

• CAST GLASS OR CRYSTAL
• FACETED
• DOUBLE CAST
• MOVEMENT IS A CONCERN
• GEOMETRIC
• LIGHT FROM BELOW

Above A large chandelier, composed of acrylic prisms, hangs over the stairway that leads from the Lobby to the lower level.

Left A sketch of the entry stairway with an early design for the chandelier

Opposite The walnut and ipe staircase is surrounded by Ramon gray limestone in a linear hand-chisel.

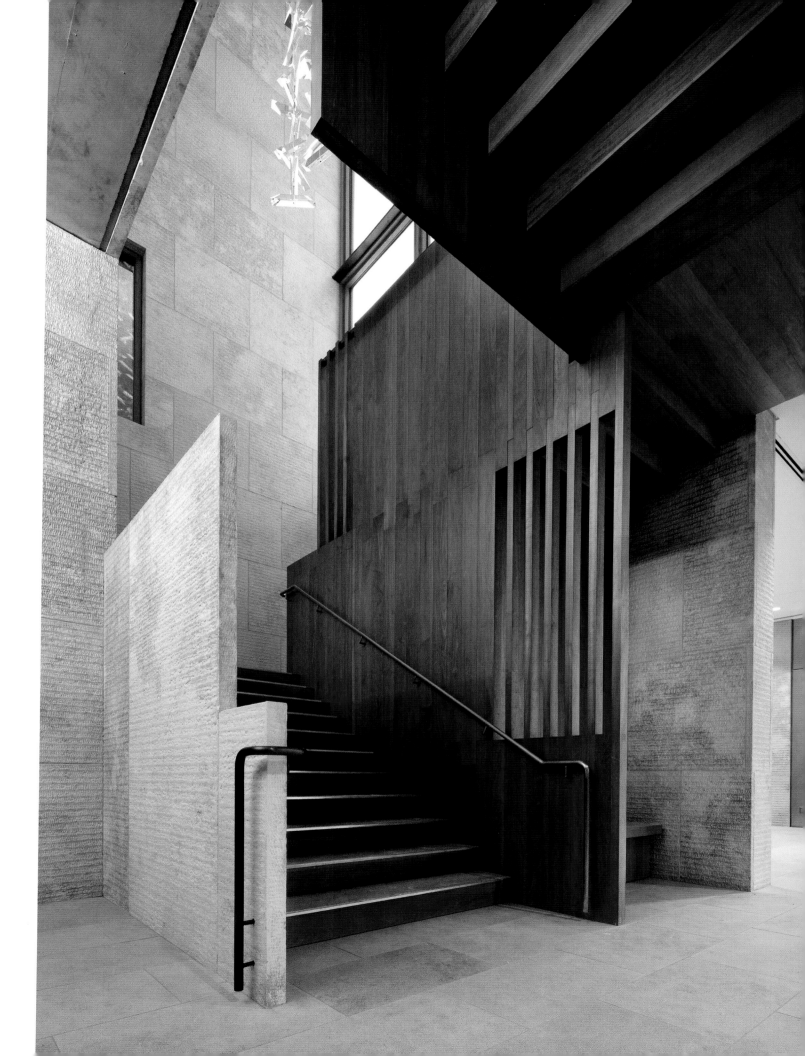

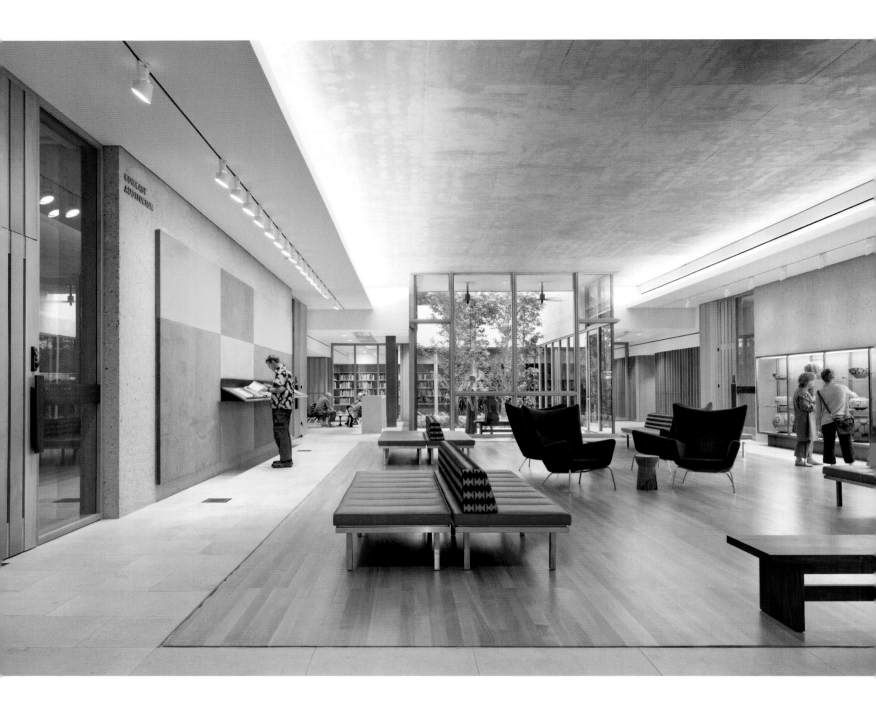

On the lower level, a reading
area, auditorium, coffee bar, library,
seminar rooms, coatroom, and
shop are configured around the
Gallery Garden.

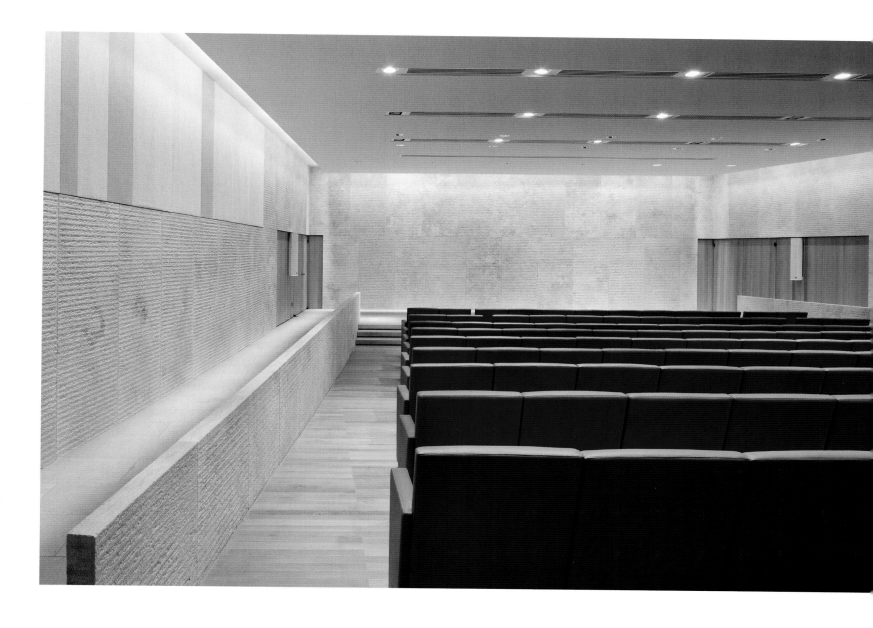

The 2,750-square-foot auditorium
accommodates 150 people. Walls
feature both Ramon gold stone
panels and acoustic panels wrapped
in dyed Belgian linen. Chairs in
cognac-colored leather rest atop a
white oak floor.

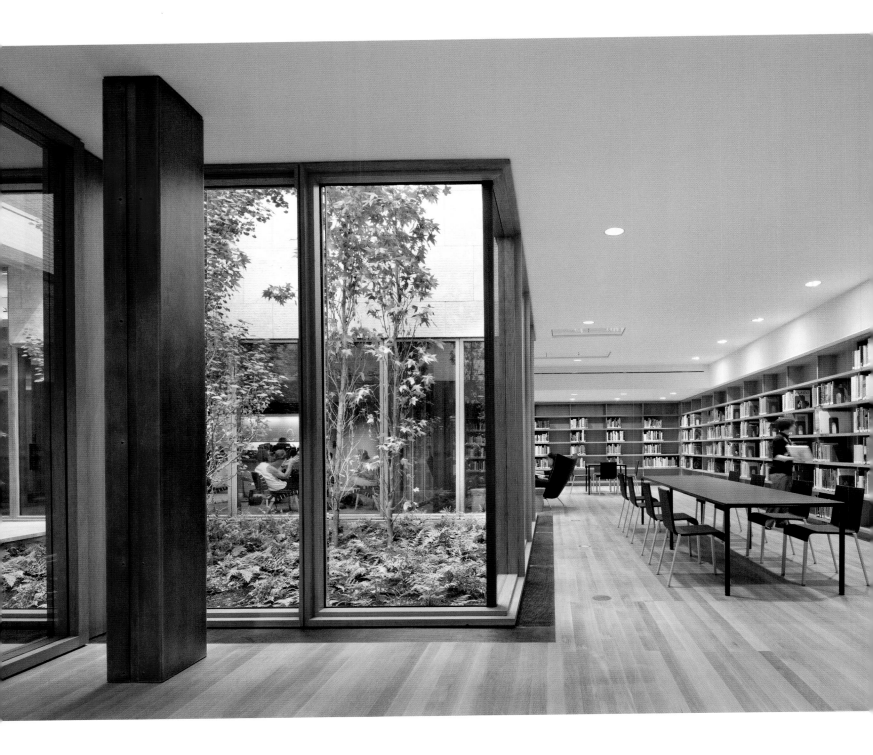

Above The library has walls of white oak shelves and wood-framed windows that look into the Gallery Garden.

Opposite On the lower level visitors can step outside into the 570-square-foot Gallery Garden.

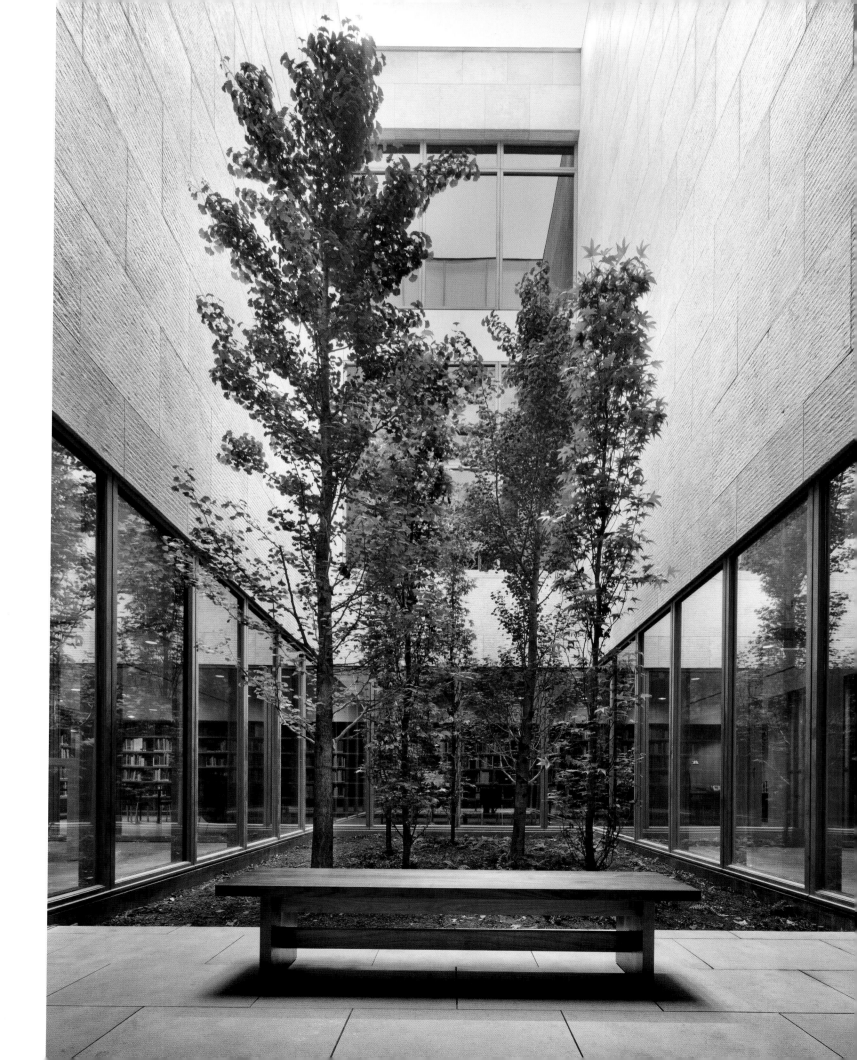

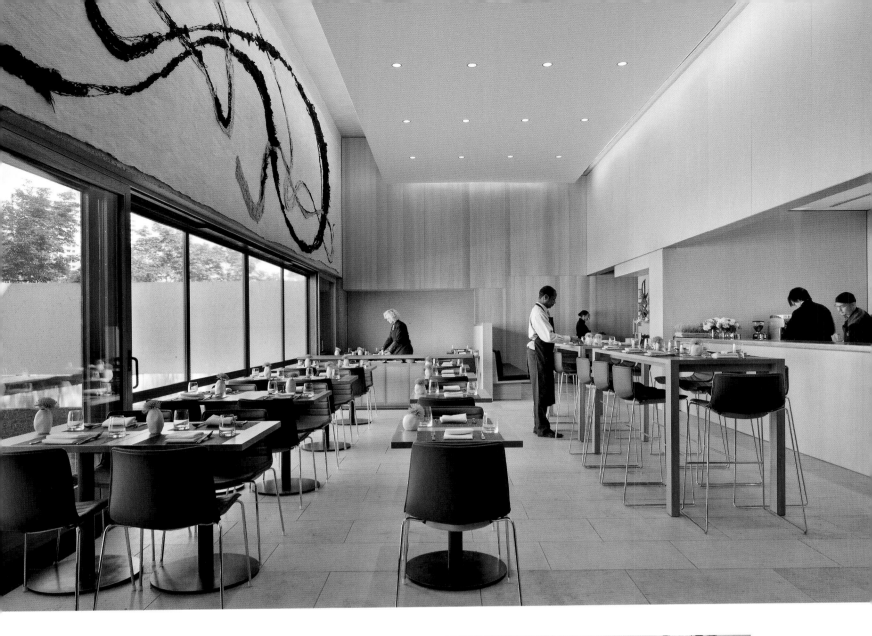

planted here. Two wall hangings—the work of Dutch artist Claudy Jongstra—refer to the world of nature and horticulture. Made of wool sheared from Jongstra's own sheep, the wall hangings have been colored with natural plant dyes from recipes that the artist has developed based on traditional dyes and colors from medieval times.

The second new element is a special exhibition gallery. This gallery can be divided into two spaces, and is accessible from both the Light Court and the lobby. This space is larger in scale, has sixteen-foot ceilings throughout, and is detailed in a much more contemporary and minimal way than the Collection Gallery rooms. The floor is constructed of edge-grain blocks of white oak, and track lights are recessed into a stretched scrim ceiling. In one corner, a low window brings in natural light and allows the visitor to connect with the world outside: in this case, the water and reflection of the long pool by the entry. Designed as a space where even contemporary work can be shown, the gallery will allow the Barnes Foundation to expand its educational mission.

The second level of the Pavilion is shielded from the public. It reveals itself on the exterior through the windows that are inserted between the stone panels on the north facade's upper level. Offices for curators and other staff are open spaces off a long corridor illuminated by light from the court. Natural light is diffused through a long veil of acid-etched glass that runs the length of the space. At the western end of the corridor is the conservation laboratory. A large floor-to-ceiling window lets in the northern light needed for the conservators' work. At the opposite, eastern, end of the corridor is a large window above a conference table, framing a view of the Free Library next door.

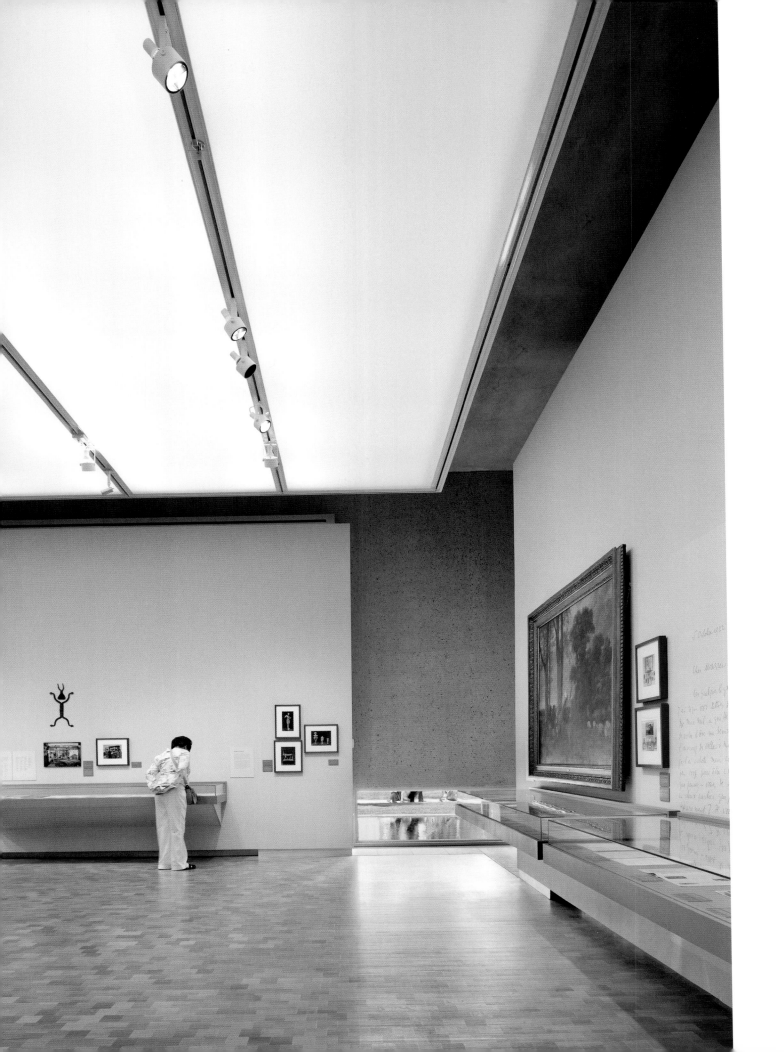

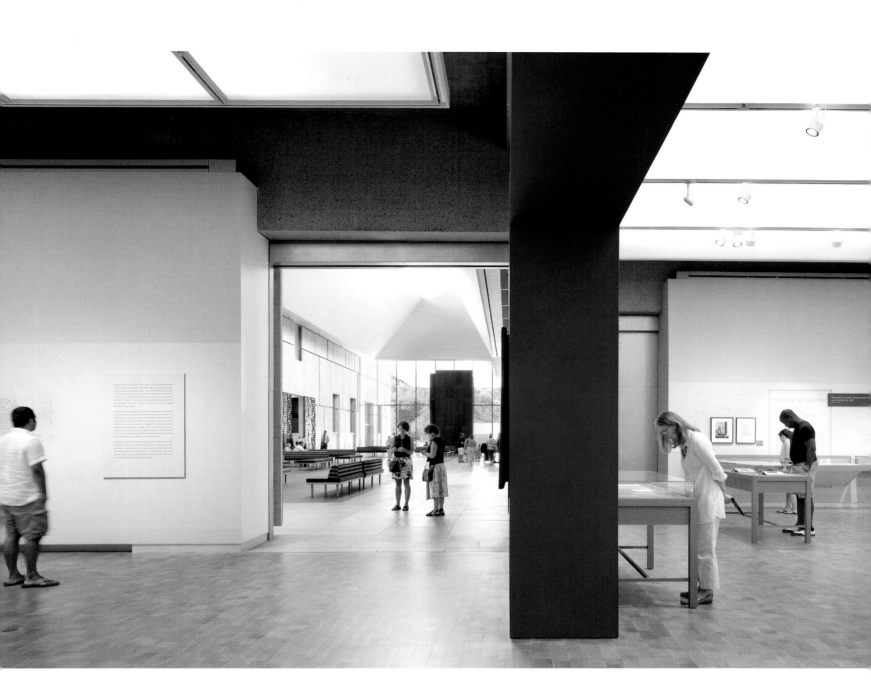

Opposite A low window on the north wall of the special exhibition gallery frames the feet of visitors walking by the reflecting pool outside.

Above The 4,300-square-foot special exhibition gallery is at the east end of the Light Court.

Left Williams's perspective of the special exhibition gallery, March 2009

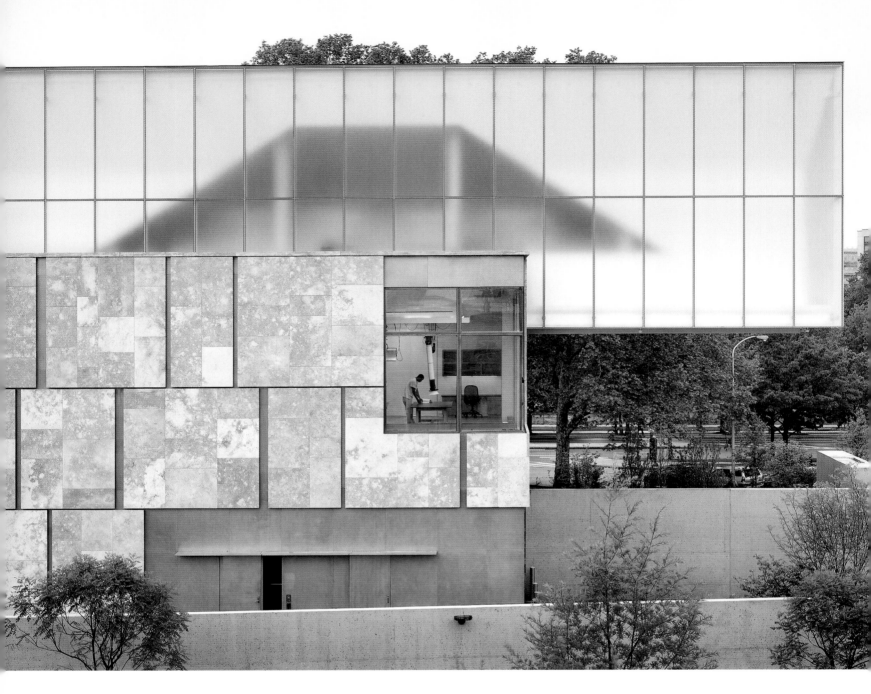

Opposite, top and bottom Exterior
and interior views of the 1,700-
square-foot conservation laboratory
with its large corner window

Above A long corridor runs the length
of the second floor of the Pavilion
and receives natural light from the
Light Court, through a veil of acid-
etched glass.

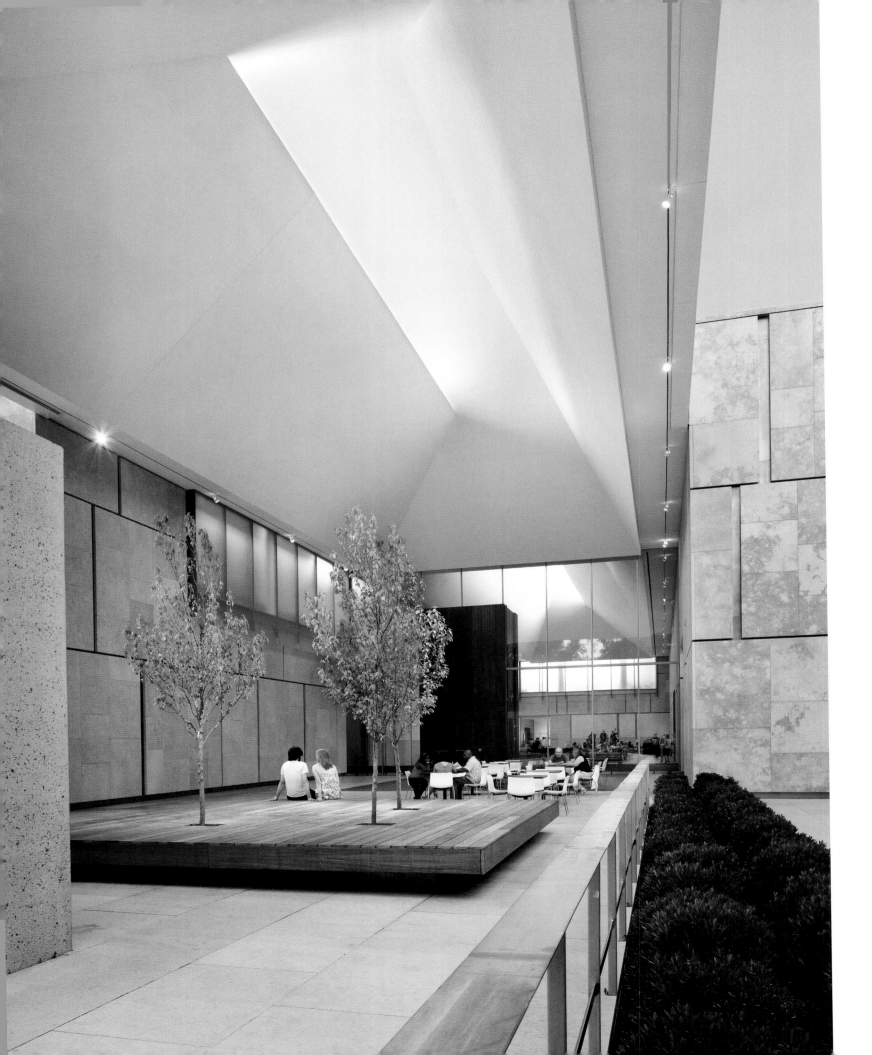

The Living Room

In Merion, one enters the Cret Gallery from the garden directly into a small antechamber that connected to the first great room of paintings. We knew it would be impossible to go directly from the exterior into the new Gallery due to contemporary conservation requirements that temperature and humidity remain constant. We also knew that in the new location a comfortable and generous waiting space would be needed. Ideally, this space would be filled with changing natural light, but it might not need the sophisticated temperature and humidity controls required by the Collection Gallery.

Our first schemes had an eight-foot-wide slot cut through the floor to the level below that, like a moat, separated the public spaces from the Collection Gallery. The idea was that this area could have more direct light and a less sophisticated level of environmental control. We proposed continuous overhead skylights in the public area and a bridge with glass doors to span the slot and connect to the Collection Gallery. For months we convinced ourselves that this gap solved our desire to separate the Collection Gallery from the entry experience. In time we felt dissatisfied and realized that the continuous overhead skylights and the eight-foot slot between the Pavilion and the Collection Gallery created a building that felt disjointed. It was only by accepting that the environmental requirements of the Pavilion should be as stringent as those in the Collection Gallery that we could join the Light Court directly to the Collection Gallery.

If the intensity of Barnes's extraordinary collection is to be a visitor's primary experience, then the Light Court is the place to rest and reflect. The actual programmatic requirement is a waiting space for timed entrances to the Collection Gallery, a place to gather before entering the special exhibition gallery, an occasional performance court, and an event space.

The light box cantilevers out sixty feet to cover a large planted terrace.

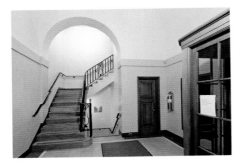

The Light Court is a living room on a grand scale—the larger part of this room is indoors, but it extends outdoors as a terrace under cover of the cantilevered glass light box. As an interior garden, it also serves to bring indirect natural light to the north-facing windows of the Collection Gallery and to the offices. The Light Court and terrace are simultaneously powerful and quietly magical. Inside and out, it is the "atmosphere" of the new Barnes.

The court is filled with natural light, and, through the great glass wall at the end, one can see the terrace and, beyond it, a glimpse of the gardens of the Rodin Museum. The exact origin of the light in this space is not obvious. With the lighting designers Paul Marantz and Zack Zanolli, we shaped both the natural and artificial light. The interior of the light box is defined by giant, folded, plastered planes that intersect and form two identical but separate volumes—one oriented to the south that sits over the interior space and the other to the north that covers the exterior space. At their apex they are fifty feet high. The exterior of the light box is clad in acid-etched glass. The etching produces a diffused light that enters the two separate vaulted chambers. Each chamber opens to the space below, through tilted planes. The interior of these chambers is covered in a sound-absorbent material. One never sees the sky but clearly perceives the shifting light of day.

The floor of the Light Court is surfaced in wood reclaimed from the Coney Island boardwalk. It is laid in a herringbone pattern and set in a gray limestone border. Several years ago, while traveling in Chile, we walked into a church that was built at the turn of the seventeenth century. The ancient and beautifully worn floor had a herringbone pattern made from very long boards. The warmth and scale of this floor made it very powerful. The wood of the Light Court floor also provides physical relief from the

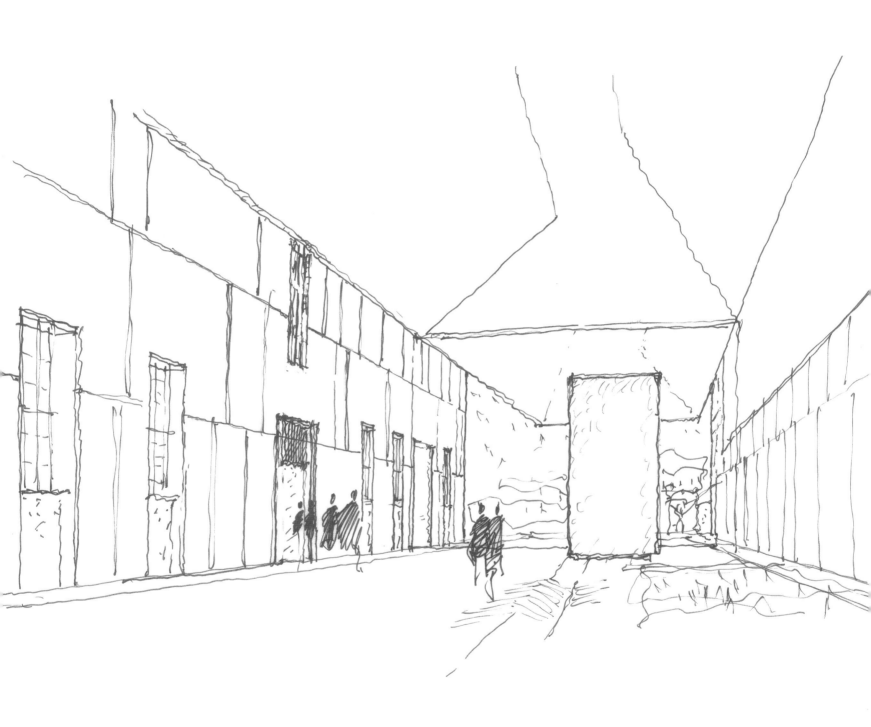

The Light Court is the living room of the Barnes Foundation. During the day, it is used for gathering, repose, and conversation. In the evening, the space can be reconfigured to accommodate a variety of events.

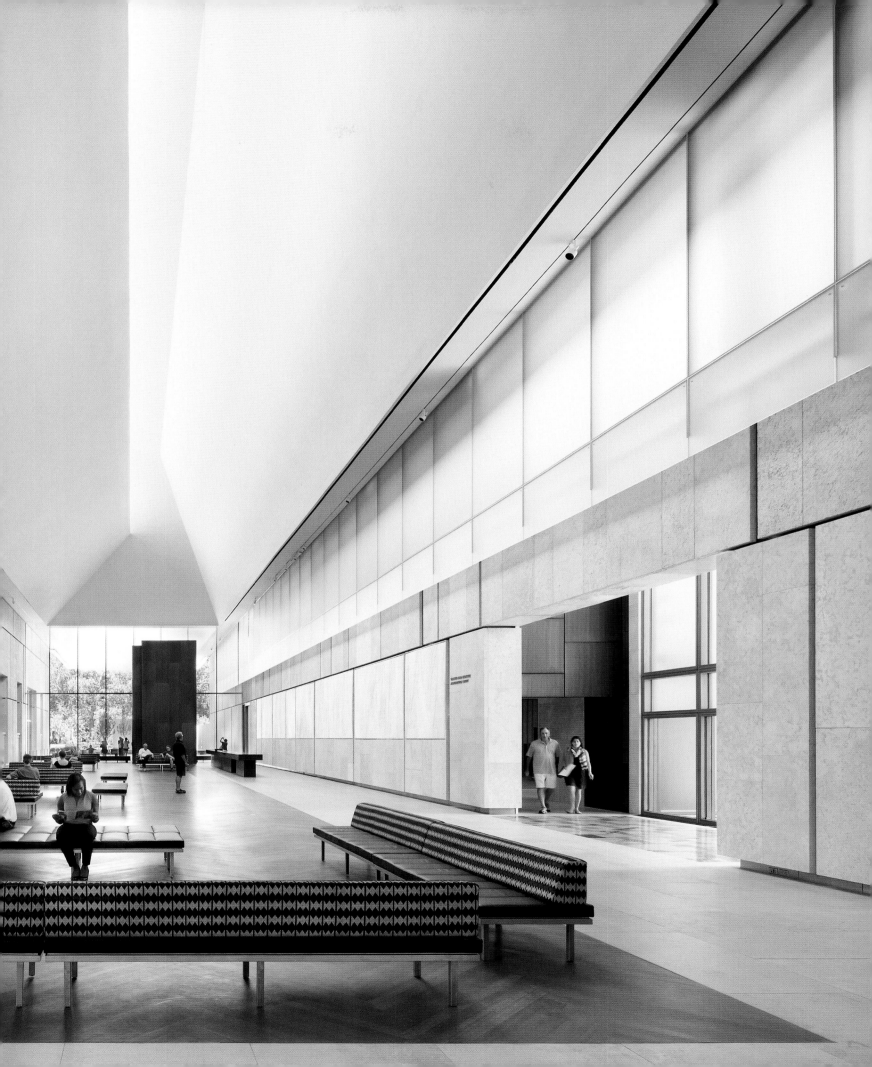

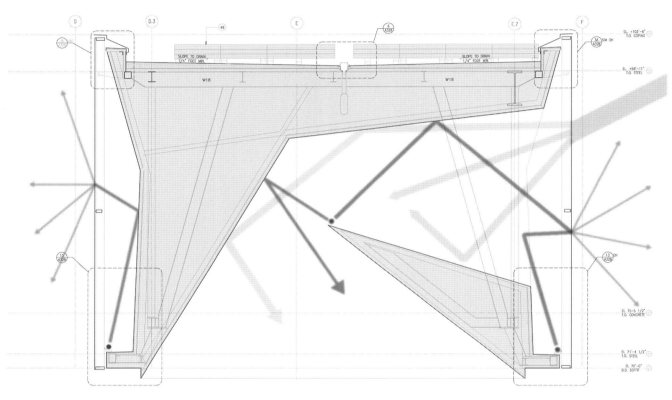

EL. +102'-6"
T.O. COPING

3A SIM OH
A.328

SLOPE TO DRAIN
1/4" FOOT MIN.

SLOPE TO DRAIN
1/4" FOOT MIN.

EL. +98'-11"
T.O. STEEL

W18 W18

1.2 OH
A.328

EL 75'-5 1/2"
T.O. CONCRETE

EL 71'-4 1/2"
T.O. STEEL

EL 70'-0"
B.O. SOFFIT

4 WALL SECTION
 3/8" = 1'-0"

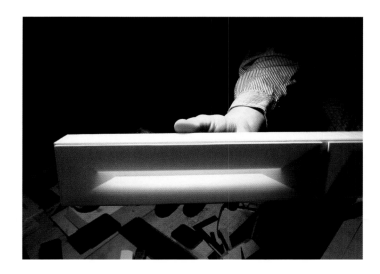

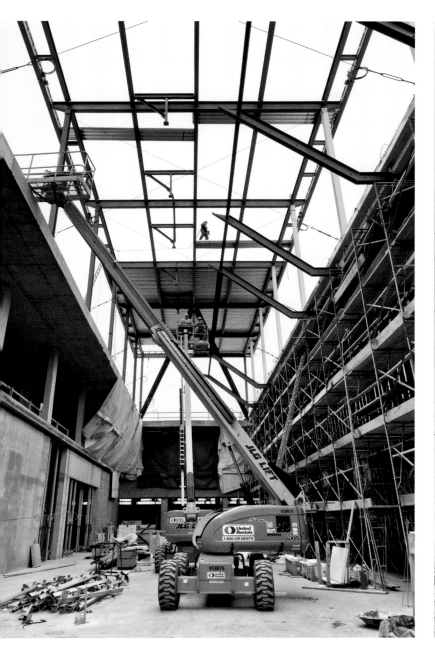

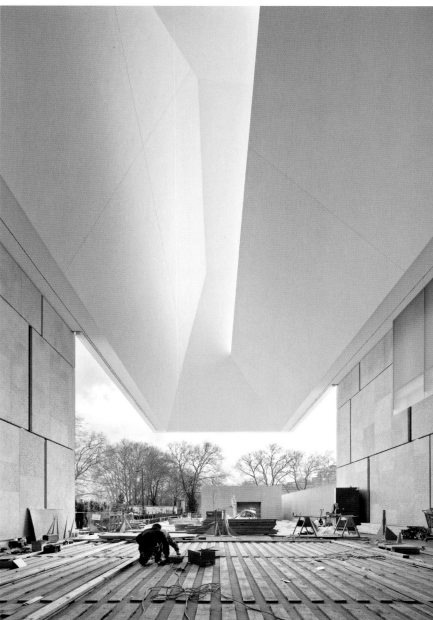

Opposite, top Natural light enters
the large vertical windows of
the light box, reflects off the interior
planes, and illuminates the
space below.

Opposite, bottom A model of the
light box

Above, left Construction
of the Light Court and light box,
December 2011

Above, right The inner ceilings
of the light box are shaped
by sound-absorbing wool acoustic
boards covered in plaster.

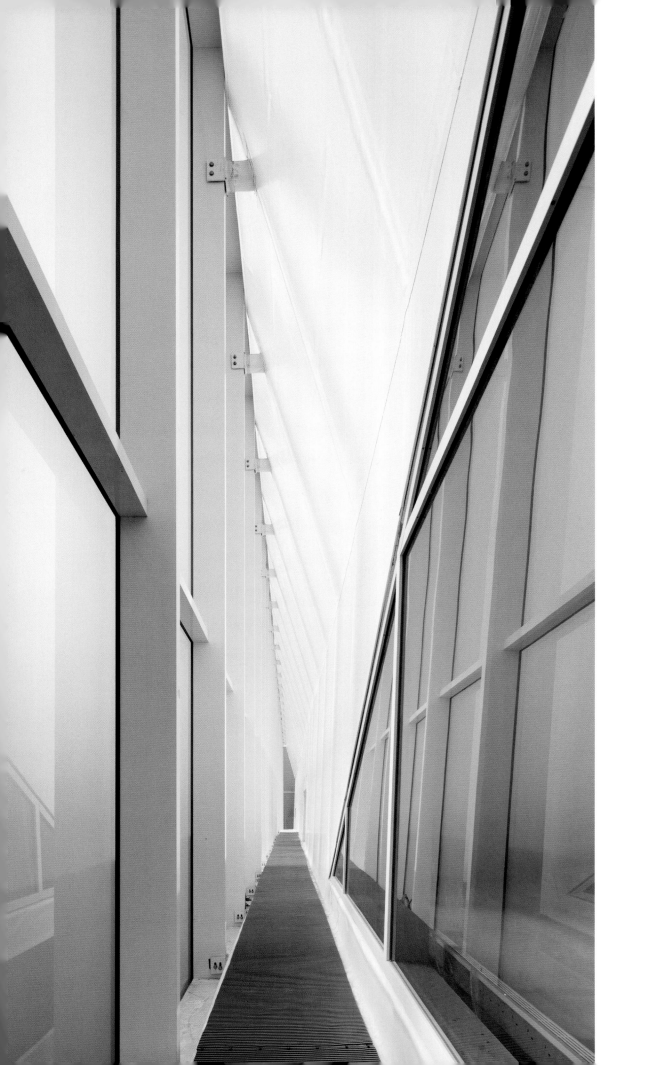

Opposite A view inside the light box reveals a narrow walkway that provides access to the roof and vertical window.

Above The light box is constructed of nearly 17-foot-tall sheets of low-iron glass.

Following spread In the evening, a continuous strip of florescent lights provides a soft glow to the entire 300-foot-long light box.

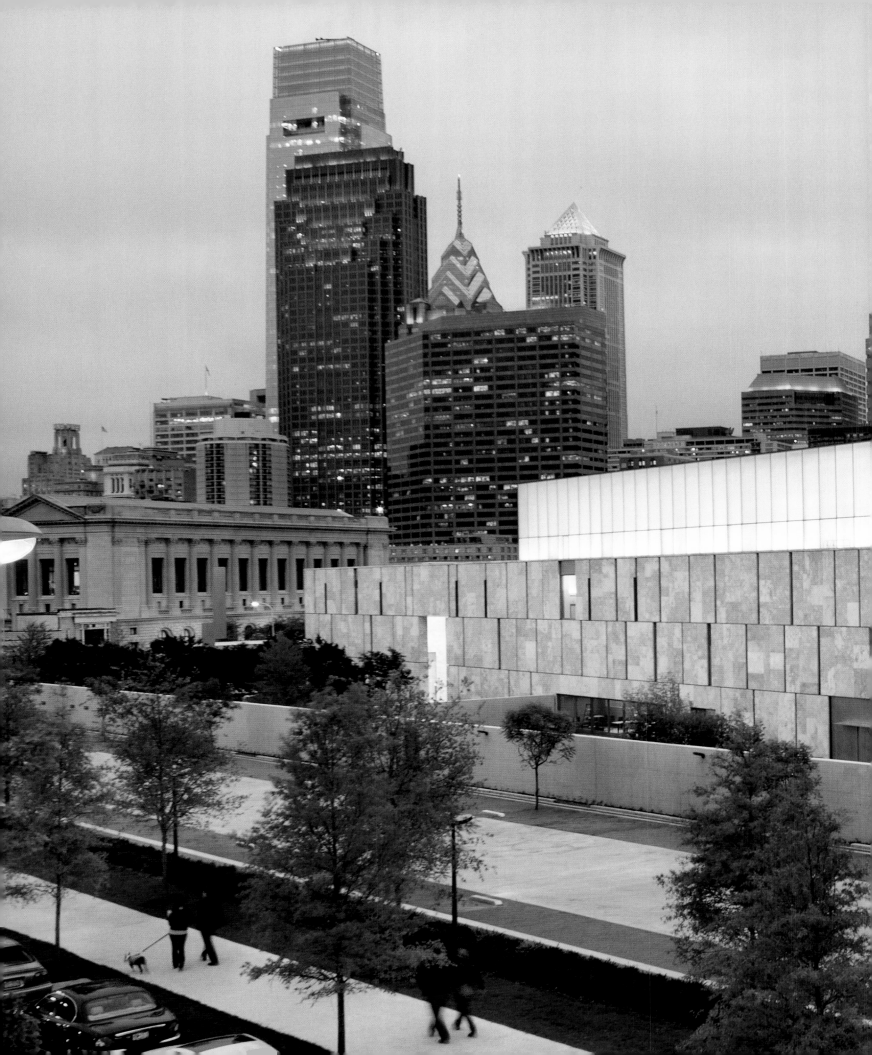

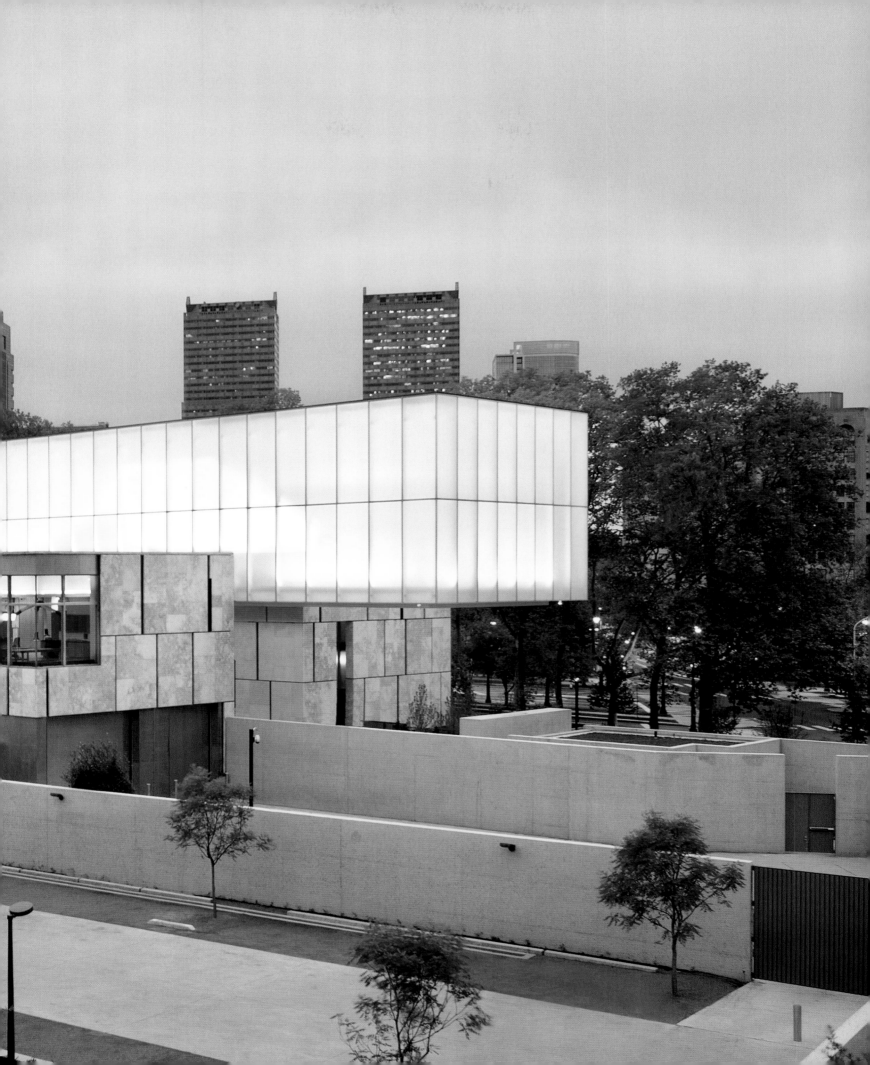

Opposite The 5,300-square-foot
West Terrace is the exterior extension
of the Light Court. A fireplace is
recessed into a concrete wall at the
far end of the terrace.

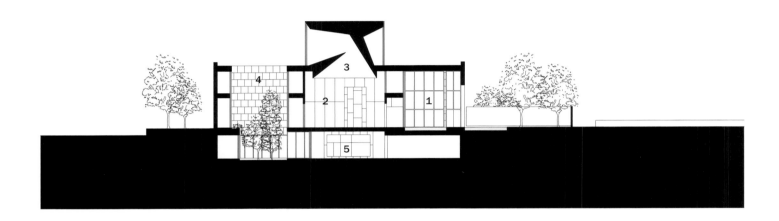

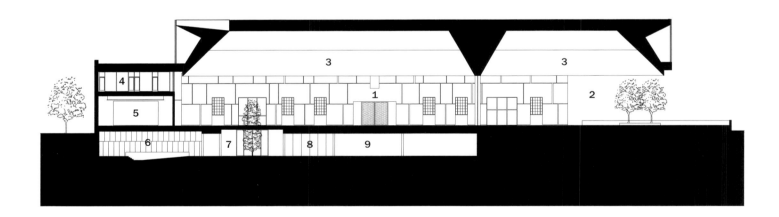

North-South Section (Top)

1 ENTRY

2 LIGHT COURT

3 LIGHT BOX

4 GALLERY GARDEN

5 LOWER LOBBY

East-West Section (Above)

1 LIGHT COURT

2 WEST TERRACE

3 LIGHT BOX

4 ADMINISTRATION

5 SPECIAL EXHIBITION GALLERY

6 AUDITORIUM

7 LOWER LOBBY

8 SEMINAR ROOMS

9 SUPPORT

0 10 35

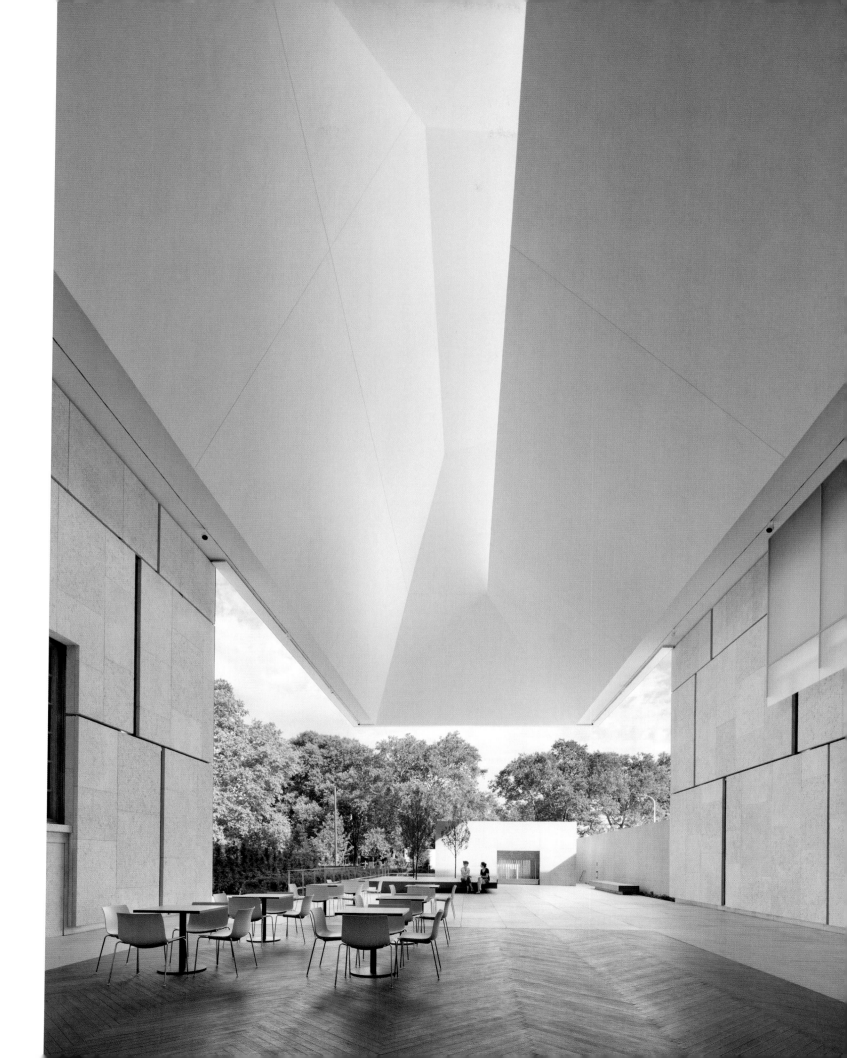

Opposite The main area of the Light Court floor is a lively tapestry of reclaimed ipe from the structural members below the Coney Island boardwalk.

Below, top Bird's-eye view of the Coney Island boardwalk in 1948

Bottom The worn herringbone-patterned floor at the Iglesia de San Francisco in Santiago, Chile

stone border. Once the wood was laid, many people were surprised by the great variation in the color of the boards. This was our intention, prompted by a belief that it would create a tapestry that was livelier than if the color had been uniform. There was also a relationship to the variation of color in the stone outside.

There are additional details that give the Light Court a human scale even though its primary experience is one of monumentality. The first of these is the mosaic at the entrance. Made from the same limestone that borders the wood, but in a honed finish, it is based on a Liar's Cloth pattern from western Africa. This mosaic pays homage to an aspect of Barnes's collection and the integration of African motifs in the tile work at the entrance to Merion. Another detail is a long, low slab of carved black granite that runs parallel to the length of the space along its north side. This is a fountain. The surface is cut in angular planes to relate to the folds of the ceiling and to contain water. At the far end of the slab is a flat surface for what we imagine could hold a huge arrangement of flowers. While we could not introduce water into the Collection Gallery, as we first imagined, we brought it to the place where people rest. We also designed low sofas of stainless steel and leather with bolsters upholstered in black cotton and raffia fabric hand-woven in Senegal.

Three walls of the Light Court are Ramon gold, which is a warmer version of the exterior stone. The stone has a more golden color, with areas that are rosy in hue. This type of Jerusalem stone is less resistant to harsh weather, so we have used it indoors or in areas that are more protected from the elements. The finish used here is the hand-chiseled marking. Opposite the Collection Gallery and above the stone, we have used acoustic panels to temper the sound. They are covered in wool felt, once again created

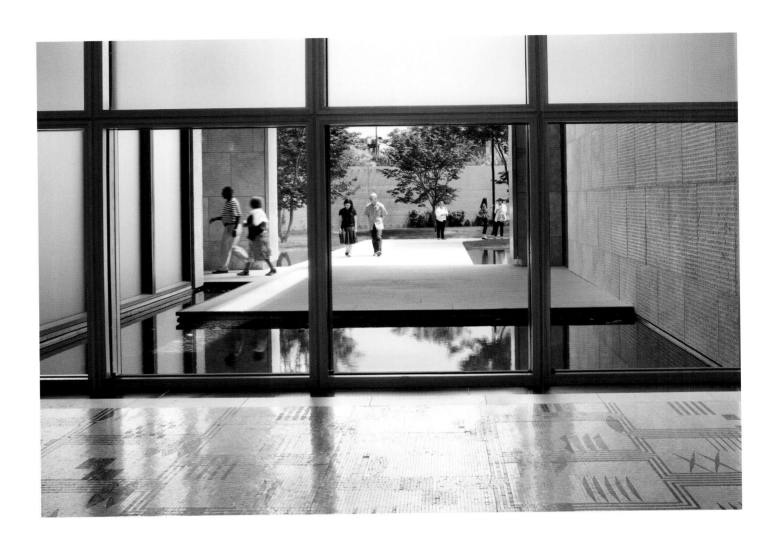

Opposite, top The floor mosaic greets visitors at the threshold to the Light Court.

Opposite, bottom The mosaic is based on Tsien's April 2010 drawing that is derived from the Liar's Cloth pattern of African Kente textiles.

Below The stone tile mosaic was fabricated by Long Island artisan Nelson Londono of Artsaics.

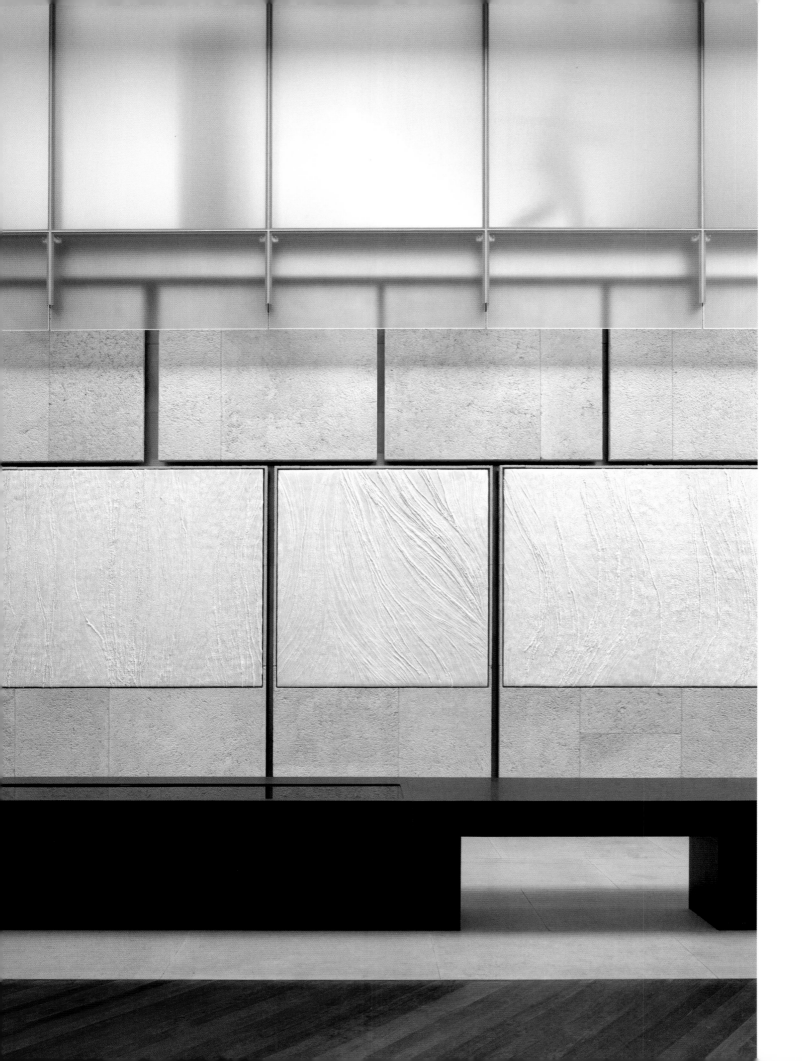

by the artist Claudy Jongstra. This fabric is combined with silk and is subtly dyed to match and complement the colors in the stone. The felt panels help to absorb sound, and the shimmer of the handspun raw silk cords helps to draw light down into the space. A long wall of acid-etched glass carries the light from the court to the office spaces on the second floor of the Pavilion. From the Light Court, one might sense the occasional movement of figures passing by behind the glass.

The wall of the Collection Gallery building is separated from the L-shaped Pavilion building by a narrow thirty-foot-high glass window set between the two, in the southeast corner of the court. We did this to emphasize the Collection Gallery's distinct identity. The more traditional appearance of the mullioned windows and their symmetrical placement reinforce it as a separate building even as it forms the southern enclosure of the Light Court. The two floor-to-ceiling windows with contemporary mullion-free detailing indicate the new insertions—the Gallery Garden and the classroom. We wanted to balance the distinct identity of the insertions without disrupting the wholeness of the Light Court.

Two large decorative metal doors backed by glass separate the Light Court from the Collection Gallery. The doors are made from bronze rods that have circles and rectangles welded to them in an irregular pattern. This pattern is inspired by the simple decorative bronze poles that are displayed as a sign of wealth on the exterior of buildings in West Africa. When the Collection Gallery is closed, the doors help to retain the strict climatic conditions of the Gallery, and the Light Court requirements can be relaxed. Visitors to public functions in the Light Court are still able to look through the screen. When open, these doors lie flat against the wall in a recess that is clad in the same stone that borders the wood floor, but

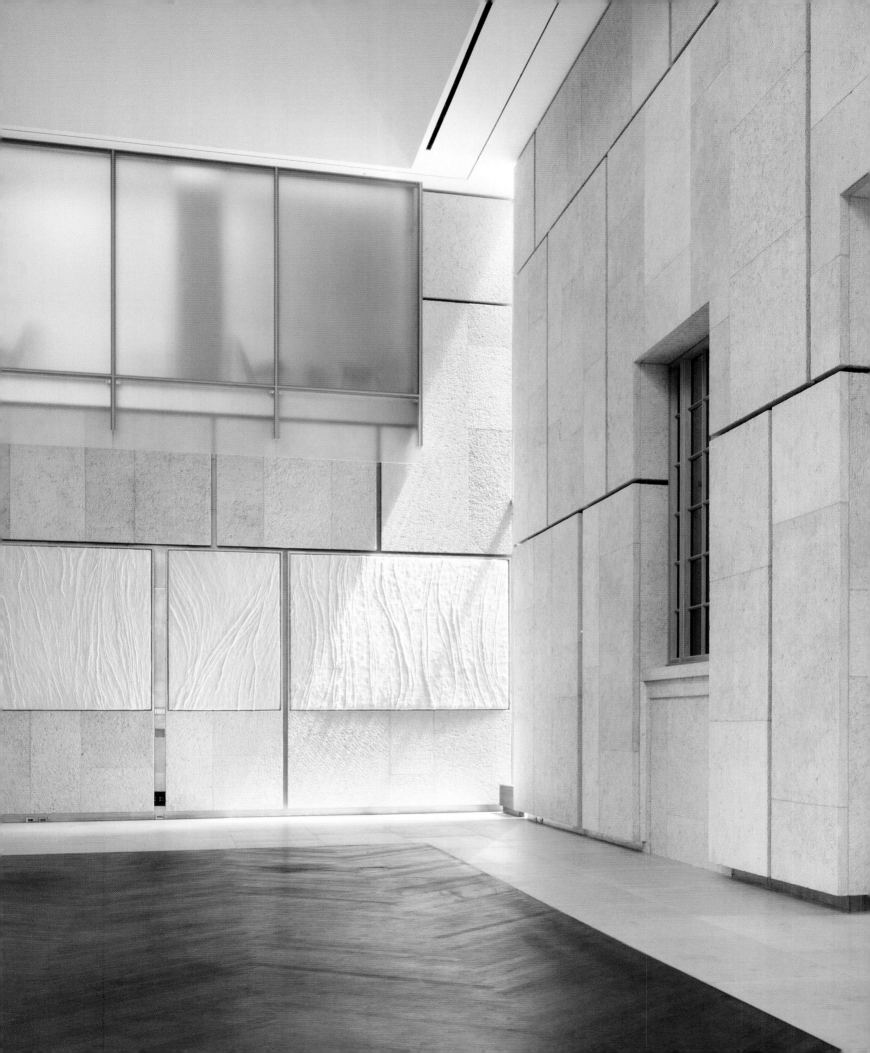

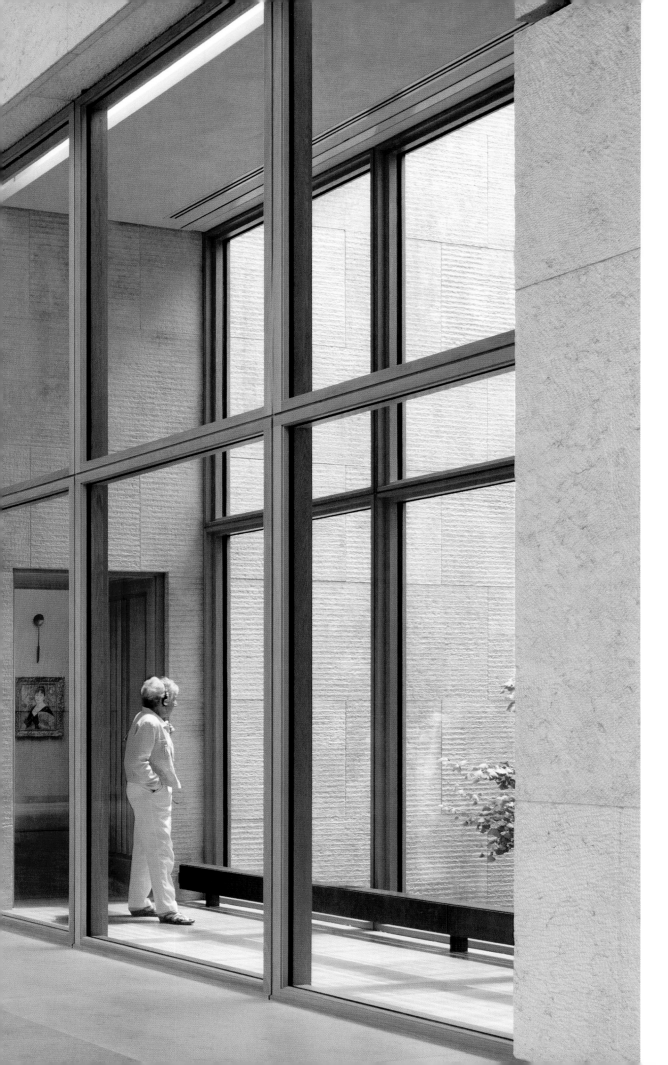

The Collection Gallery (right) and the Pavilion are separated to emphasize the distinct identities of the structures. Light—from a 30-foot-tall narrow window at the juncture—enters the court.

Below Williams's sketch from August 2011 for the Collection Gallery doors

Opposite, top left The bronze-and-glass doors are inspired by African metalwork.

Opposite, top right The interwoven geometric motifs of hammered bronze complement the hand-chiseled stone.

Opposite, bottom The Light Court sofas, designed by Williams and Tsien, were produced in collaboration with Knoll.

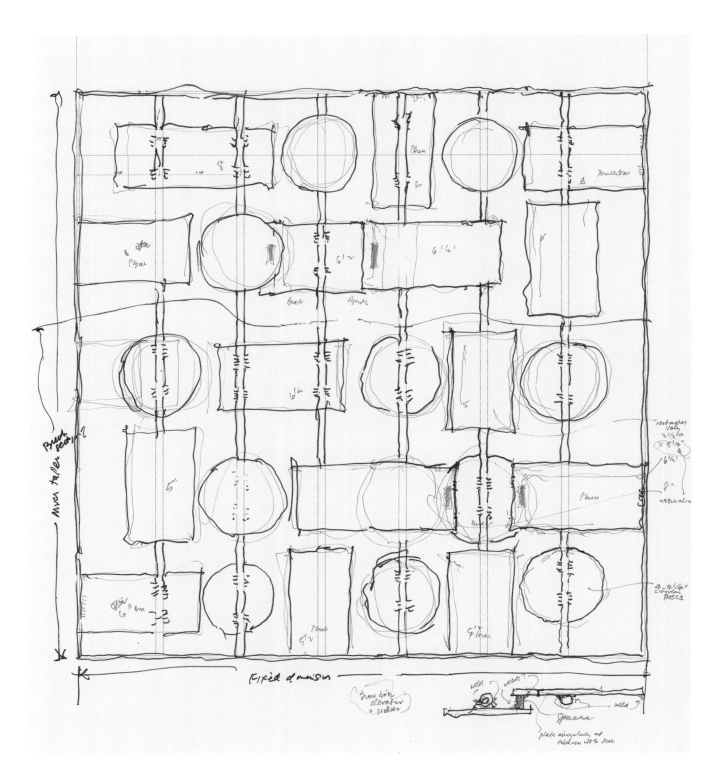

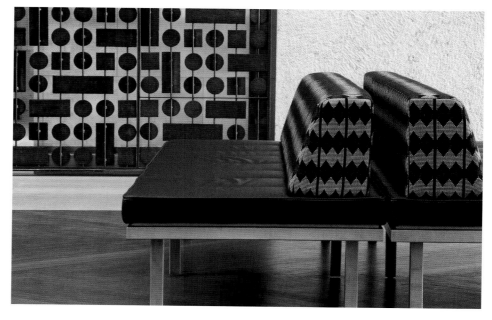

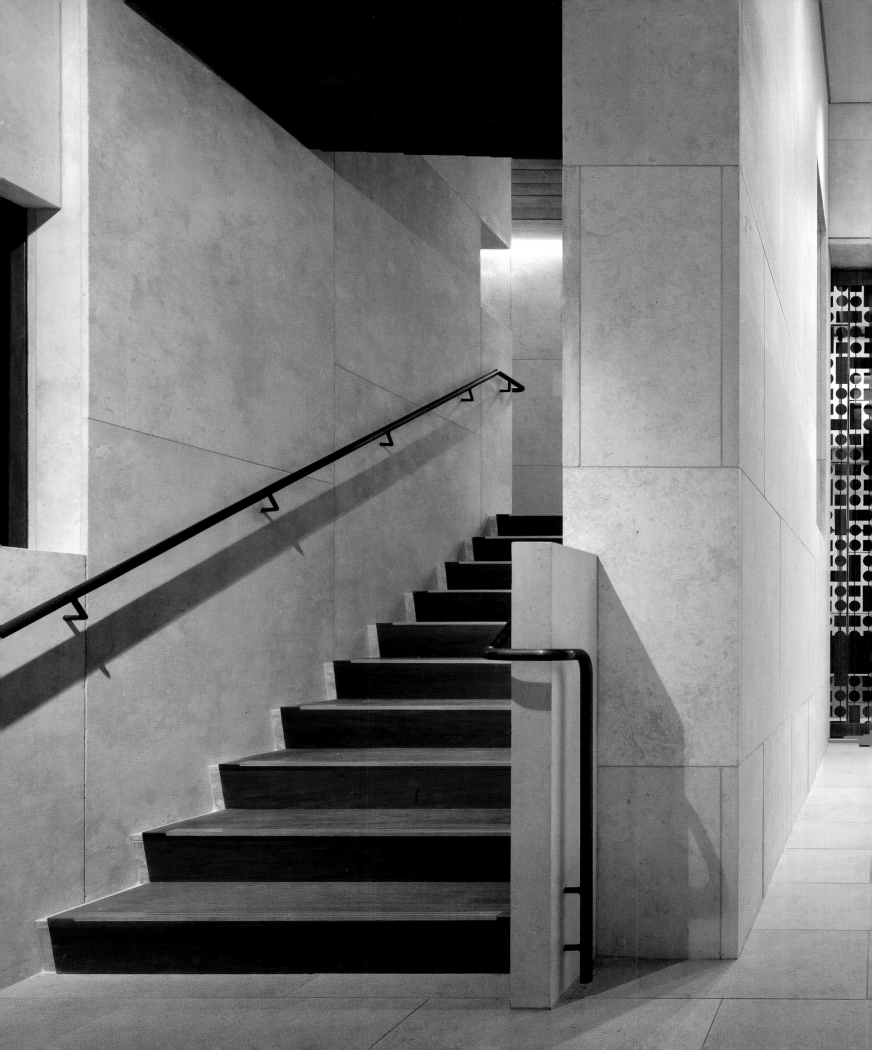

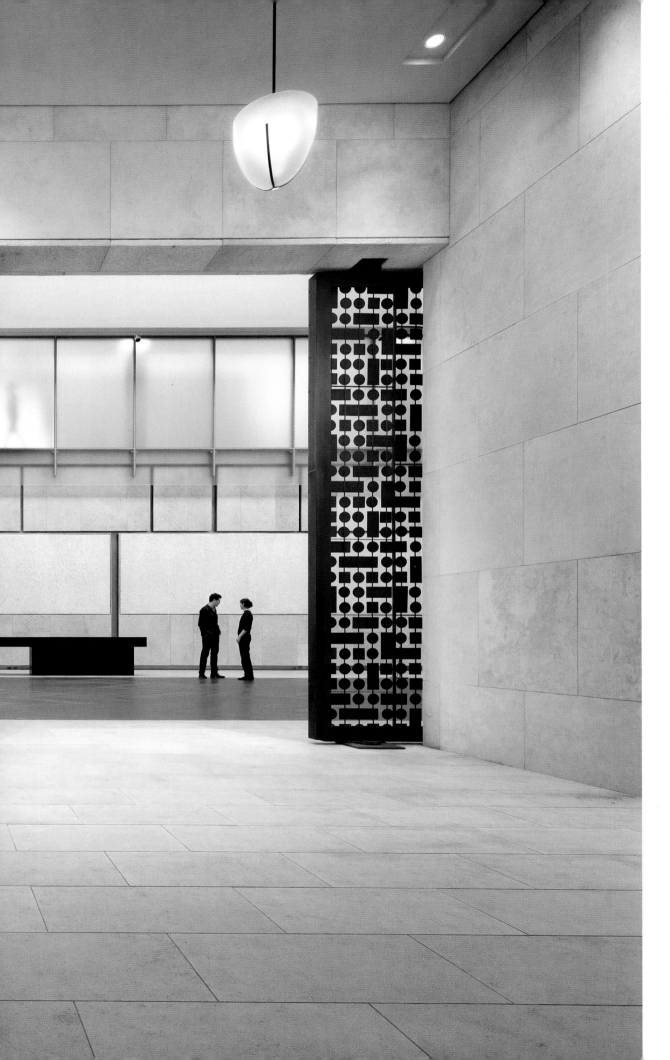

The 2,000-pound pivoting doors
open to welcome visitors and are
closed to isolate the Collection
Gallery's climate from the rest of
the building at night.

A large bronze-clad vestibule leads
visitors from the Light Court to the
West Terrace.

with a sand-blasted finish—making the stone extremely quiet in
appearance. These doors frame the entry and announce the beginning
of the experience of the Gallery.

The fourth wall of the Light Court is glass and separates the interior
from the exterior. In order for the glass to have as little structural
interruption as possible, the top half of the glass is hung from a very large
concealed beam. A tall vertical box, clad in bronze panels, sits in front
of the glass. This box camouflages and abstracts the vestibule required to
temper the air from outside. It also helps to buttress and stiffen the glass
wall. Beyond the glass and accessible through the vestibule is the outdoor
extension of the Light Court, referred to as the West Terrace. The herring-
bone-patterned wood floor extends outside to create a feeling of seamless-
ness between indoors and out. The stone walls of the Pavilion and the
Gallery, coupled with the concrete walls shielding service elements and
loading docks, frame views of the Rodin Museum's garden next door
and create a terrace that is protected from the sun and rain.

An abstraction of a hearth ends the long axis of the Light Court. The
recessed fireplace is lined in gold-leafed tile to reflect the flicker of flames
running in a straight line from a raised steel platform. More a source of
light than warmth, this detail is the most direct reference to domesticity.
The dynamic interaction between the sense of a house and the sense
of an institution has influenced all facets of the design for the Barnes
Foundation, Philadelphia.

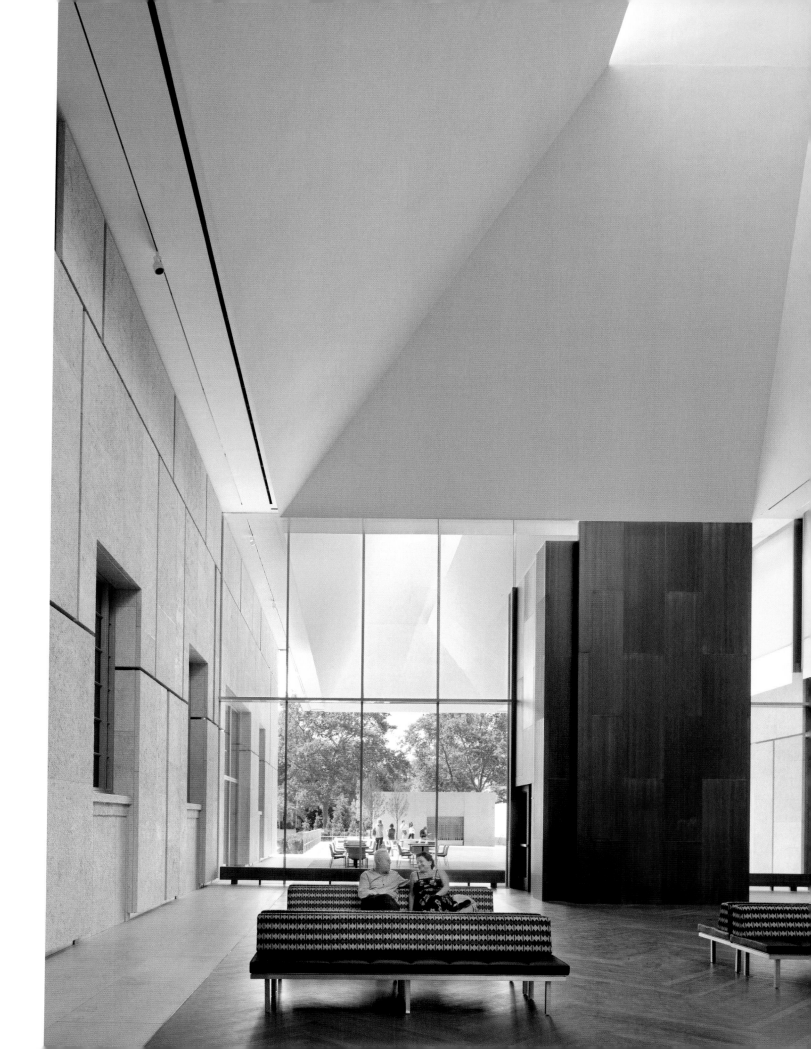

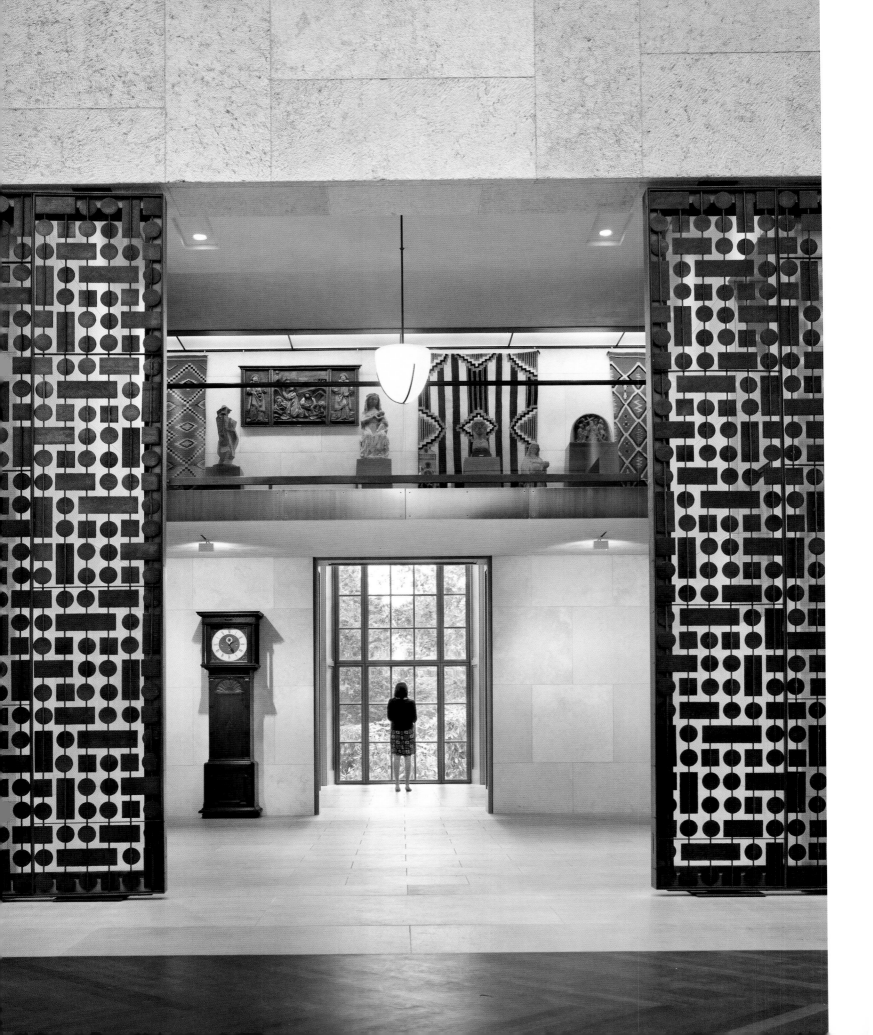

Simplify, Intensify

The directive from the Foundation that the ensembles remain intact and the rooms remain in sequence helped to resolve what could and could not be done. We knew this would be the beginning of a very difficult and exciting creative search. All great architecture is created through the struggle with constraint. Even as the strictures give backbone to the creative search, they can never lift it to the level of art. It is questioning and persistence that add the necessary muscle and strength. Still, with all this in place, the art of architecture remains elusive. Grace and vision must also be present.

In the Barnes assignment, perhaps more than any other, the struggle for truth was everywhere and in everyone's minds. There were those who decried the move from Merion. Some would never be convinced. There were the believers in profound change, people who believed Barnes was over-controlling and that the paintings should be returned to "the people." And, there were the legal requirements. There was our own early skepticism, primarily about the collection. We had not been taught the Barnes method. We attended lectures, read, talked, and looked; and over time we have come to have profound appreciation for Barnes's unique and, from a twenty-first-century perspective, almost mad way of hanging. His method was driven by intellect, passion, and intuition (which itself must have been born of insecurity as well as desire). We have no way of knowing whether he would have forged ahead, altered his method, or perhaps turned 180 degrees around. What is clear is that he continued to change and add works on a regular basis. It is certain that had he lived longer, other arrangements would have been tested.

The first thing we did was look at the size of the rooms in terms of the plan. The twelve end rooms (three at each end of the building on two floors) are very small and densely hung. Space was so tight that classes

Opposite Passing through the entry to the Collection Gallery, the visitor is greeted by exterior views framed by the central window of the Main Room.

Following spread The Main Room of the Collection Gallery in Philadelphia

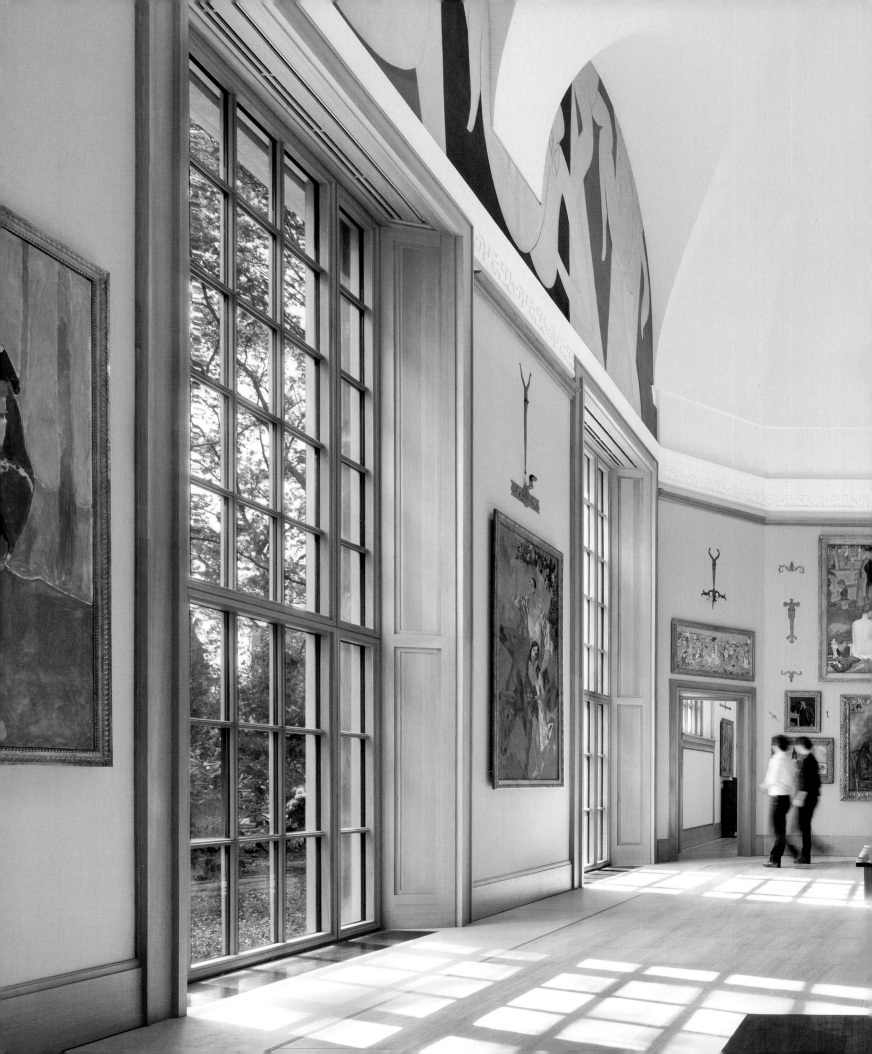

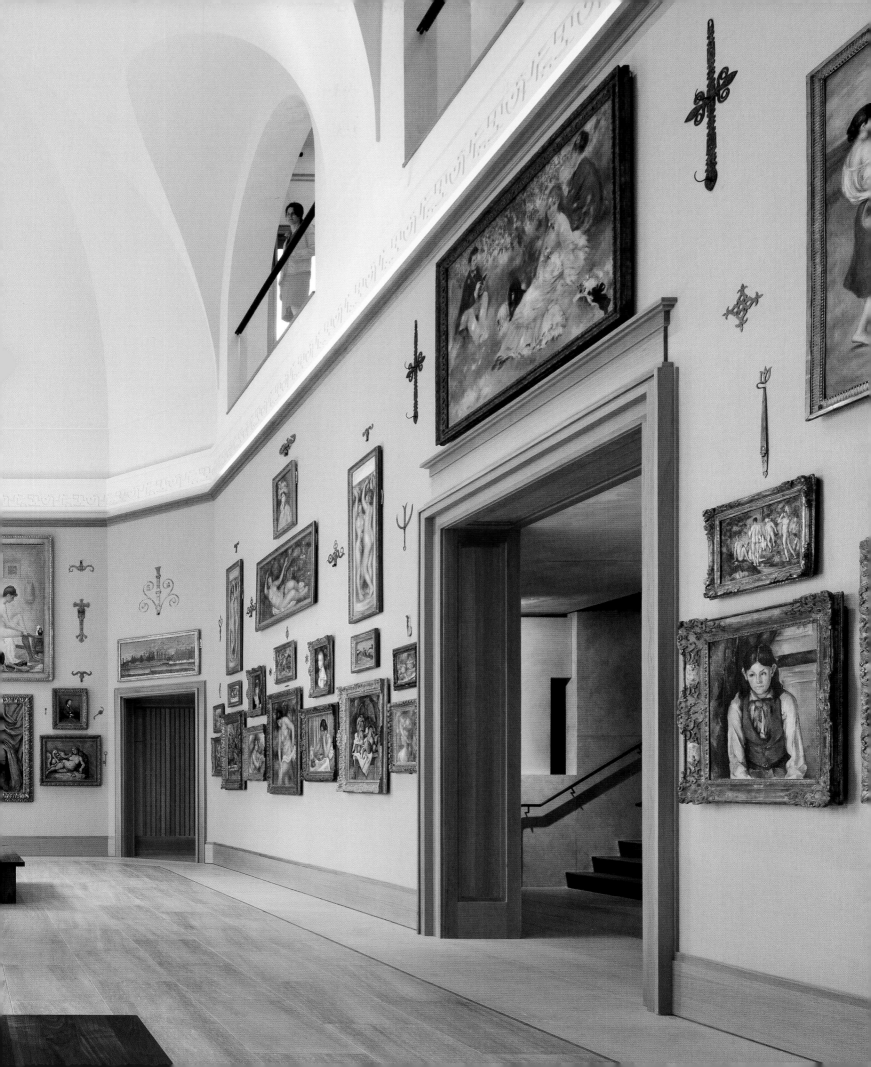

A nearly hidden storage space located between the first and second floors of the Cret Gallery is adapted as a small mezzanine. This space now holds objects moved from the cluttered Balcony.

could not be held in many of the rooms. During Barnes's time an assistant would remove works from the walls and bring them individually into the Main Gallery. In time, taped lines on the floor were added to protect the works. These, along with insufficient light, distanced students and visitors from the works, so we hoped we might be able to resolve the problems. We considered subtly increasing every dimension just a small (imperceptible) amount. With the computer this was not a difficult task and we examined inflating the rooms, and thus the building, by 1 percent, 5 percent, and 20 percent. Even though thicker walls and greater room sizes might be welcome in terms of mechanical systems and crowd flow, it simply was not appropriate for the ensembles. The very carefully considered and tight spacing of the ensembles was a hallmark of Barnes's thinking. Sometimes paintings were actually pushed into the corners of the rooms. Obviously, paintings, hardware, and artifacts would never change size. Thus, if we altered the wall space, it would be similar to inflating the size of our faces, even though our eyes, nose, and mouth stay the same. Enlarging the rooms produced the same result; the tension and connection between the paintings and objects were lost, and the total effect was flaccid. We had to keep the room and wall dimensions exactly the same. And since the main double-height room had a very specific height dimension determined by the Matisse mural *The Dance*, the frieze, and the paintings below, we understood that we would need to keep the floor-to-floor height the same as well. Along with some temporary frustration, this realization also provided a sense of relief, for it meant that we could set the size problem aside and move on to other issues.

The cramped entry sequence in Merion, with its steps and tight spaces, created a major problem with the public's experience. The second level

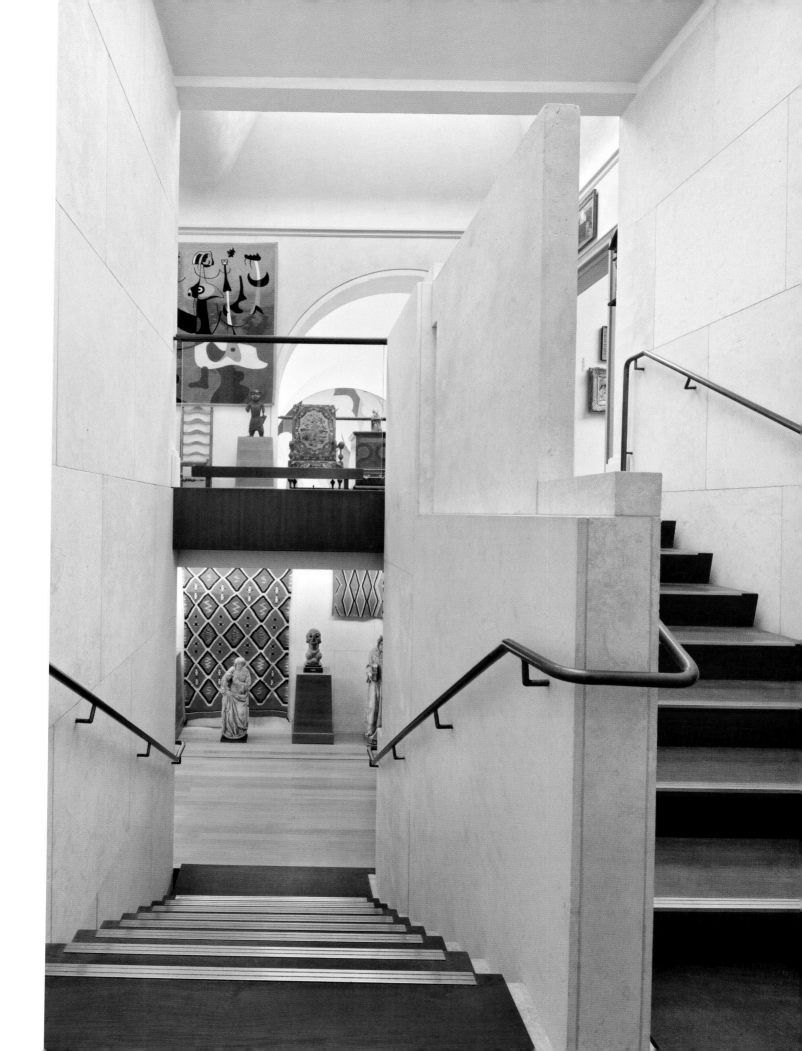

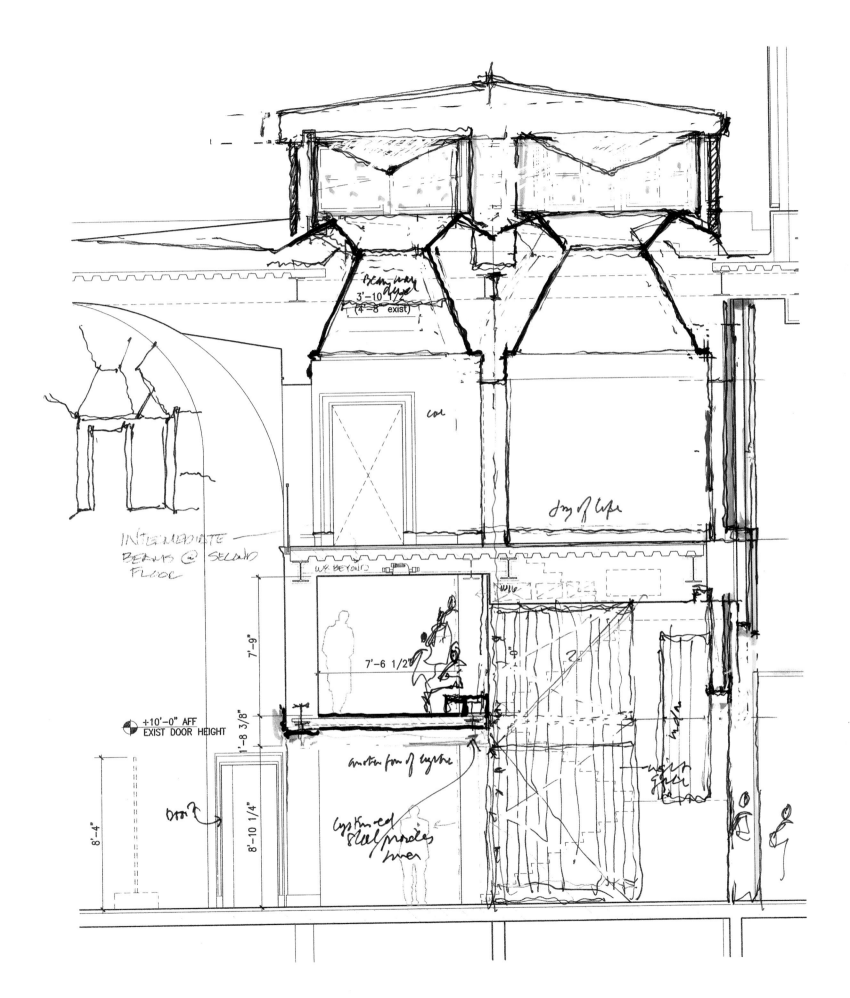

INTERMEDIATE
BEAMS @ SECOND
FLOOR

Beam way
3'-10 1/2"
(4'-8 exist)

col

Joy of life

WP BEYOND

7'-9"

7'-6 1/2"

+10'-0" AFF
EXIST DOOR HEIGHT

1'-8 3/8"

8'-4"

8'-10 1/4"

Door?

another form of cypress

cypress and
steel panels
over

wood
panel

was occasionally completely overlooked. Although a small elevator had been added during a renovation, some visitors would either not notice or simply not have the energy to visit the galleries above. Since we had determined that we would keep the same sizes for the rooms, our design for the new entry needed to be resolved in the very small footprint of the original building. We found some additional space at the entry since there were no longer requirements for a guard, a ticketing area, and the stairway to the basement. We also discovered that there were both the volume of the former director's office directly above and a small, nearly hidden storage space located between the first and second floors.

The entry sequence was challenging in other ways. The Balcony overlooking the Main Gallery was almost dangerously small and dense. Barnes had filled it with objects that seemed to restrict movement. Perhaps the most important question was how to reposition Matisse's seminal *Le Bonheur de vivre*, the tapestries, and a small maquette of *The Dance* that had been hung above the landing of the staircase. The twenty-foot floor-to-floor height of the Merion Gallery has always been arduous to ascend. We joked that Dr. Barnes had placed *Le Bonheur de vivre* on the landing to make the long ascent more enjoyable. But these works in the stairway had always been difficult to view, and they were not accessible to anyone in a wheelchair. Sketches show something of our design's development around the entry as, working with the curatorial staff, we relocated the Matisse and the tapestries to a new small room directly opposite *The Dance*. This room had originally been the private office of the director. Enlarging and opening the Balcony above the Main Room also required reconsideration and a careful relocating of many of the objects and tapestries on the second floor. Placing *Le Bonheur de vivre* in its own appropriate

space on the Balcony opposite *The Dance* required us to find room for the objects that had lined the north wall of the passage overlooking the Main Gallery. These objects are now located on a newly visible mezzanine, seen from the entry and the Light Court below, and that now can be accessed from both a comfortable wooden stairway and a generous elevator.

Believing that we should illuminate *The Dance* naturally, we began to question the illumination of all second-level rooms. Only two of these rooms in Merion had been top-lit by natural light. Why shouldn't every gallery space receive some natural light? At London's National Gallery we visited the Sainsbury Wing by Robert Venturi and Denise Scott Brown. Our lighting consultant Paul Marantz had worked on the lighting there and described the difference between lighting a room that holds paintings versus lighting the paintings specifically. We observed the light at the Dulwich Picture Gallery where all galleries are illuminated with clerestories, and we studied the light at the Sainsbury Wing. The illumination was magical, and we returned convinced.

Our own realization of the importance of lighting the rooms at the Barnes as opposed to the paintings came rather late in our design process so we needed to take this issue (which would involve additional cost) to the Barnes board, which fortunately recognized that a creative search does not always deliver answers in perfect order. With so many objects in any one room, lighting the whole space would make the rooms feel larger and vastly improve viewing the ensembles. Every room on the second floor is now top-lit with clerestory light. The new clerestories are positioned in a soft recess that sits above the height of the original ceilings. Louvers are adjusted individually and then fixed in place to permit each room's light to be fine-tuned to the requirements of the art. Acid-etched glass

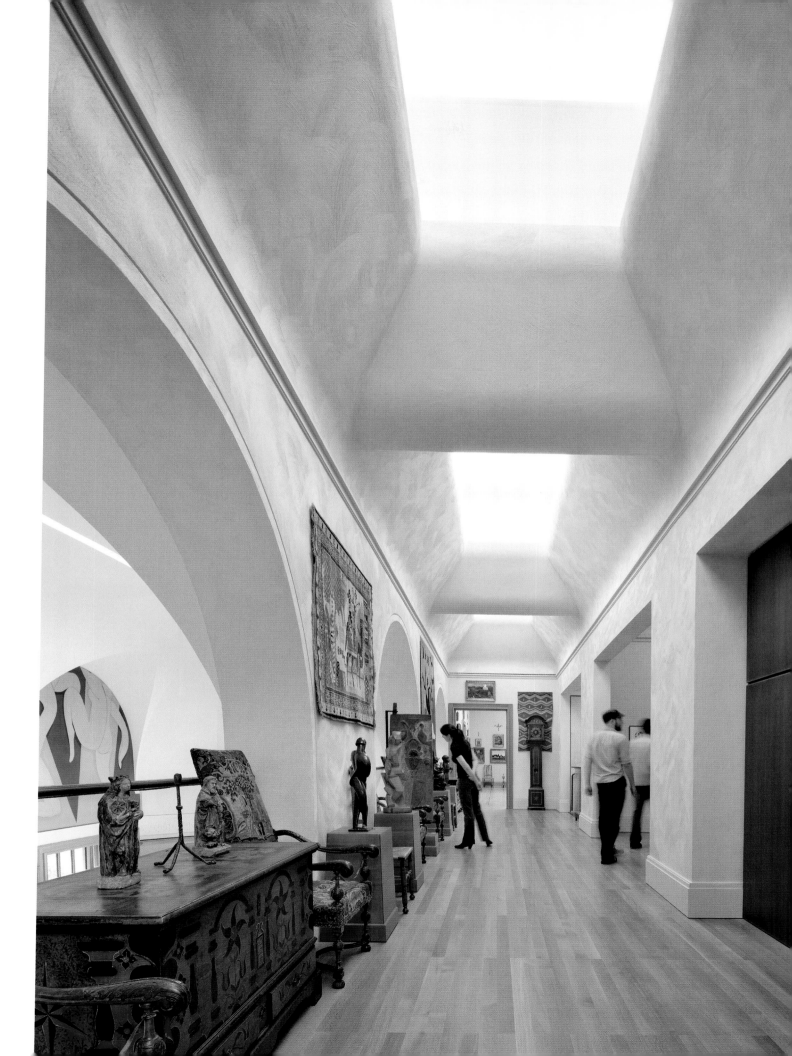

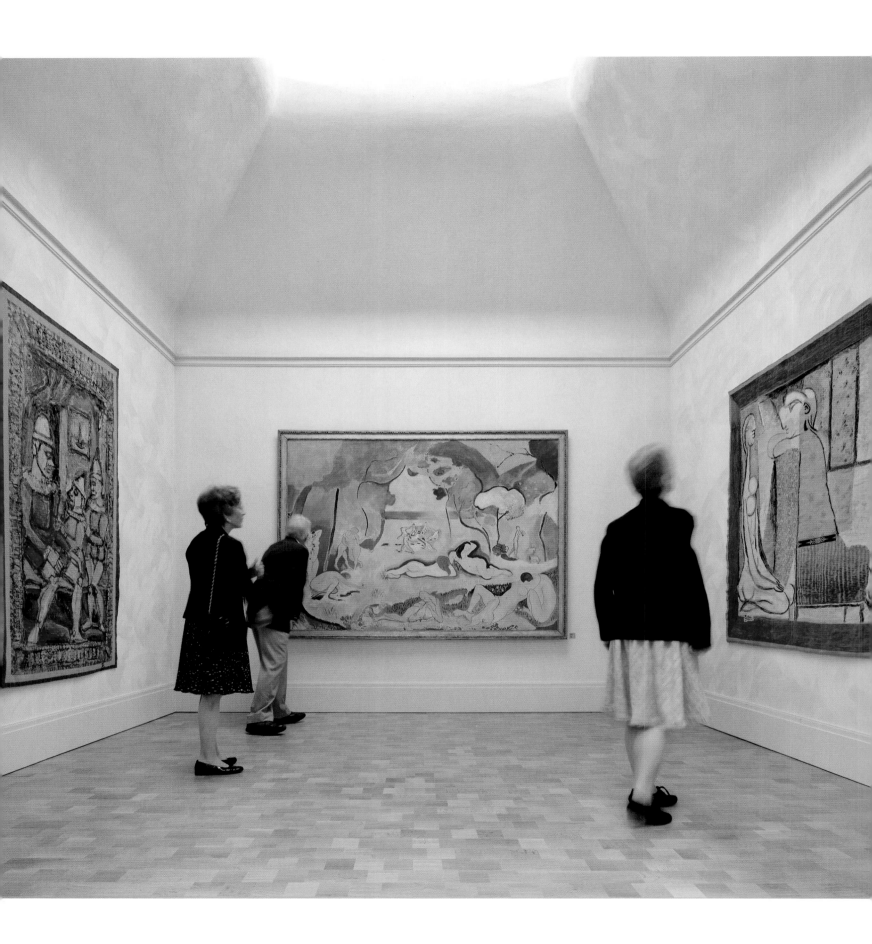

Opposite Matisse's seminal painting *Le Bonheur de vivre* is now in an intimate room off the Balcony on the second floor.

Right Williams's perspective of *Le Bonheur de vivre* room, July 2009

Below Williams's reflected ceiling plan from July 2009 shows second-level spaces with clerestories.

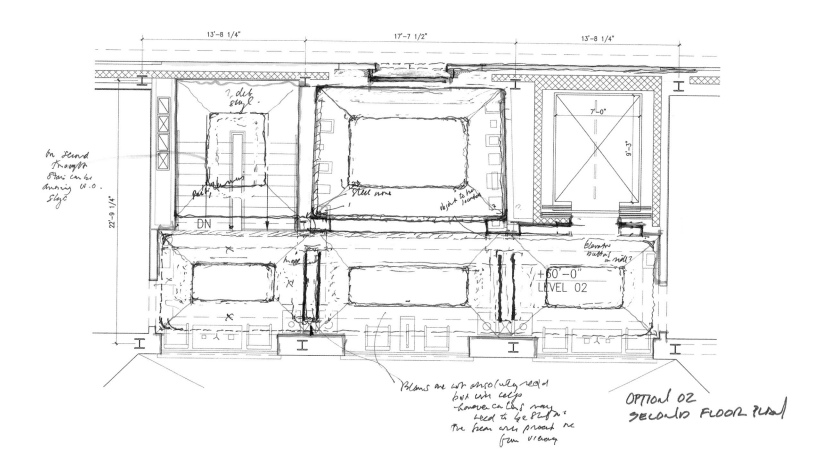

OPTION 02
SECOND FLOOR PLAN

in front of the clerestory glass creates a blurred effect that hides all details such as fasteners or mullions so as not to draw the visitor's gaze above the ensembles. Blackout shades are lowered automatically when the Gallery is closed.

The visual connection from the rooms in the Collection Gallery to the gardens outside was of utmost importance. New glass technology, which uses tinted and reflected glass layers, allows in only 14 percent of the natural light, making it possible to eliminate the heavy white draperies that sheathed the windows in Merion. One can stand at the full-height windows in the Main Room and look out directly into the raised garden. And on the upper floors, the tops of the trees are visible against the sky. Lighting-control systems have been customized for each room, designed to respond to the appropriate light-exposure level established in consultation with the conservation and curatorial staff. When necessary, a combination of exterior solar-veil shades and interior blackout shades can be deployed to further reduce natural light or eliminate daylight when the Collection Gallery is closed to the public. Photo sensors in each Gallery room measure the light levels. A scale replica of the rooms within the Collection Gallery sits on the roof, where similar photo-sensors measure the exterior light levels. In all the rooms, new hanging lamps have been designed. These lamps are placebos to give a sense that the light emanates from them and to reaffirm the domestic scale. The paintings are now seen in natural light enhanced by a sophisticated and almost invisible system of artificial illumination. The connection between light, landscape, and the great paintings in the collection has been reinstated.

Today, on entering the Main Room, one immediately senses the entirety of the room and its powerful relationship to nature. *The Dance*, a

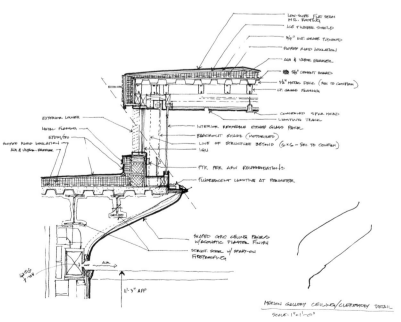

MERION GALLERY CEILING/CLERESTORY DETAIL
SCALE: 1"=1'-0"

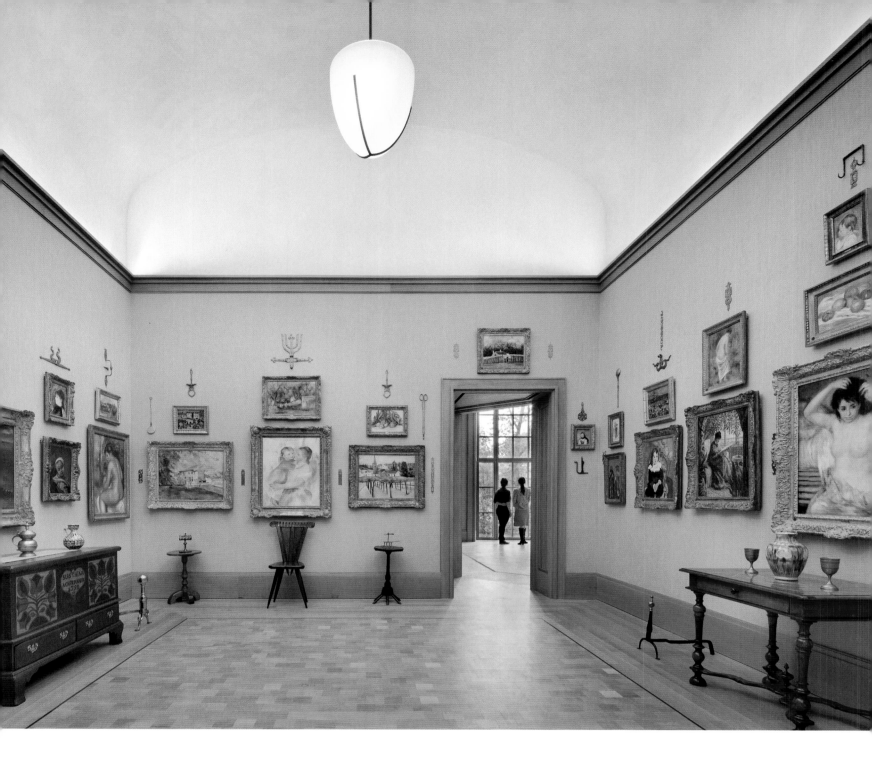

Above First-floor rooms are illuminated by natural light from windows, a finely calibrated lighting system hidden in the cornice, and custom-designed light fixtures.

Right A scale replica of the Gallery sits on the roof, where photo sensors measure the exterior light levels.

Opposite Williams's December 2008 section drawing of a gallery window illustrates both the external solar-veil shades and the internal blackout shades.

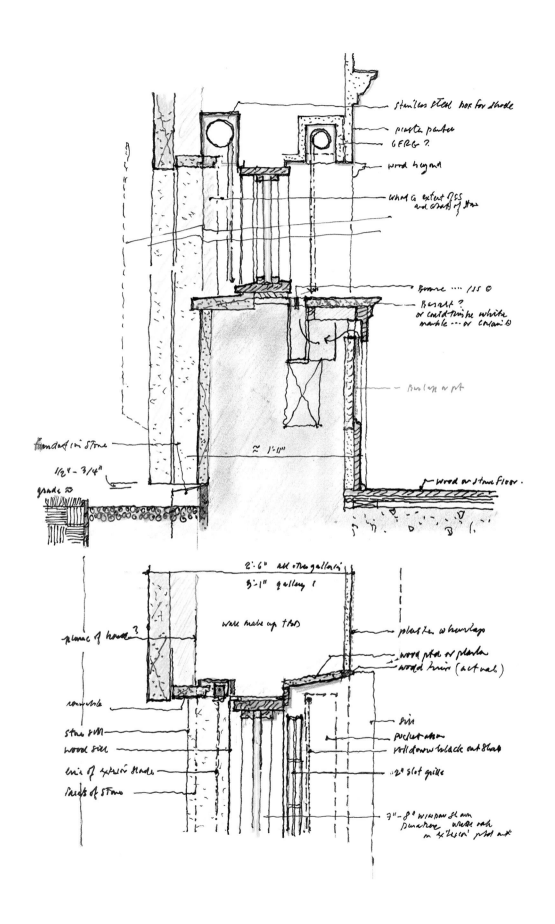

stainless steel box for shade

plaster panel

GFRG ?

wood beyond

what is extent of SS
and coats of floor

ensure SS ⊘

Basalt ?
or could finish be white
marble --- or ceramic ⊘

Burlap or plt

foundation stone

1/2" - 3/4"

grade ≈

≈ 1'-0"

wood or stone floor.

2'-6" all other galleries

3'-1" gallery 1

wall make up TBD

plane of hood ?

removable

plaster w burlap

wood pltr or plaster

wood trim (actual)

stone sill

wood sill

line of exterior shade

back of stone

sill

pocket above

roll down black out shade

2" slot grille

7" - 8" window shade
pinstripe white oak
or oil stained plat oak

commanding presence in the room, is brought to life as never before—with the windows no longer curtained, the room lit with a sophisticated system, and the painting lightly surface-cleaned. Matisse complained to Barnes that, because of the white glass used in the side and upper panels of the windows, he couldn't see the garden. And, although Matisse collected African masks and textiles, he felt that the frieze designed by Cret, which subtly interpreted motifs found in African masks and ran directly below his mural, interfered with seeing the painting. Using an abstract Kuba cloth pattern, we have simplified and reinterpreted the frieze, leaving a simple off-white band that runs below the three panels. However, it is from the second level where the great mural and Matisse's modernity, color sense, and brushstrokes are most vivid. It is from this vantage point that one can finally view two of the twentieth century's greatest works in relationship to each other, *Le Bonheur de vivre* of 1905–06 and *The Dance* of 1932–33.

In order to carefully study all the large and small associated details, we built a full-scale mock-up of a Collection Gallery room on a vacant lot. The mock-up included clerestories, windows, shades, moldings, plaster, the burlap wall covering, wood flooring, and several large color copies of paintings. As we developed the details for the Collection Gallery's interiors, we used two principles to help guide our decisions. Whatever we did must serve to *simplify* and *intensify* the art experience. Every choice we made was held to these criteria.

We began to think about the Collection Gallery moldings that play such a prominent role in framing the ensembles. There was no specific ruling on moldings. Were they to be duplicated, removed, or rethought?

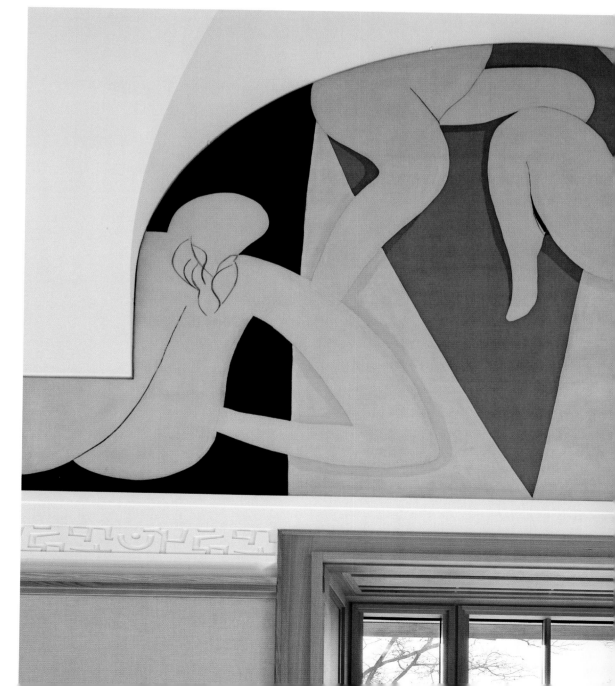

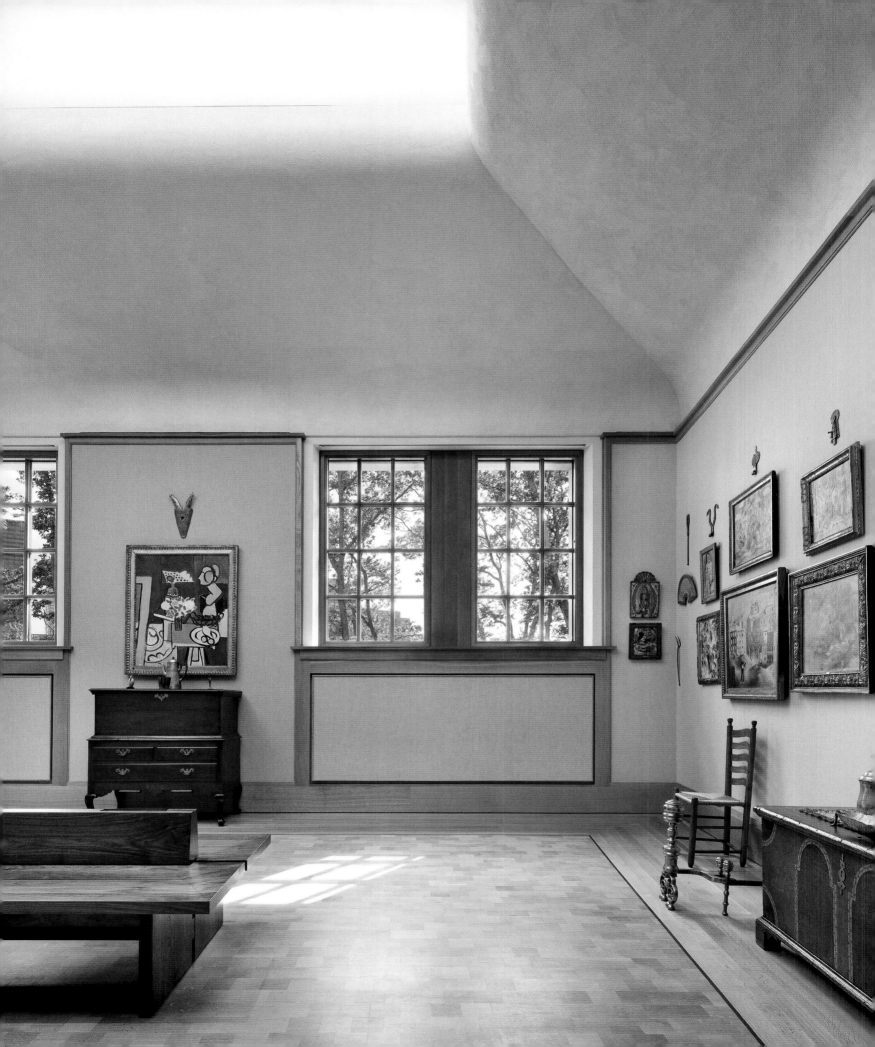

As contemporary architects, we had never used moldings in our work, and our first impulse was to remove them. Returning to the facial analogy, we quickly realized that if we removed the moldings it would be as if we removed the eyebrows from our faces. While removing the distraction of the molding might simplify and bring a sense of spaciousness to each room, it would surely unbalance Barnes's compositional ideas. Perhaps it would be best to replicate the moldings. But if we tried to replicate the moldings, we now knew that the windows were not being exactly replicated and there would inevitably be transitions between the Collection Gallery rooms and new spaces (the entry, the Gallery Garden, and the classroom) where replication was not possible technically or aesthetically. Finally, we felt that replication was, in a sense, the easy way out, and we were more interested in the idea of interpretation.

We knew so little about moldings that we immediately immersed ourselves in the subject—reading, looking, and building full-scale models of the Barnes moldings in wood and foam to better understand both the logic of their construction and their form. A colleague, who knew so much more than we, helped us understand the history, theory, and functionality. In time, we analyzed the Cret Gallery molding by molding. In order to simplify and intensify the moldings, we chose to use the same number of steps and similar three-dimensional proportions but eliminated all curves from the profile. Through the full-scale mock-ups, we saw that we needed to increase certain dimensions in order to enhance shadow lines—cast by the original moldings and a quiet but integral part of the ensembles.

We selected oak window frames rather than duplicating the white-painted steel window frames in Merion, because the presence of oak

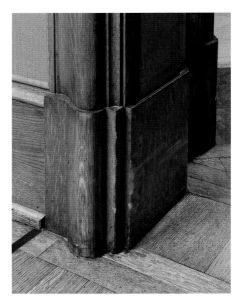

simplified the palette, tying it in with the oak moldings and baseboard. We believed it would warm and intensify the Gallery experience. The oak is slightly lighter in hue than the wood in Merion, which has darkened over time. We used side-grain oak squares bordered by straight oak strips to make a simplified version of the different parquet floor types used in the Cret building. Instead of using the traditional method of cutting against the grain, we had the oak squares cut with the grain of the wood. A dark strip of ipe wood is set into the floor to act as a boundary line to protect the paintings and objects. The transitional spaces between rooms now hide mechanical systems concealed behind vertical wooden battens. A thorough understanding of the "less romantic" needs of structure and mechanical systems gives us the capability of better integrating these systems invisibly into the fabric of the building.

We considered using Belgian linen with a heavy weave in place of the original jute wall covering, believing that the thicker weave would not only have more texture but also be more refined. Derek Gillman fought fiercely for the irregularity and essential crudeness of the burlap. And looking at the mock-ups, we finally agreed. We darkened the tone of the burlap a bit by using a tinted glue to intensify the final color.

Our very earliest concept of introducing places of repose and reflection into the Gallery experience remains the conceptual heart of our design. Both garden and classroom spaces provide places of reflection and rest before entering the last three rooms at the ends of each floor. The garden had no complex program requirements other than to bring in a sense of nature and light, and to give visitors a comfortable place to sit. The study component was more complex, since the Barnes's educational

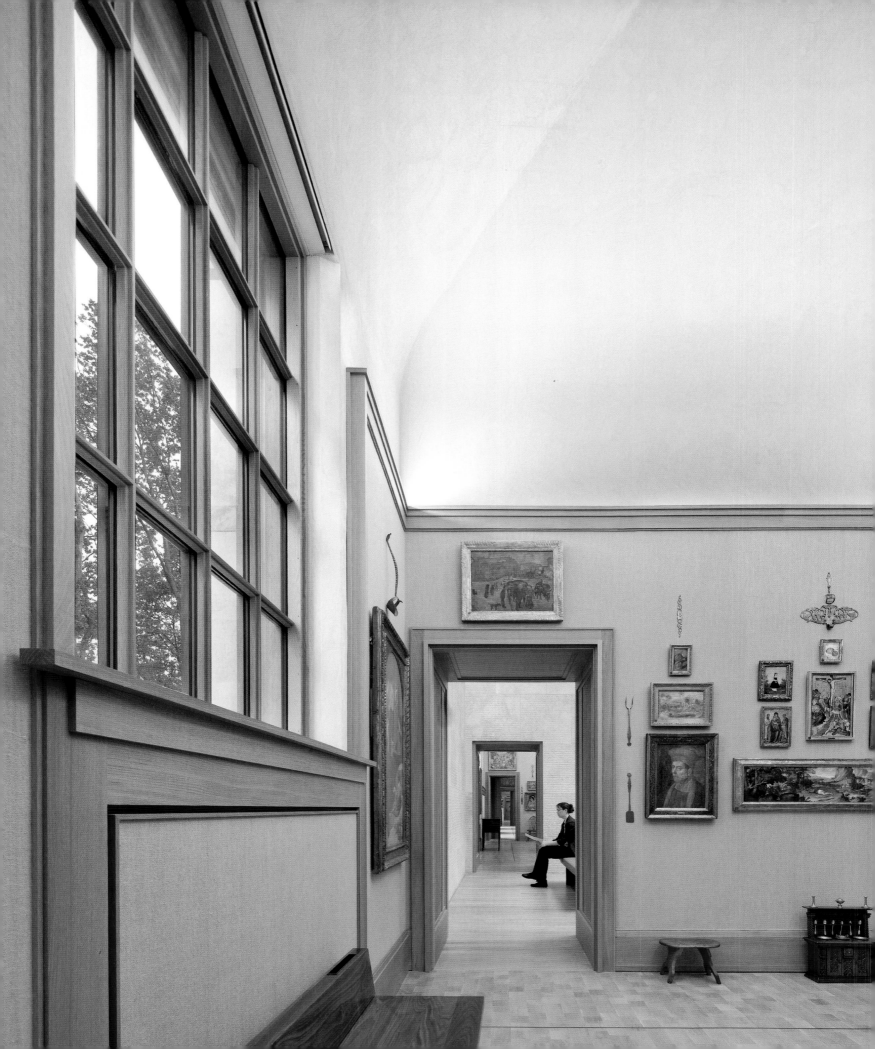

mission and ways of teaching have both historical roots and a contemporary need to make use of technology in order to serve a larger community.

Since the garden and classroom were not original to the Merion Gallery, they needed to be inserted gently, so as to provide a pause but not an interruption in the experience. The wall surfaces are simply stone with the hand-chiseled cuneiform surface. There is no wood detailing, and the stone simply runs from floor to ceiling. The flooring reverts to the simple, straight plank flooring used in the new special exhibition gallery in the Pavilion. An etched-glass and wood wall separates the first-floor classroom from the passageway. When there are no classes, this wall can fold back opening the room to the passage. Visitors or students can sit at a black walnut table made especially for the classroom by Stephen Iino, who built the benches in the Gallery rooms. Whether in the Gallery Garden or in the classroom, a quiet place has been made for people to appreciate the experience of Barnes's rich and complicated vision. In the Collection Gallery building, everything is the same, but everything is different.

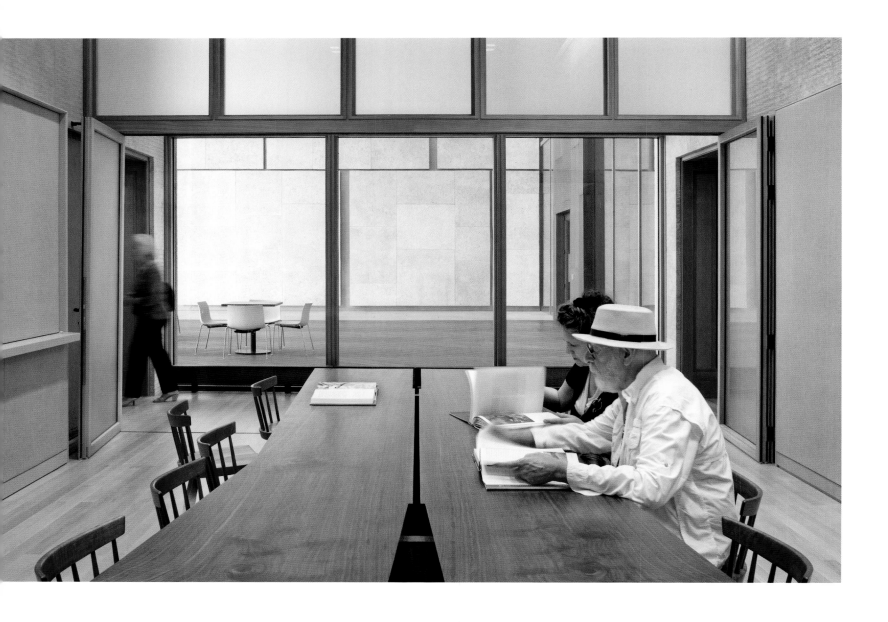

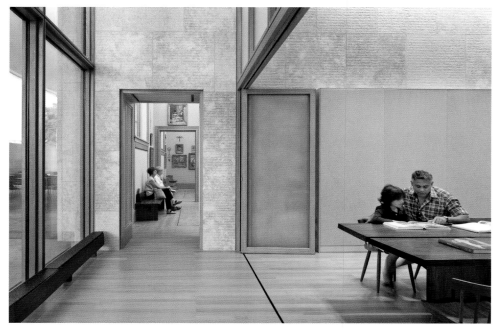

Above A thirteen-foot walnut table, made by woodworker Stephen Iino, in the first-floor classroom

Left An etched-glass and wood wall separates the classroom from the Collection Gallery circulation. The wall can fold back to open the room to the passageway and a view of the West Terrace.

Opposite The stone-clad Gallery Garden is inserted into the room sequence to provide a pause in, and not an interruption to, the viewing experience.

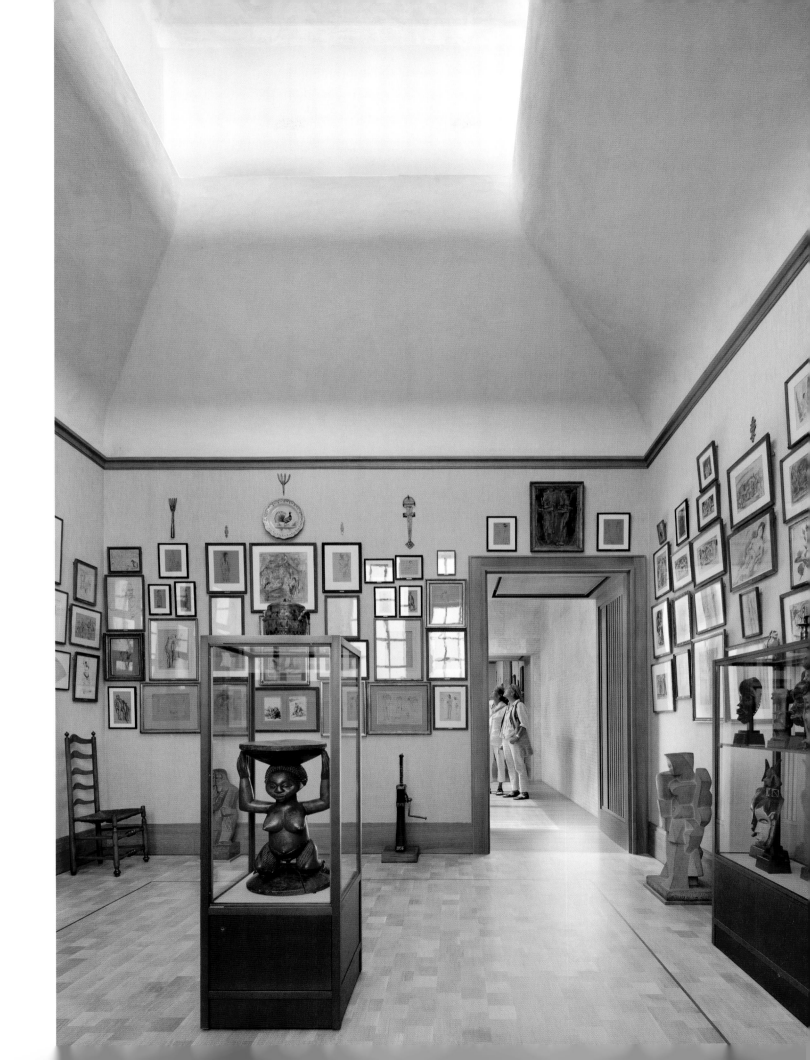

In this Collection Gallery passageway, visitors walk between the Light Court and a view into the Gallery Garden. Here, the stone runs from floor to ceiling and the flooring reverts to straight-plank.

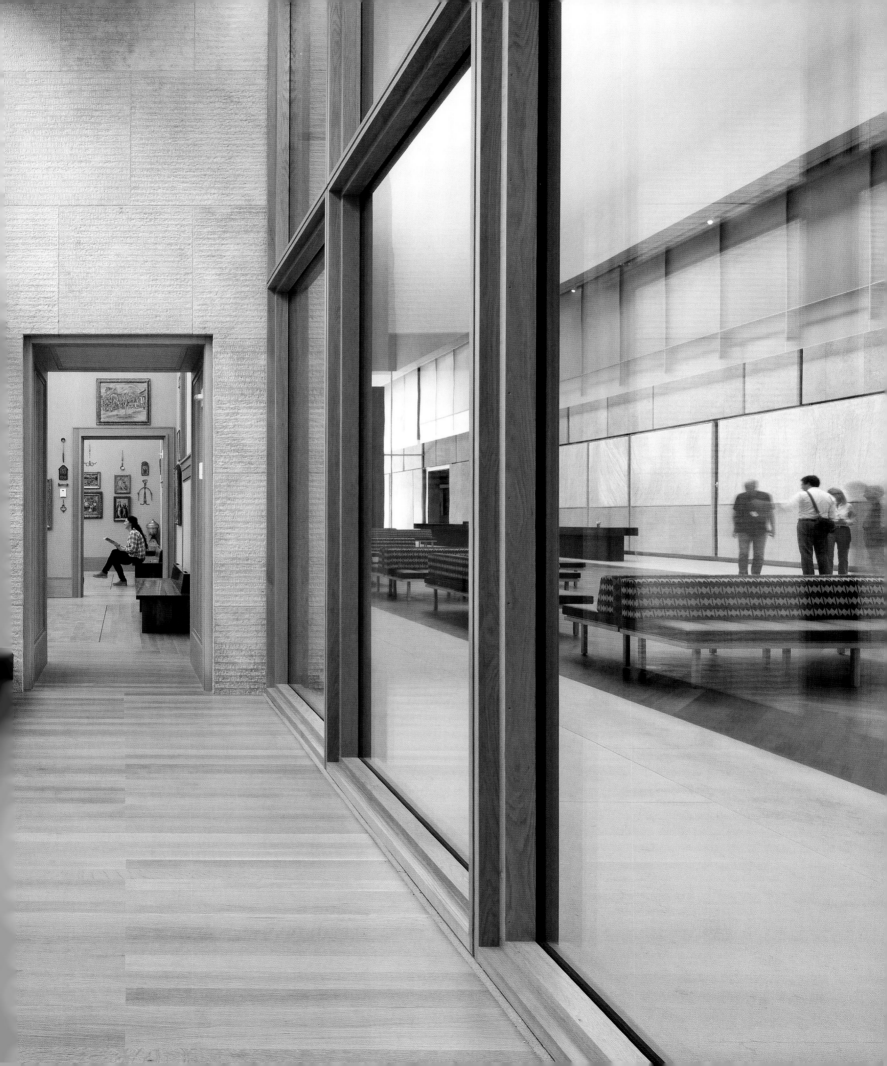

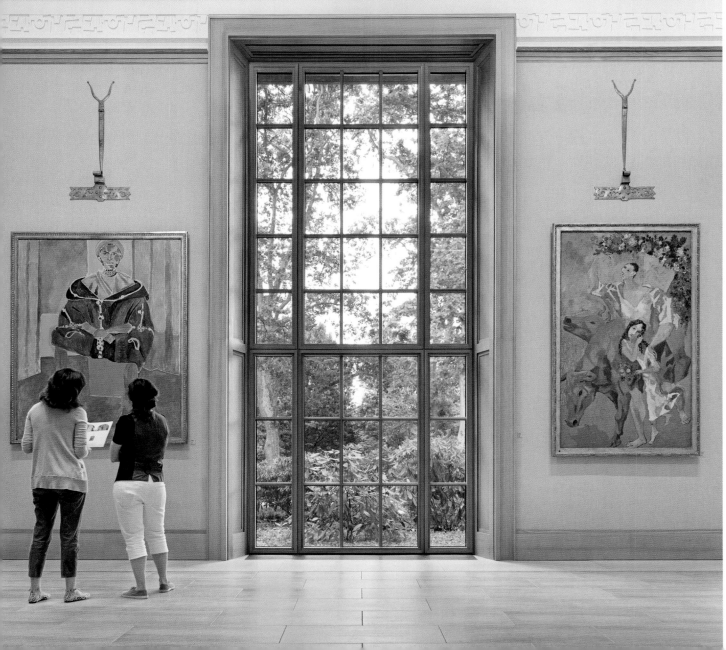

Opposite From the Main Room in the Collection Gallery, visitors sense the building's relationship to nature. An outdoor plinth is planted with ornamental trees and broadleaf shrubs, evoking the Merion arboretum.

Right An exterior view of the south facade into the Main Room

Following spread At dusk, passersby can see through a garden into the windows of the Collection Gallery building.

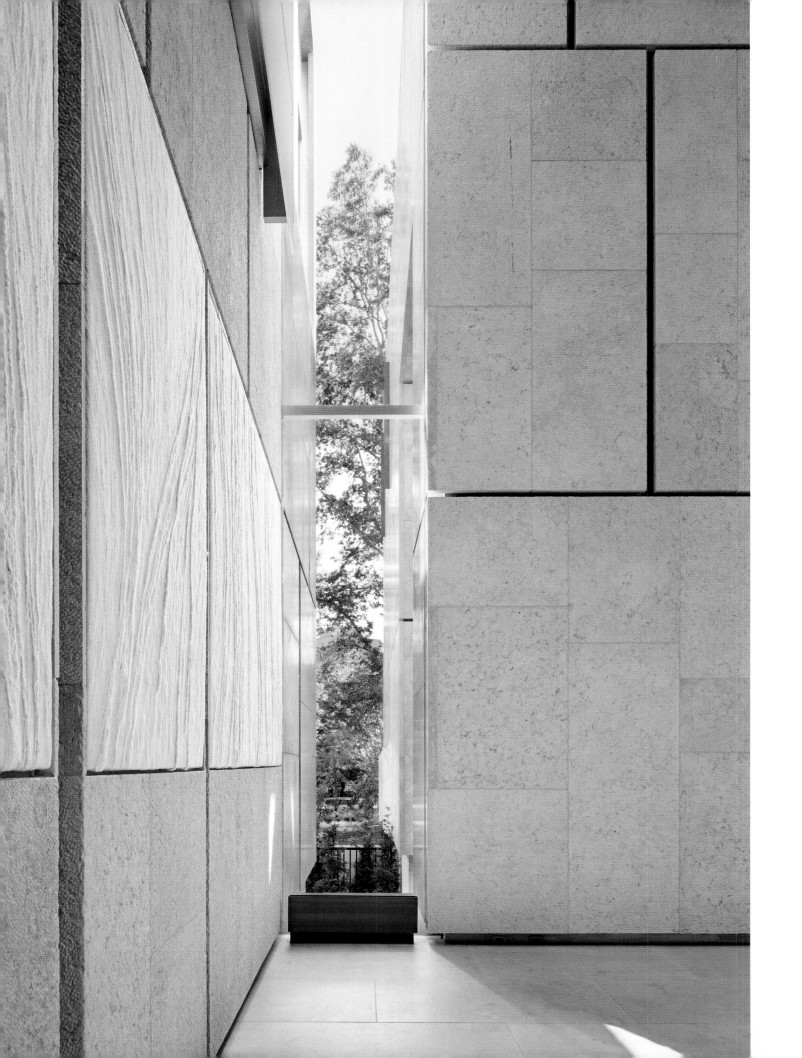

This book began by introducing a man and tells the story of the making of a building. We have never so thoroughly described the process of a project, and we have tried to be clear about how ideas were inspired and decisions made. In hindsight, the messy collaborative efforts required to complete a project of this scale and ambition now appear simple.

Words pale in comparison to what a building can do. We believe this building has brought the collection to light and has brought new life to the city of Philadelphia. And now that the building has opened, the controversy has begun to fade. What will last is Barnes's collection, his beloved ensembles, his commitment to the education of all, his love of nature's beauty, and his belief in the city where he was born.

Architecture differs from painting, sculpture, and writing in that it must contain the physical lives of humans and not just depict or project their image or their essence. We have attempted to describe our building from the inside and the outside, likening it to the human body, but we have barely touched on its structure. Many architects might believe it is better to say less and retain a sense of mystery. We do want to demystify our process, but we also want to note that this book, like a description of a life, can only present a set of facts. We know that behind a simple fact lie many layers of nuance and complexity. What seems so clear cut seems that way because we have edited out the confusion of missteps and uncertainties.

Finally, whatever is rational has a shadow sister—the intuitive. Some decisions have the framework of logic, and some decisions are made for magic.

PROJECT ACKNOWLEDGMENTS

The Barnes Foundation building, like each of our architectural projects, has not emerged from the minds, hands, or hearts of two, but of many. While we are the architects and call this project our own, it is truly a collaborative effort. A special thank-you goes to Aileen Roberts, who as head of the Building Committee, was always present and encouraged the best decisions and the highest standards. We owe deep gratitude to fellow architect and now good friend Bill McDowell, the Barnes Foundation's senior building project executive, for managing every issue, no matter how minute. Finally, we are profoundly indebted to Philip Ryan, our project manager, whose passion and clarity of ideas are key to the quality of the built work. Without the incredible intelligence, craft, and devotion of many others, this building could not have been successful. A plaque on the West Terrace recognizes the individuals who contributed to the development, design, and construction of the Barnes Foundation, Philadelphia. Their names are reproduced on the following pages. We thank each of them for the years of committed labor and love.

Samuel Abbruzzese, Gregory Abduljaley, Giorgia Abruzzese, Stephen Abruzzese, John Adams, Walt Adams, Troy Addis, Allen Akrigg, Joseph Alaia, Rick Alleback, Jacqueline Allen, Sam Amery, Joseph Amicone, Harry Amos, Harold Anderson, Samuel Anderson, Larry Andreozzi, Gary Angelo, Mark Antell, Michael Antell, Jenee Anzelone, David Aramski, Bill Arbuckle, Chris Ardizzi, Walt Armbrusteh, Michael Armbruster, Milton Arnold, Billy Ashjian, Rick Aurnheimer, Jack Bachmann, Mark Bachmann, Edward Backer, William Bader, Al Bagusky, David Bailey, Carlos Bailon, Richard Bainger, Albert Baker, Chris Baker, Debbie Baker, Keith Baker, Reggie Baker, Reggie Baker, Drake Ballard, Joseph Bamberger, Jesse Banas, Garrett Banclay, Harold Banks, Jerry Barks, Anthony Barksdale, David Barlow, Steve Barnard, Ryan Barnett, Carlos Barreira, Jack Barrett, Edward Barron, Joe Barron, Michael P. Barry, Kenneth Bartell, Bryan Bartleson, Mark Bassett, Charles Batchelder, James Bates, William P. Bavcom Jr., Frank Baxter, Patrick Baylor, Kareem Baylore, Dennis Beachan, Richard Bealer, Greg Bear, Barbara Beaucar, Mike Beaumont Jr., Kevin Beaupit, Phyllis Beck, John P. Becker, Michael Becker, Jeffrey Belh, Rasaan Bell, Curtis L. Bell, Miles Bellamy, Gary Belmont, Kevin Benales, Matthew Benales, Brett Benson, Jude Bernick, Mario Berrios, Joe Bertorillo, Paul Bevilaqua, Francis Bewson, Richard Bibeau, Timothy Bigley, Wendell Birch, David Bird, Keith Birden, Mike Blaceter, Jeffrey Black, Thomas William Blackie Jr., Joe Blanch, Michaeld Blaunt, James Blazier, William Blessing, Chris Blinebury, Gerry Blinebury, Michael Blinebury, Robin Blodgett, Michael Blowney, Michael Boarer, Dexter Bobcombe, Bryan Bolden, David Bolli, Renee Bomgardner, Mike Boncich, Louis Bonilla, Kurt Bonk, Bernard Bonner, Sheldon Bonovitz, Darryl Booker, Randall Bordon, Robert Boreas Jr., Michael Bouman, Anthony Bowan, Jerry Bowers, Richard Bowman, Timothy Bown, Peter Boyd, Jay Boye, Michael Boyer, Stephen Boylan, Tom Boylan, Blake Bradford, John Bradley, Chris Bragg, Glenn Bragg, Carman Bramorto, Larry Branigan, Joseph Brasberber, Mark Brasch, Gregory Braxtor, Darran Brennan, Mark Breslin, Mon Bresnan, Ken Breyer, Clyde Briar, Casey Bridwell, Jim Brodhead, John Brogan, Dan Brogley, Daniel Broker, Jarrett Brooks, Kevin Brooks, Philip Brown, Raymond Brown, Richard Brown, Scott Brown, Steven Brown, Thomas Brown Jr., Stephen Brownell, Andrew Bruggman, Stephanie Brusco, Bob Bryan, John Bryszewski, Susan Brzozowski, Thomas A. Buccella, Barbara Buckley, David Buehler, Gary Buehler, Justin Buhs, Timothy Bullock Sr., David Bulsza, Peter Bumasser, Bruce Burcaw, Willie Burgess, Jennifer Burke, John Burke, John Burke, John Burns, Michael Burns, Steve Burns, John Burr, Stephen Burt, Shawntonie Burton, Sean Burtse, Charles Bush, David Bussey, Robert Butera, Eric Butler, Michael Butler, Kristen Butts, Robert Butwin Jr., Shawn Byers, Tyhon Byers, Kevin Bygott, Sean Byrne, Gil Chris Cabnia, John Caccese, Michael Cahill, Niall Cain, Jim Calhaun, Joe Calicyo, Nicholas Calvanese, Chris Campana, Daniel Campbell, Mark Campona, Jim Cannon, Christopher Cannon, Scott Cantwell, Andrew Capaldi Jr., Diego Carabatal, Kenneth Carey, David Carlson, Christopher Carolli, Paul R. Caron, Charles Carr III, Arthur Carter, Gary Carter, Mike Carter, Paul Cartularn, Terence Casey, Michael Casgrove, Kevin Cashin, Charles Cassie, Dominic Cassise, Cesar E. Castaneda, Andrew Castillo, Thomas Castongna III, Norman Ceibson, Carlos Cespedes, Casey Chapman, William Chapman, Daniel Chavis, Alan Cheeseman, Terrence Cheng, Brian Cherevko, Dave Chila, Jeff Childs, Soo Choi, Eric Chorzelewski, Richard Christman, Robert D. Ciabattoni, Walt Cichonski, Angelo Ciocca, Dave Cirsons, Joe Clabbers, Michael Clabbers, Neil Clabbers, Pat Clancy Jr., Eric Clanton, Chris Clark, James Clark, James Clark, John Clark, Sean Clarke, Robert Clayton, Scott Clayton, Robert Clemens, Jordan Clendening, Tom Cliggett, Mark Clongshore, John Paul Cobin, Arthur M. Cohen, Joseph Coiurgio, Mike Colangelo, Michael Colletti, Michael

Collins, Elena Colombo, Christian Colozzi, Ed Colsher, Michael Coluzzi, Joe Comanat, Tony Conenna, Greg P. Conklin, James Connelly, Matt Connolly, Michael Connelly, Jeffrey Connors, Dennis Cook, Christopher Cooper, David Copeland, Nick Copeland, Carmelo Coppolino, Joe Coppolino, Antonio Corenna, Jack Corsetti, Michael Corsetti, Mathew Cortex, Cory Cottingham, Ed Cottrell, Jon Cowart Jr., Kenan Coyle, Matt Coyle, Mark Coyne, Paul Craig, Jay Crandall, Walter Craven, Dave Crawford, Mark Crecelius, James P. Creedon, Frank Criniti Jr., Joseph Cristinzio, Mike Cristinzio, Carolyn Cross, Keith Crowther, Kevin Crowthers, David Crute, Jesus Cruz, Claude Culbreth, Dennis Cumiskey, Maceo Cummings, Justin Cunningham, Ryan Curran, Michael Currie, Ron Cusick, Doug Cusiek, Kevin Custis, Bob Cwalino, James Czerwonka, Alex D'Agostino, Rocco D'Angelico, Chris D'Angelo, Frank D'Angelo, Mike D'Angelo, Anthony D'Angelo, Vince D'Antonio, Steve Dalton, Thomas Damario, Roy Dantz, Mark Daptula, Dennis Dasilva, Lisa Dasilva, Gerald Davidson, Gary Davis, Michael Davis, Ralph Davis, Roy Davis, Seth Davis, Kevin Dawkins, Robert Deagler, Roger Dechaine, Joe DeCresi, Matthew Deegan, Mark DeFelice, Eugene DeFino, Ryan DeJoseph, Steve Delariva, Domenic DeRita, Tom DeSante, Ralph DeSimone, John Destefano, Edward Devine, Bill Devitt, Mike Dewoski, Anthony DiAngelis Jr., Joseph Diaz, Robert DiBnumo, Michael DiCarlo, Anthony Diciccio, John DiDomenico, James DiGregorio, Salvatore A. DiMania, Joseph DiMaria, Francis Dintino, Rocco DiSalvo, Americo Disantis Jr., Joseph DiTorio, Anthony Ditri, Joseph Dittio, Jay Ditzler, Scott Ditzler, Mario DiVentor, Harvey Dixon, Phil Dobinson, Dave Dockard, Anthony Doggett Sr., Jeff Doko, Jim Dolente Sr., Jim Dolente Jr., Steve Dolente, Judith Dolkart, Michael Domenick, William M. Domiano Jr., Keith Domicz Sr., Keith Domicz Jr., Ted Domzalski, Jack Donnelly, Michael Donnelly, Jim Donnelly, Matt Donohue, Brian Donovan, Christian Donovan, James Dorrisett, Bernard Dougherty, Frank Dougherty, Kathleen Dougherty, Robert Dougherty, Vinny Dougherty, Gregory Doyle, Hugh Doyle, Michael Dreslin, Robert Ducibella, Christopher Duerr, Harry Duff, Andre Duggin, Harry Duke, Thomas Dukes, Diana Duke Duncan, Eric Duncan, Brian Dunn, Stephen Duphily, Ramon Durand, Ryan Durrett, Richard Durso, Peter Dustin, John Dworak, Luis Echevarria, Thomas Edwards, Clarence Eggleston, Brad Ehien, Joseph Ehmann, Joseph Ehmann Jr., H. Eldridge, Troy Eldridge, Ronald Eligator, John Elliot, Tamikia Elliott, Henry Ellis, William Elser, Marleen Engbersen, Phil Engers, Claude Enoch, Jamie Erazo, David Erhart, Gary Erick, Steve Ertle, Omar Escamille, Phil Esco, Tom Eskuchen, Dan Euser, Richard Evans Jr., Keith Evans, Kevin Everett, Roger Everett Jr., Michael Evert, Steven Fahey, Brian Falconer, Joseph Falsette, Mike Farrow, Virgil Farrow, Henn Fedo, Keith Feight, Kevin Fennell, Francis Fenningham, Jo-El Fequiere, Bob Ferguson, David Ferguson, Claude Fergusory, Christopher Fernes, Dominic Ferretti, Barry Ferriolo, Ryan Fiedler, Dona File, Daniel Finn, Fred Fischer, Joe Fisiearu, Kevin Fitzgerald, Joseph Fitzpatrick, Mark Fitzpatrick, Jim Fizur, Robert Flagg, Brian Flanagan, Christina Flanagan, David Flores, Tom Flynn, David Fonseda, Kevin Ford, Stuart Ford, Calvin Forde, Paul Forlewski, Ian Forster, Rob Foster, Eric D. Fox, Patrick Fox, Paul Fox, Regan Fox, James Fragassi, Tyler Francis, Carlyle Fraser, Dion Frasia, Donald Frazier, Paul Frederick, Tom Frederick, Carl Freedman, Stephen Freret, James J. Friskey, Michael Fritzges, Gregory Frobel, Robert Fucci, Matt Futon, Bryan Gabriel, Dana Gaeta, Anthony Gainey, Mario H. Galicia, Declan Gallagher, Joe Gallagher, H. Daniel Galloh, Carlos Gamarro, William Gamarro, Jim Gannon, Andrew Gant, Eliezer Garcia, William Gardner, Matthew Gardocki, Emilio Gareia-Castro, Joseph Garofalo, Jack Garrett, Kevin F. Garrison, John Gatti, Raymond Gawronski, Mike Gedraitis, Paul Gettz, John Giacomucci, Joseph Giardinelli, Tony Gibson, Alan Scott Gidney, Tim Gierschick, Chris Gilder, Regonald Giles, Ed Gillen, Derek Gillman, Octavia Giovannini-Torelli, John Gleason, Michael Glisson, Edward Godlewski Jr., Matthew Goeta, Ken Gold, Joseph Gollotto, Kevin Gondek, Rosemo Gonzales, Antonio Gonzalez, Carlos Gonzalez, Emiliano Gonzalez, Wilfredo Gonzalez, Frank Good, Dale Goodman, Dacek Gorcsuski, Brian Gordon, Edward Gordon Jr., Noel Gordon, William Gordon, Daniel Gore, Pete Gorillo, Edward Gormley, Paul Gorski, Andrew Gould, Wade Gouse, Raymond Graber, Michael Graham, Mike Graham Jr., David Grajales, Vincent Grassia, Jason Grasso, Keith Graum, Dan Gray, Michael Gray, Mike Gray, Jack Green, James Green, Martiz Green, Leslie Greene, Rich Greenspan, Stephen Grela, Robert Gremmel, Garry Griffin, Greg Griffin, Tracey Griffin, Christopher Grillo, David Groome, Henry Grossbard, John Grossi, Rick Grossman, Dave Groves, Robert Grow, Gerald Grunidy, Gary Guarrara, Justin Guerin, Jim Guertin, Agnes Gund, Yavyz Gunor, Edward Gutierret, Eric J. Guvraki, Robert W. Guzzi, Larry Haban, Aaron Hadley, Fred Hagen, Kenneth Haines, Robert L. Hales, Frank Halgash, Ricky Hall, John Hally, Gerald Hamill, Andrew Hamilton, Brian Hamilton, Eugene Hamilton, William Hamilton, Mike Hanna, Kevin Hannah, Marco Hansell, Carl Hansen, John Harder, Samuel Harding, Steve Harding, Sean Harkin, William Harkins, Bob Harkness, Stephen Harmelin, Derrick Harmon, Michael Harmon Sr., Michael Harmon Jr., Mweli Harmon, William Harr, Jimmy Harris, Thomas Harron, Richard Hartman, Felipe Haubrich, Graig Haudsworth, Michael Hawkins, Dereck J. Hawthorn, Adam Hayes, Charles Haywood, Matt Heil, Carl Heimerl, Edward Heiser, Bernard Helder, William Heller, Scott Heller, Jim Helveston, Phanna Hem, Kevin Hemple, Allen Hendershol, Brian Henderson, Ted Henderson, Jason Henninger, John Herens, Michael Hernandez, James Hertfelder, Chris Heston, Robert Heyouk, Michael Hickey, Thomas M. Highland, Christopher Hildebrand, Roy Hiliard, Jim Hill, Tim Hill, Jeffrey Hines, Larry Hodge, Ray Hodges, Robert Hoffman, Peter Holdsworth, Rianne Holtrop, Nick Holz, Eric Holzhauer, George Holzhauer, Geoffrey Homan, Lamont Hopson, Ray Horn III, Shamus Houck, Reginald Hough, Forrest Houser, Stephen Howofsky Jr., Joseph Huber, Walter Huder, Charles Hughes, Joseph Hughes, Bill Hunt, Bill Hunt Sr., Bill Hunt Jr., Chris Hunt, Christine T. Hunt, Betty Huntley, Henry Hurtt III, Michael Huston, Jeff Hutwelker, Larry Hwieozrejko, Gregory Iacobacci, Joshua Iaconelli, Joe Iehle, Michael Igo, Stephen Iino, Mike Ilisco, Joe Ingram, Ken Innella, Demetrius Isaac, Gustauo Izquerdo, Bruce Jackson, George Jackson, Raymond Jackson, Rich Jacobs, Richard Jacobs, Erik Jaeger, Ed Jakmauh, Lee James, Rick Jankowski, Joseph Jarosz, Mark Jarosz, Jerry Jaskolka, Paul Jaskulski, Vance Jenkins, Walter Jenkins, John Jennings, Michael Jereb, John Jodleyo Jr., Jason Johns, James Johnson, Melvin Johnson, Nate Johnson, Patricia Johnson, Scott J. Johnson, Shawn Johnson, William Johnson, Joanna Johnson-Horris, Alonzo Jones, Damien Jones, Hakeem Jones, Jeffrey C. Jones, Julian Jones Jr., Karl Jones, Leon Jones, William Jones, Claudy Jongstra, Helen Joo, James Jowisck, Frank Joyce, Gerald Joyce, Jack Joyce, Pat Joyce, Pat Joyce, Andrew Juliana, Joe Julliano, John Juliano, Charles

Juneau, Dean Juwock, Paul Kabaci, Richard Kaczinski, Roy Kaffenberger, Zach Kaiser, Sameer Kaldoon, Andrew Kane, Mark Kane, Rolan Kane, Anthony Karaboyas, Allen Karl, Andrew Kasiewski, Edward Kay, William Kee, Joseph Keebler, Dan Keefe, Scott Keely, Terry Kellemer, Emily Kelly, Peter Kelsen, Edward Kempf, Ernest Kennedy, James Kennedy, Jeff Kennedy Jr., Jeffrey Kennedy, Michael Kennedy, Francis Kenney, Leonaro I. Kersey, Daniel Bradley Kershaw, Brian Kidd, Bill Kierbler, David Kilburn, Robert Kilburn, Martin Killen, Dave Kilroy, Dave Kilroy, Arthur King, Norman King, Daniel Kitchen, Joseph J. Kivleu III, Mike Klosinski, William Knorr, Michael S. Knuer, John Kollhoff, Eve L. Kootchick, Aaron Korntreger, Edward Kosinski, William Koslosky, Stephen Kowalski, Steven Kozlowski, Dennis Kozubol, Justin Krail, Ron Krajewski, Mike Kramer, Thomas Kraw, Jeremiah Krigbaum, Anne Kristensen, Brandon Krohnert, Joseph Krol, Jason Kufta, Jason Kufta, Donald Kulick, Peter Kura, Chris Kuzer, Howard Kyttle, John La Serre, Mark Lally, Bill Lambing, Henry Land, James Lang, Scot Lang, Christopher Lange, David Later, Mark Laughlin, Ray Laurinaitis, John Lavelle, Damian Lavginiger, Patrick J. Lavin, Wayne Lawley, Marshall Lawrence, Perry Lawrence, Thang Le, Andrew Leach, Charles Leake, Allen Ledrew, Ruslan Lehenngs, Jeremy Lehr, Deborah Lenert, Kevin Lennon, John Leonard, William Leonard Jr., Keith Lepard, Greg Lepore, Eugene Lepore, Rich Lerch, Darrin Letzgus, Eric Leva, Victoria Levesque, Joseph Levi, Eva Lew, Jim Lewis, Moses Lewis, James Leyden, Yue Li, Michael Lieb, Steven Lilley, Beth Lillis, Stephen Lindemuth, Erik Lindgren, Chris Link, Ray Linn, Donald Linnenbaugh, Paul Lisby, Margaret Little, Timothy Litz, Xiao Liu, Joseph Lockley, Dave Lodato, Henry Lomas, Lil London, Adam Long, Jason B. Looby, David Lopez, Jose G. Lopez, Craig Lord, Christopher Lotgus, Robert Louth, Eric Lovett, Larry Lucas, Michael Lucera, Louis Luchetti, Albert Lucia, Gregory Lucia, Gregory Lucia, Frank Lucisano Jr., Martha Lucy, Royce Ludwig, Steven Lui, Lane Lundberg, Doug Lutz, James Lynch, Todd Lynch, Stuart Lynd, Kristin Lyons, Tom Lyons, Wale Mabogunje, Kyle MacGeorge, Doug Mack, Shelton Mack, Scott MacPherson, Richard Madden, Meghan Madeira, Anthony Mairone, Luis Maldonado, Jonathan Maldonado, Ted Malecki, Peter Malishuk, Sean Malone, Thomas Maloney, Samuel Malowey, Ken Malpizzi, Joe Mancuso, Lauren Mandel, Jared Mangino, Larry Manigly, Shawn Manigly, Bryan Manion, Timothy Manley, Riv Manning, George Manny, Wm. Tyrone Mansfield, Michael Manuel, Paul Marantz, Louis Marchozzi, Vincent Mariano, Nicholas Marino, Robert Markegene, Bill Marker, Bill Markham, Paul Marmorato, Peter Marmorato Jr., Jimmy Marren, Erice Martiello, Fran Martin, Mike Martin, Michael Martinez, Paula Martinez-Nobles, Frank Masciotro, Greg Mason, James Mathis, John Matlias, Anthony Matozzo, Damon Matthews, James Matthews, Timothy Mattox, Robert Mawhinney, Jennifer May, Eric Mayerscough, Kevin Mayoros, Nicholas Mazio, Steve McAlary, Thomas McAnally, Pat McAnulty, John McBride, Harold McCall, Sean McCarrie, Sean McCarrie, Norris McCarry Jr., Thomas McCarthy, Michael McCloskey, Blake McClure, Mark McCombs, Frankie McComeskey, Devon McConnell, Ronald McConnell, Thomas McConnell, Geoffrey McCormac, Joseph McCormick, Rich McCormick, John McCoubrey, Mike McCown, Lamont McCoy, Melissa McCoy, Lance McCue, Victoria McCue, Marty McCullough, Patrick McCullough, Brian McCusker, Francis McDade, Francis McDade Jr., John McDermott Jr., Martin McDermott, Stephanie Mcdermott, Steve McDermott, Rob McDevitt, Patrick McDonald, Mark McDonnell, Brian McDonough, Bob McDowell, Mike McDowell, William McDowell, Drew McElhinney, Florence McFall, Steven M. McFee, Sean McGettigan, Kevin McGinly, Kevin McGinnis, John McGorley, Timothy McGovern, Tim McGrail, Vince McGrath, Thomas McGrogan, Robin McGruder, Kevin McGuigan, Michael McHale, Francis McHugh, Matthew Mcilhenny, Kevin McIntyre, Ryan McIntyre, Jon McKee, Henry Mckendon, Michael E. McKenna, William McKenna Jr., Thomas McKeown, Ken McLaughlin, Michael McLaughlin, William McLead, Robert McLean, Robert McLoughlin, Peter McMahon, Ward McMasters, Michael McMouigle, Patrick M. McNamara, Robert McPoyle, Mike McSonsley, Michael McSorley, Donald Mealey, Donald Megalgan, Ami Mehta, Andrew Melhando, Anthony Mellen, Donald Mellwig, Jose L. Mendoza, Thomas J. Menichol III, Anthony Merlino, David Messenger, Rod Messenger, Edward Messina, John Messina, Sam Messina, Joseph Meyer, Robert Meyer, Nick Micenec, Norm Middleton, Frank Miles, Kevin Millen, Abbott Miller, Ari Miller, Brett Miller, Jason Miller, Joseph Miller, Michael Miller, Donald Milliams Jr., Bill Milligan, Christopher Mills, Mark Mills, Michael Mills, Darlene Mims, Darlene Mims, Dave Mirra, Kiran Mistry, Lonni Mitchell, Michael Mohler, Stephen Mokychic, Rafael Molina, Dan Monaghan, Shon Monroe, Anthony Montana, Lorri Montgomery, David Moore, Thomas Moore, Edwin Morales, Joe Moran, Robert Moran, Steve Moran, Joe More, Bill Morgan, Knole Morning, Michael Morgan, Willam Morgan, Tyree Morris, William Morrison, Aaron Morse, Daniel Morzizi, William Motfilubo, Glen Movzon, Tyrick Moy, William Muehlenhard, Hassan Muhammad, Naji Muhammad, Rich Mullen, Archibald Murdock, Jeanette Murdock-Ullah, Dawod Murphy, Dwayne Murphy, Joseph Murphy, Michael Murphy, Tim Murphy, Drew Murray, McKenzie F. Myers, Robert Myers, Thomas Myers, Charles Naegele, Reginald Nash Jr., Rich Nathan, Eric Navarro, Casey Nave, Richard Nave, Ryan Neels, Jerry Negler, Donny Nelson, Kalvin Nelson, Deborah N. Nemiroff, Joseph Neubauer, Ed Newman, Anthony Newsome, Robert Nichols, Matthew Nicolai, Dean Nicolette, Silvili Niculce, Mark Nielson, Kodi Nixon, Jay Nofer, Phillip Nofer, Timothy Nolan, Michael O'Brien, Daniel O'Connell, Robert O'Connor, John O'Hara, Philip O'Mara, Ronald O'Neal, Jim O'Neil, Thomas O'Neill, Timothy O'Neill, Gerard O'Rourke, Kevin O'Toole, Kevin O'Toole, Robert Oakes, Kevin Obrian, Marc Oczkowski, Donald Odom, Drew Ogdin, Laurie D. Olin, Dominic Onofrio, Michael Onorato, Regina Onorato, William Opdyke, Levan Opher, Brian Orseno, Greg Otman, John Pace, Paul Pacello, Dennis J. Pacetti, Michael Pacioces, Margarita Padin, Michael Pagano, David Paglia, Frank Pagliaccetti, Michael Palestini, Wilson Palm, Patricia Palmer, Michael Palmisano, Ronald Paluba, Thomas Palumbo, Tom Pappanastasiou, Chris Park, Dennis Parker, Elliot Parker, Matthew Parsi, Glen Parson, Kenneth Parylak, David Pascoe, Gennaro Patitucci, Jeffrey Patrick, Thomas Patsch, Mark Patterson, Crayton Patterson, Yuriy Pavlivhka, Michael Peahola, Bruce Peart, William Peck, Desmond Peel, Matthew Peitz, Joseph Pellegrino Jr., David Peoples, Marc Peraino, Dennis Perangeli, Alex Perez, Suzanne Person, Jim Perugini, Joseph Pessa, Edward Peters, Erik Petersen, Miriam Peterson, Nicholas Petrovsky, Zeev Petrucci, Albert Pettil, Christopher Phelps, Mark Phillips, Ray Picc, Bud Picconi, Renaldo Pickering, Steve Picnotore, Jonathan Pierce, Steve Pinclotti, Aaron Pine, Anthony Pini, Dennis Pino, Jason Pinto, Tom Pippett, Chris Piso, Chad Pittman, Daniel Pizzelli, William Plan, Robert Pleasant, George Plotts, Robert Plunkett, Eric Pohl,

Shara Pollie, Gene Pollock, Adam Poloney, Vincent Polverini, Timothy Poole, Tim Pooler, Donald Posey, Peter Potoma, Mark Potter, Robert Pouliott, Mike Powell, Vanna Prak, Ajay Prasad, Robert Prettyman, Joe Prevost, Robert Price, Timothy Price, David Prickett, Andrew Prince, Patrick Prior, John Przepioski, Mack A. Pugh, Steven Purcell, Joe Pursell, Tom Pursell, Justin Quacco, Charles Robert Quincey Jr., Joshua Quinn, John Quirk Paul Quirk, Brian Raby, Bredan Rafferty, Jonathan Rafter, Kenneth Rainer, Gus Ramirez, Mike Randall, Thomas Ranpoyolk, Josh Rastelli, Katy Rawdon, Jim Reath, Ben Redman, Krista Reeder, Brian Rees, Brandon Reeves, Ralph Reeves, Eol Reilly, Jan Reinhardt, Joseph Renzulli, Cesar Reyes, Manuel Reyes, Gerold J. Reynolds, Michael Ricchezza, Robert Riceck, David Rich, Joseph Rich, Kyle C. Rich, Darrell Richardson, Kathryn Richardson, Irving Richburg, Anthony Richter, Chio Ridge, Robert Riding, Ken Rienstra, James Riley, Joshua A. Rink, Marc Riordan, Juan Rios, Peter Rivera, Virgil Rivera, Frank Rizzo, Tyree Roang, Steve Rob, Aileen Roberts, George Roberts, John Roberts, Paul Roberts, Clinton Robertson, Derrick Robinson, Henry Robinson, James Robinson, Keith Robinson, Paul Robinson, Rob Robinson, Stephen Rodgers, Carlos Rodriguez, Edwin Rodriguez, Juan Rosaly Rodriguez, Rodrigo Rodriquez, David Rodweller, Matt Roe, Jim Rogers, Gerald Rogers, Anthony Brian Rogevich, Eric Rogtach, Greg Romine, Terrence Rooney, Tim Rooney, Laylon Rorie, Zachary Rose, Eric Rosenbaum, Jason Rosetta, Nancy Rosner, Palmer Rossi Sr., Anthony Rossi, Paul Rossi, Jan Rothschild, Anthony Rowan, Stephen Rucci, David Rude, Neil Rudenstine, Robert Rudolph, John Rue, Bill Rush, William Rush, Jade Russell, Kip Russell, Frank Russo, Steven Russo, Joe Ryan, Kevin Ryan, Philip Ryan, John Sabatini, John Sabia, Matthew Sabia, Nick Sabia, Tom Sabia, Marvin Sabir, Tony Sabo, Gregory K. Sadowski, John Salera, Jason Salera, Randall Saling Jr., Augustus Samuel, Bernard Samuel III, Paul Sansoni, Mark Santangelo, Luis Santiago, Ray Santiago, Samuel Santiago-Rolon, Daniel Santoniello, Carlos Santos, Ted Santos, Dominic M. Sapienza, Elmer Sarauic, Ken Saretsky, Andrew Satmary, Christine Sauer, Michael Sava, Paul Savander, Andrew J. Scanlan Jr., Tom Scannell, Justin Scarinci, Nick Scarinci, Bryan Schaffer, Martin Scharnitz, Jim Schiffner, Mark Schilder, Adam Schildt, Mike Schillinger, Robert Schlear, Joe Schmidt, John Schmidt, Kevin Schulz, Axel Schulze, Paul Scipione, Enrico Sciulli, Gary Scofield, Bernard Scott, Earnest Scott, Eric Scott, Mark Scott, Mike Scott, Henderson Sealy, Harold E. Seartass Jr., Eric Seaverns, Jermaine Seawright, Andrew J. Sebor, Mike Sedor, Thomas Seebes, Bill Seifried, Howard Sellers, Jason Semprevivo, Maxi Senderowitsch, Steven Serio, William Settle, Joe Seward, David Seyferhelt, Bill Shallock, Kevin Shands, Daniel Shaw, Kenneth Shaw Jr., Kenn Sheahan, Paul Shedaker, Scott Shelley, Paul Shepherd, Byron Sheppard, James Sheridan Jr., Eric Shields, Howeard Shields, James Shields, David Shihadek, Jeff Showers, Helmut Shugg, Steve Silver, John Silvestera, Scott Simmons, Michael Simonka, Adam Siwek, Buell Slaughter, Gilbert Slaughter, Mark Slavin, Lawrence Sliwinse, Wade Slone, Richard Small, Steve Small, Kenny Smilgo, Brant Smith, David Smith, Guy Smith, Michael Smith, Michael Smith, Michael T. Smith, Richard Smith, Tony Smith, Vernon Smith, Steve Smolskly, James Snyder, Paul Snyder, Dave Sochacki, George Sol, Carl Solano, Rene Solano, Joseph Solina, Joshua Solomon, Rosario Sorbello, Alberto Soto, Ricardo Soto, Dominic Soukhaphonh, Craig Spangler, Charles Sparks, Francis Spause, Scott Spicher, Lewis Spigler, Kristen Spilman, Walter T. Spry Jr., Jeff Stark, Glenn Stauffer, Willard Steele, Jason Stefanski, Howard Steinberg, Julie Steiner, Joseph Stem, Robert Stevens, Andrew Stewart, Chris Stewart, Dan Stickley, Michael Stillman, Jim Stinsman, Robert Stoeckle, Joseph Stone, Ryan Story, Dennis Strahan, Pete Strauss, Ed Strockbine, Tim Stroud, Brian Stroup, William Strubilla, Mack Stulb, Dave Stunzi, Richard Sturgeon, Calray Suber Sr., Whang Suh, Eric Suhoskey, Andrew Sullivan, Dennis Sullivan, Patrick Sulzman, Daniel Surrett, Jason Swander, Sha Sweeney, Amy Syernick, Brad Sylvester, Walton Sylvia, Chris Szewczak, Brian Takacs, Frank Talamo, Richard Taphorn Jr., John Taranto, Larkin Tartaglia, Carla Tate, Joshua Taylor, Michael Taylor, Terence Taylor, William Teske, John Thayer, Patrick Theakston, Eric Thielking, Jacob Thomas, Theodore Thomas, Bud Thomas, Hans Thomas, Virgil Thomas, Pasquale Thomaselli, Carol Thrower, Simon Tickell, Silvio P. Tino, Carl Tkachuk, James Tkachuk, Carlo Tocci, Bill Tolle, John Tolliver Jr., Nicholas Tomburro, Kasey R. Toomey, Rick Topy, Joseph Torrento, Efrain Torres, Jose Torres, Chris Torrey, Jennifer W. Toy, Thomas Trago, Michael Trainor, Tom Tralies, Matthew Trey, Adam J. Trojanowski, Brian Trophy, Owen Truax, George Tumold, Michael Turner, Rodney Turner, Patrick Ubele, Matthew Uhrig, Joe Urbanowski, Joe Valecce, Richard Valentino, Saul Valladares, Maeve van Klaveren, Richard Van Trieste, Rhil Van Veen, Stephen Varallo, Carlos Varana, Kevin Vardergrift, Carlos Vasques, Israel Vasquez, Heriberto Vazguez, Dominic Vecehione, Richard Vermeulen, Brian Vinchesi, Paul Vitullo, Eric Voegele, John Vogt, Paul Volkwine Jr., Brandon Volpe, Eric Von Berge, Rob Vresilovic, Mike Wagner, Thomas Wagner, Michael Waldman, Kurt Walker, Zanas Walker, Jack Wallace, Michael Wallet, Bob Walls, Ed Walls, Kevin Walls, Shawn Walsh, Charles Walters, Andrew D. Ward Jr., Alan Warner, Eric Washington, John Washington, Steve Wasnicwski, Peter Wates, Bernard Watson, Chris Watson, Anthony Wattis Jr., Calvin Webb, Chris Webber, Garren Webster, Bill Weicker, Jason Weicker, Charles Weigh, Sue K. Weiler, Stan Weisbrod, David Weiser Jr., Christopher Weixler Jr., Ralph Wellington, Dennis Wells, Martin Welsh, Herbert H. Wescott III, Patrick Whartenby, Kevin Whelan, Bill Whitchard, Brian Whitfield, George Whittaker, Brian Whitton, Maryellen Wikoff, Mark Wilcox, Derek Wiley, Jerome Wiley, Steven Wilkie, Tom Wilkins, Walter Wilkins, Alex Williams, Andrew Williams, Bernard Williams, Carnell Williams, Clarence Williams, Daniel Williams, David Williams, John Williams Jr., Samuel Williams, Shane Williams, Stanley Williams, Tim Williams, William Williams, Michael Wills, Allen L. Wilson, Darren Wilson, Michael Win, Michael Winter, Michael Winters, Michael Wise, Jim Wiser, Ryan Witehead, Dan Woelpper, Frank Wolfrom, Jeffrey Worsfold, Dan Wszolek, Danielle Wynn, John Wynne, Walter Wynne, Vince Yacenez, Piljo Yae, Andrew Yeager, Jason A. Yeager, Courtney Yip, Daniel Yohannes, William Young, Selena Younger, Wm. J. Zaccagni, Gerald Zaccaria, Brian Zachwieja, Michael Zadrefa, John Zanemski, Zack Zanolli, Joseph Zavislak, Margaret Zminda, Mike Zoeller, Anthony Zurzolo, Jeremy Zweeres

September 5, 2007 – May 19, 2012

Architect selection to public opening of the Barnes Foundation, Philadelphia

Tod Williams and Billie Tsien

Tod Williams and Billie Tsien began working together in New York in 1977 and nine years later established Tod Williams Billie Tsien Architects in the same Central Park South studio where they work today.

First published in the United States of America in 2012 by
Skira Rizzoli Publications
300 Park Avenue South
New York, NY 10010
www.rizzoliusa.com

In association with
The Barnes Foundation
2025 Benjamin Franklin Parkway
Philadelphia, PA 19103
www.barnesfoundation.org

ISBN-13: 978-0-8478-3805-9
Library of Congress Control Number: 2012944553

© 2012 The Barnes Foundation
Text © 2012 Tod Williams and Billie Tsien
Essay © 2012 Kenneth Frampton

FOR THE BARNES FOUNDATION
Johanna Halford-MacLeod, *Director of Publications*

FOR SKIRA RIZZOLI PUBLICATIONS, INC.
Margaret Rennolds Chace, *Associate Publisher*
Philip Reeser, *Editor*

DESIGN
Abbott Miller and Kim Walker, Pentagram

Printed and bound in the United States

2012 2013 2014 2015 2016 / 10 9 8 7 6 5 4 3 2 1

On the front cover Detail of the Collection Gallery's south facade

On the back cover Detail of mosaic floor at entrance to the Light Court

IMAGE CREDITS

All photography © Michael Moran/OTTO except for the following:

© Archimage: p. 37 (top)

© Associated Press: p. 125 (top)

Barnes Foundation Archives: p. 25 (bottom)

Barton & Martin Engineers: p.20 (source material)

© Ben Riley: p. 129

From the Collection of the Mercer Museum: p. 37 (bottom)

© Giles Ashford: pp. 22 (top), 27 (top), 28 (top), 31, 35, 57 (bottom), 78, 79, 83, 112, 155 (top right), 158 (top)

Isabella Stewart Gardner Museum, Boston. Photography by Clements & Howcroft, 2009: p. 34 (top)

Kimbell Art Museum, photography by Robert LaPrelle: p. 38 (top)

© Neil A. Meyerhoff, Inc. Panoramic Images 2012: p. 44 (top)

Newark Museum/Art Resource, NY: p. 80

© Nick Hufton/View Pictures: p. 150 (bottom)

OLIN: pp. 54 (bottom), 57 (top), 58–59 (top), 60 (bottom), 62–63, 68, 71 (bottom)

Paul Philippe Cret Collection, The Architectural Archives, University of Pennsylvania: p. 21

Photograph Collection, Barnes Foundation Archives: pp. 18, 22 (bottom)

Photograph © 2012 Barnes Foundation: pp. 24–25 (top), 27 (bottom), 29

© The Frick Collection: p. 34 (bottom)

© The National Gallery, London: p. 150 (top)

Tod Williams Billie Tsien Architects: endpapers, frontispiece, pp. 20 (modification of the site survey), 23, 32 (bottom), 33, 36, 38 (bottom), 40 (top), 41, 43, 45 (top), 46, 48–49, 50, 51 (top), 56, 61 (top), 67, 69, 72, 84–85, 86, 87, 88 (top and middle), 89, 90, 91, 98, 107 (bottom), 113, 116, 119, 122, 125 (bottom), 126 (bottom), 132, 144, 149, 151 (bottom), 152, 154, 155 (top left and bottom left), 157, 158 (bottom), 159

© Tom Crane: pp. 32 (top), 40 (bottom), 51 (bottom), 96, 117 (left)

All photography of works in the Barnes Foundation are © 2012 The Barnes Foundation.

gallery in a
garden